In the Mind but Not from There

In the Mind but Not from There

*Real Abstraction
and Contemporary Art*

Edited by Gean Moreno

VERSO
London • New York

First published by Verso 2019
Contributions © Individual Contributors 2019
Collection © Gean Moreno 2019

1 3 5 7 9 10 8 6 4 2

Verso
UK: 6 Meard Street, London W1F 0EG
US: 20 Jay Street, Suite 1010, Brooklyn, NY 11201
versobooks.com

Verso is the imprint of New Left Books

ISBN-13: 978-1-78873-069-3
ISBN-13: 978-1-78873-643-5 (HBK)
ISBN-13: 978-1-78873-070-9 (UK EBK)
ISBN-13: 978-1-78873-071-6 (US EBK)

British Library Cataloguing in Publication Data
A catalogue record for this book is available from the British Library

Library of Congress Cataloging-in-Publication Data

Names: Moreno, Gean, 1972- editor.
Title: In the mind but not from there : real abstraction and contemporary
art / edited by Gean Moreno.
Description: Brooklyn : Verso, 2019. | Includes bibliographical references.
Identifiers: LCCN 2018059840| ISBN 9781788730693 (paperback) | ISBN
9781788736435 (hardback)
Subjects: LCSH: Art, Modern—21st century—Philosophy. | Art and
society—History—21st century. | Marx, Karl, 1818-1883—Aesthetics. |
BISAC: ART / Criticism & Theory. | ART / Art & Politics. | ART / History /
Contemporary (1945-).
Classification: LCC N6497 .I53 2019 | DDC 709.05—dc23
LC record available at https://lccn.loc.gov/2018059840

Typeset in Sabon by MJ & N Gavan, Truro, Cornwall
Printed in the UK by CPI Group

Contents

CONTENTS

Introduction

Gean Moreno

In the last decade or so, the lockstep incursion of flat ontologies, notions of quasi-sentient matter, slime-lined and mushroom-sprouting vitalisms, and network-everything into contemporary art discourse and exhibitions has been hard to miss. Embraced with steady fanfare, a slushy and exhilaratingly immoderate carnival of chemistry and composting across our discursive landscape has us querying the unfathomable inexhaustibility of objects, their capacity to pipeline unwieldy forces and transgress the tiny territory of the *real* available to human access. But as excitement for this vivacious and mud-splattered thinking spikes, ostensibly terraforming a new plateau from which to assess our cultural artifacts, skepticism tactfully summons sharpened attention. Slight misgivings we felt all along for the conceptual pirouettes encouraged by this complicity with the powers of the object or the Earth or the cosmos find some oxygen and molt their modesty. As they are elaborated, it is evident that these suspicions can't be hastily explained by charging intellectual miserliness before new proposals or blindness to the ways in which nonhuman forces are implicated in the structuring of things. It is, rather, that the scales and temporalities, the profound entanglements of apparatus and knowledge production, on which these discourses often rely and reflect in their native conceptual neighborhoods and disciplinary enclosures become, in transit and translation, something quite minor: the supposedly intractable potency

and bottomless ineffability of art objects. Weird forms are taken for inscrutable structures that harbor alien things and purposes; sculptures are confused for the mysterious artifacts that fall to earth in cheap sci-fi movies and unravel everything. The agential capacity of the inanimate, and the supra- and subhuman organic, becomes, by sheer force of spectatorial desire and zany writing, the disproportionate and timeless power of the nonstandard little thing, perched on its pedestal or gawking back from the wall, to purportedly vectorialize forces and tap dimensions that we can only know vicariously and imperfectly. The dilution of complexity and swap of scale feels rotten enough to put the stench of swindle in all this. As these objects begin to feel like sham prisms to the Vastness, we draw from the ecstatic rhetoric that conveys their supposed radical dynamics the contours of a hidden transaction, a suppressed need, which faintly registers in an eagerness to adapt and graduate discourses that subjectivize everything into dominant cultural interpretative machinery in a world increasingly structured by algorithmic governmentality, financialization and global logistics. It's a world in which abstraction seems less a thing without reference—as modernists used to boast about certain paintings and morphologies—than the ultimate reference of everything.

It's not that our diagnostic powers are exhausted by pointing out, once again, that the old pot mystifies a fragmented process of production, along with the ruination of subjectivity that this fragmentation entails. The world is of another order, every inch of it quantifiable, and we cannot but slip into weirder knots of thinking as we try to apprehend it. But it's also not that, in fear of falling out of step with the ostensible leading edge of cultural discourse, of missing the leap over the last barricade that keeps us from some exo-human plenitude and dispersion, we need to discard the critical ways in which we once approached the pot. Whatever the pitfalls and paradoxical uses of art production and interpretation

that retains critique as its dominant mode—something that even those best known for this must have begun to lament, shipwrecked as they surely feel in the toss between their stringent persistence and the unending ineffectiveness of the results—these types of exercises at least seek to understand the art object within a material matrix of institutions, economic pressures, historical determinations and concrete modes of distribution. Champions of the supercharged object are realists about everything—except, of course, the material conditions in which art objects are currently embedded—a transnational socio-institutional ecology that is structured, on the one hand, by a logic of artificial asset valorization, of foreshortened incubation periods through the manipulation of price and information; and, on the other, by "freedom" from any need to line up with larger historical projects (aside from the neoliberal one). It is a world in which art objects, beyond their social actualization as extraordinary commodities, are subsumed into a financialization process whereby the pictures on the wall, or the .mov files on the portable drive or the unwieldy installations in freeport storage, neatly tucked in their crates, can be collateralized, leveraged and turned into currency without the actual artifacts having to return to the market and have their biographies affected—and, by extension, potentially cripple the credibility of their owners and erode some of their social prestige by being taken for investors or flippers. Through procedures such as art-backed lending, the art object ceases to merely be a safe bet against the volatility of other markets or a daring gamble, afforded by a well-guarded and opaque art market, in which merchants can pry money from the clutches of stock traders and other analogous types. The art object sets frozen capital in motion; it puts it to work. This enhanced function points to the way in which capital's most recent restructuring has found a route to reach into the very structural core of the art object and repurpose it to serve new ends, disregarding the object's self-definition

as an enclosed signifying unit, embedded in historical and conventional webs. This repurposing is voracious and subsumes art objects that come from various historical periods; however, while it touches the Fragonard and the Watteau, the Picasso and the Florine Stettheimer, contemporary art bares an irrevocable tethering to this process as birthmark, as teratological blemish.

By becoming a collateralizable entity that frees itself from its conventional illiquid status, the art object swells to be more than itself. It grows an entrapping appendage, a kind of snare embedded in the prey, that captures it for a process it can neither critique nor curtail if such things are measured by effectiveness and not intention. The art object is, in a sense, self-differentiated. It is "internally" cleaved so that it is itself and yet, rendered available to an autonomous and adjacent (to its institutional habitat) field of financial operations, something that is not quite itself. It appears boundary-bent beyond what we always thought was its elastic limit. It is irrelevant if the art object (or its producer) develops any sort of reflexive stance, or even basic awareness, of this ontological enlargement of its social being as a financial instrument. Its capacity to intervene in this new reality is, in the end, nonexistent. The critical unveiling of the artwork's inherent antinomy between autonomy and commodity; the disposition to establish alternatives to capitalist culture through unprecedented forms and novel modes of distribution; the dream to be part of the constituent power of the multitude; the desire to retain a twisted—and therefore denuding—relationship with ideology; the drive to turn the artwork into a kind of void point that short-circuits easy absorption into spectacle economies; the aim to pry local truth, discrepant temporalities and repressed histories from a homogenizing globalization—all these laudable exercises and impulses, these promises of rupture and renewal, can continue to find articulation. They just live, from the perspective of the object's new ontological appendage and the actions of those

who benefit from it, relegated to a fantasy island of dreams playing on repeat. Abstraction, instantiated in actual practice, supersedes the claims of the sensible thing, determining not its form but its behavior in the world—often against its very commitments.

Some of this may explain why certain discourses have flooded, as compensatory mechanisms, contemporary art production and its interpretative exercises with such ease. In light of the financial abstracting of the artwork—one of numerous abstractive processes it faces before algorithmic governmentality, the proliferation of instruments engineered to capture future value, and the emergence of new policy and legal frameworks —what could be more enticing than the object that overruns mere semantic mysteriousness to become an autonomous agent, a thing-in-itself of sorts that has crashed into phenomenal reality, heavy with qualities that manifest beyond what we can grasp, with dimensions that exceed the limited things we can comprehend? We just have to plug in, vibe on the affective resonances. These mysterious objects maintain relations, we are reminded, with other objects, while excluding us from the exchange. They possess an inner richness that can never be exhausted by either our conceptual capture mechanisms or any structural determination.

The enthusiasm for the inexhaustible object, however, even with the perfect alibi that a justified spread of concern over anthropogenic climate disturbance extends to it, as it peaks, also sputters, and it can't help but give up the "hidden transaction" that is at stake in all of this: the eagerness to re-mystify the object registers as the *displacement* of what is surely the trauma of having artworks assume a new dimension, pressured into existence by a process of accumulation that generates profit through financial instruments, through the proliferation of capital as commodity, rather than through production and sales, and over which the art object has no say and possibly finds no footing for resistance, aside from

its own kamikaze-like destruction. The new uses that can be extracted from the art object are positively recoded as its secret power to extend beyond human cognitive reach and other horizons. In the end, however, it turns out that the object's supposed unfathomable "inexhaustibility," beyond its self-understanding and controlled operations, is financial, before it is inward or relational or cosmic or whatever. The unwieldy flows of energy and matter turn out to be stand-ins for the flows of capital in moist and mushroomy garb, enveloped in deep earth smell.

Since the subordination of the concrete to an abstract asset functions in absolute disregard of the artwork's content and self-definition, unencumbered by critical resistance and sophisticated diagnostics, how, then, does it manifest itself in the actual production or circulation of contemporary art? The essays collected *In the Mind but Not from There* wrestle with this sort of question, alongside related ones that probe capitalist temporalities, value production, mediation, visualization, risk and—struggling against a general dour mood—new possibilities of resistance. They propose, representing a burgeoning tendency, that a potential first and fruitful step in addressing the problems that cultural production currently faces may lie in an engagement with the problem of abstraction and of "real abstraction," more specifically, as elaborated by Marx and Alfred Sohn-Rethel, and revisited in our times by the likes of Paolo Virno and Slavoj Žižek. Real abstraction involves an understanding of abstraction not as a process of thinking that distills complex empirical reality, but, on the contrary, as that which emerges from material practice itself, in the world, before thought—behind thought's back, as they say. In turn, it determines epistemic limits and orients conceptualizations. If we move away from strictly epistemological concerns, we can hazard that it also impinges on the process that determines the morphologies of social and cultural institutions and conventions.

In the Mind but Not from There begins with a pair of framing essays by Alberto Toscano and Leigh Claire La Berge. Toscano traces the history of the concept of real abstraction and La Berge turns more directly to the concept's usefulness in times of financialization. Against the conceptual backdrop and historical genealogies that these texts establish, Marina Vishmidt delves into how the alignment of financial speculation, as "a self-expanding, or self-valorizing, dynamic of capital...with the 'open-ended speculation' of thinking and art," sheds light on "the characteristic valorization processes of art and financialized capital as two social forms that show their internal logical relations in how they pattern our time." Leaning away from tacky dispositions that an ersatz hope often affords us, Vishmidt probes the harmonization of financialization and art, alongside their mediation through cybernetic modes of governmentality and spreading automation, in order to ask the essential question of whether, in our conjuncture, art can "do anything more than perform a mimesis of this speculative voracity [of finance capital], or can it respond with a politics of alterity capable of putting itself into question as one...of its own future orientations?"

Vishmidt's answer, in its negative slant, aligns with our dire times, their extreme and relentless pull doing its work, and also with the paradox that, according to Benjamin Noys, contemporary artists can't escape: simply put, the artist "is the most capitalistic subject," knowing precarity, flexibility and mobility quite intimately, and, for this very reason, is also the subject "most resistant to capitalist value extraction." There is some critical maneuvering that can be elaborated out of the very knot of this paradox, but the places we go looking for it these days—namely, the positions in regard to art developed by Jacques Rancière, Antonio Negri and Alain Badiou, the troika of post-poststructuralists that the art world loves to love —offer very little. What we need, instead, Noys contends, is to elaborate a "punk realism"—the term, left unelaborated,

is Negri's. And Noys, like the rest of us, cringes a little upon hearing it, fearing that the gunk of commercialized nostalgia weighs down and stiffens any fugitive and liberatory potential that may have once inhabited the terms. But in urgent times, we well know, one has to make do with salvageable scraps and off-the-cuff détournements. Even if we end up having to save it from its name, what is important is punk realism's program to reach for the concrete "through a process of mediation and engagement with abstraction."

A critical take on Rancière also structures the core of Nathan Brown's contribution. Brown's critique pivots on the fact that Rancière's now-famous notion of "the distribution of the sensible" is inseparable from an underestimation of capitalism's process of valorization—that is, from the system's insensible procedures. Using the work of Canadian artist Nicolas Baier as a case study, Brown proposes that in thinking through the "distribution of the insensible"—the abstracting procedures that find articulation in the actual material interactions between many actors and apparatuses—we may find the proper relationship between political economy and artistic production. This relationship can only be understood properly when the history of technology—a history that is itself determined by the mutations and demands of capitalism— serves as the mediating element. The task of the art object is to mimetically display, while assuming the self-critical tendencies of representation itself, these abstracting conditions and to shed light on the distribution of the insensible mechanisms that organize the social totality, including the very conditions that determine the spaces and modes of labor available for cultural production.

Artist Mark Curran and artists João Enxuto and Erica Love, in their respective projects, engage in a kind of artistic fieldwork in the spheres of financialization and datafication. Curran, in long-term projects of visual and media anthropology, travels to, photographs, records and otherwise engages

the actual sites where, and people through which, disembodied financial activity takes place. In the facet of his project *The Market* (2010–ongoing) which is presented in this book, he combines images taken at these sites with quotes pulled from long interviews conducted with traders. Understanding the challenge that finance places before photographic capture and representation, he supplements this visual-verbal portraiture with the results of algorithmic dredging through the speeches of state players and samples of the media artifacts that sustain and promote the whole system. The result is a collage of strangely desolate spaces, cold as the marble that seems an obligatory part of the décor; people that, despite their nice suits, seem as lost as those who are on the receiving end of their botched operations; and a language on the verge of being rent asunder by the pressure a massive underlying fear, the bubbling up of a substrate of swirling disorientation. The nebulosity of financial processes not only envelopes dolts like us, who end up with outrageous debt, repossessed homes and whittled pensions; its haziness may be there from the very genesis of these processes, first channeled by those who, keeping an eye on the bonus, "blindly" execute them on the ground.

In order to "test the potential of algorithms for delivering predictive art market advantages," artists João Enxuto and Erica Love sought out one of the producers of such an algorithm, Hugo Liu, co-founder of the art-ranking site ArtAdvisor. In the adventure that ensued, Liu first worked enthusiastically with the artists, but eventually stopped communicating with them as he went off to become some kind of illuminated techno-shaman and Chief Data Scientist for Artsy, a platform which had in the meantime acquired ArtAdvisor (Enxuto and Love did some prior critical work on Artsy, so the abrupt end of the exchange is not all that surprising). The conclusion that the artists reach is that exercises in data aggregation only serve as instruments that reinforce tendencies already latent in

the art system. They are something like self-fulfilling prophe-
cies and not tools to predict emerging, heterogeneous patterns
or provide any advantage beyond tracking what is already
foreseeable.

Responding to a historicist demand, Sven Lütticken pro-
poses that we are in need of an updated understanding of real
abstraction. We need a "vectorial" version of it that can help
us conceptualize the convergence of juridical, technoscientific
and monetary spheres. Beyond abstract labor and exchange,
there are other abstractions which assume the form of legal,
technoscientific, and data-based instruments and protocols as
they aid in establishing, in Sohn-Rethel's words but extend-
ing his scope, an "identity between the formal elements of
the social synthesis and the formal components of cognition."
What this "vectorial" field of interrelated abstractions, insofar
as it has stretched production itself into cognitive and affective
dimensions, demands is a constant upgrade and "optimization
of one's performance." Design, in these conditions, ceases to
be a discrete field and becomes a totalizing structure through
which we incessantly calibrate ourselves and our worlds. Once
we grasp this, the following question gains purchase: "What,
if any, contributions can artistic or aesthetic practice make
to a *praxis* directed against our current regime of accumula-
tion and abstraction? The aim, of course," Lütticken suggests,
"would not be to instrumentalize art in the name of a polit-
ical project, but to sound out possibilities for an aesthetic
contestation in conjunction with a political one." He sounds
out some possibilities himself around alternative currencies,
e-publishing, and time banks.

Jaleh Mansoor, also attending to a historicist demand,
tracks the recent ontological reconfiguration of the line—that
"basic tool of representation"—in artistic practice from a
strictly formal element to an indexical one. In her account,
this change, as the symptom of a mutation at the register of
the real, anticipates the possibility of properly representing

the seismic shifts that capitalism itself has undergone in the last half century and the reconfiguration of the entire planet that these have led to, making the displacement of people at unprecedented scale one of its dominant features. Mansoor reminds us that art's real critical potential may reside less in its interventionist forays than its capacity to obliquely index real abstractions through symptomatic mutations to its structural conditions. And if this is the case, then in our conjuncture, there is perhaps no question as pressing for art history and criticism (and possibly for artists, too) than that of context, in so far that the qualities we usually associate with the term—concrete location and historical period—and the work that the term does in our thinking cannot help but be severely taxed in a world of supply chains and capital flows, populations displaced by aggressive extractivist practices, capital's peripatetic restlessness in its search for ever cheaper and unprotected labor markets to exploit, and the capacity of The Bank—as in the IMF, The World Bank, and the WTO—above that of nation states and other governmental forms to determine the very conditions of life for such a large swath of the species. If this is indexed in contemporary art, if the disintegration and recomposition of the category of context registers symptomatically in cultural production, our potential blindness to this demands a restructuring of our critical methods.

Refusing to give up on art's operative capacity, Victoria Ivanova searches for conditions in which art can rearrange, at the very least, the systems in which it functions. Her essay revisits Jack Burnham's "system aesthetic" from the late 1960s, which proposed a reconfiguration of artistic production so as to have it align with and respond to "an increasingly technologically mediated society" and the "rise of mass media and integration of computational technologies into all facets of life." What remains unsaid in Burnham's work is that these technological changes were complemented by a shift in economic orientation away from industrial

production and toward financial investment, a mutation that has impinged on the sphere of contemporary art and turned it into a quasi-financial regime regulated by rating agencies (theorists, curators, museums, collectors). Exploiting the ambiguity between artworks that *represent* systems ("systems aesthetics") and artworks serving as *representatives of* systems ("systems art"), Ivanova finds in the latter the possibility to intervene in fundamental ways—more than merely aesthetically or discursively—in the "infrastructural back end" of the systems in which they function, reconfiguring things such as "market relations, institutional and legal protocols."

Diann Bauer, Suhail Malik and Natalia Zuluaga propose that real subsumption and the proliferation of cybernetic governmentality and automation have given rise to a new kind of "representational but non-indexical" image—what they call the General Abstract Image (GAI). This is a synthetic image generated from data and produced by different apparatuses, at times but not necessarily with human input. As such, these images are inevitably "concretized...versions of otherwise abstract relations." Employing conceptual tools provided by analytic philosopher Wilfrid Sellars, the authors draw on what Sellars calls the "scientific image"—the image science provides regardless of human self-conception and understanding—to argue for GAI as the image of the abstract relations that comprise the social totality in excess of our immediate subjective comprehension of the world. In light of the emergence of this synthetic image, the authors further propose that real abstraction may be rethought less as that which consolidates in actual activity and subsequently reconfigures thinking than as the endless loop between our ever-enlarging understanding of objective social conditions, facilitated by GAIs, and the constant intervention on the mediations through which we grasp these conditions. The task that art can assume in relation to this, after it sheds the strictures and insufficiencies that have organized the field's self-understanding from modernism

to contemporary art, is to operationalize GAI, to construct
new "epistemo-informatic constructions"—that is, to not just
produce new ways to see and understand the world, to cog-
nitively map things, but to generate new features in the world
that further complexify it and, presumably, tax or overhaul
some of the dominant tendencies that currently organize the
social into such a grotesque configuration.

Artist John Miller, putting some flesh back in things,
considers the genre of the diary in relation to capital's mech-
anization of time through its forms of production, demands
for consumption and impoverishment of language. This
mechanization standardizes not only our lived moments but
subsumes the past and the future, syncopating it all into the
same monotonous rhythm. Risking triviality, making room
for history's losers and for their quirky ways, reopening the
gap between work and leisure while closing the one between
utility and waste, the diary crystallizes the tangled condition
whereby its fugitive impulses are everywhere marked with the
routine of the workplace: the labor of jotting things broken
down into daily "shifts," the sequentiality of the entries, the
material regularity of the actual notebooks and journals. As
such, however, the diary may just be a place where a certain
unraveling of the regulatory and abstracting push of late cap-
italism may find a little breathing room. One should read this
meditation on the diary while keeping in mind that Miller
himself has been engaged in a multi-decade diary-like project
titled "Middle of the Day," in which he takes pictures wher-
ever he is in the world, but only between noon and two o'clock
—so, lunchtime pictures. One cannot help but recall Frank
O'Hara's *Lunch Poems* here, and of the impossibility of
really thinking about Miller's long-term project at a distance
from the fact that the images that comprise it are enveloped
by a workday that they never quite depict directly. Lunch
hour cuts through labor time, as Jasper Bernes, casting light
on the social determinants that shaped O'Hara's poems,

recently reminded us, but only to free us to enter the world of circulating commodities, of branded burgers and, lately, of a spurious hyper-connoisseurism of grass-fed beef and humanely plucked coffee beans. But where O'Hara was able to wrench meaning from this commoditized world by plunging deep into its objects, Miller seems to find nothing but staggering uniformity, an elastic and encompassing banality that is coterminous with the planet itself, and that in its unyielding repetition reveals the magnitude of its brutality. In "Middle of the Day," we see the abstract spreading evenly across everything as the unflinching reproduction of tepid sameness; in Miller's resilience before it, we see the tendency to critically face it, to the last of our resources, holding the line. Recent additions to the "Middle of the Day" project accompany Miller's text.

While the collection opens with a couple of "framing essays," it ends with a pair that open beyond the confines of contemporary art. Sianne Ngai plunges into the gelatinous depths of Ron Halpern's *Music for Porn*—a book that obsesses on the body of the male soldier and, through desire's incorrigible lens and the ambient pressure of our moment's general fuckedupness, splits and sutures this body as besieged flesh and eroticized abstraction, as overworked allegory and unknown territory, as a site of managed withdrawal and unregulated investment. What Ngai seeks through this engagement with Halpern's work are rhetorical figures that can usefully relate what is at stake in the process of capitalist abstraction. The problem of value as a social relation, touching on things but never quite in them, defies mechanisms of direct representation, forcing us, as she shows, to rely on catachresis to approximate proper expression. This is a problem that, as Ngai's tour through the rhetorical heterogeneity of Marx's writing reveals, has always been pressing and elusive of resolution. Although in her probing of the visceral as a location where bodies and abstraction congeal, Ngai doesn't refer to

any visual artworks, her overall take is a provocation to think anew the turn to the body and the abject in contemporary art practices that has coincided with the consolidation of finance economies. One may consider how her insights apply to some of the work that John Miller has produced—his brown paintings, for instance—over the last four decades, to say nothing of the fascination with the genetic and animation, with the disintegration of bodies into code, which spreads across the practices of so many younger artists.

Last, while starting with a gloss on the work of contemporary artists Goldin+Senneby, Brian Kuan Wood oversteps the confines of artistic production to propose that, beyond exchange, it is reality as gamespace that serves as the concrete abstraction that these days sets the conditions for contemporary modes of thinking and subjective production. But it is also this mutation of reality that may provide the possibility for gestures of resistance to blossom. If the logic of gamespace is determining the morphology of our epistemic terrain, this very logic leaves in play—as this is fundamental to what gamespace is—the possibility of tinkering with the social source code, with the background script, in order to alter the results. It becomes a matter of misaligning patterns, of superimposing skewed grids over the ones that we are offered; it is a matter, in the end, of finding the soft spot in the system, the slip in the numbers, where one's infringements can issue the greatest impact.

1

The Open Secret of Real Abstraction

Alberto Toscano

As a rule, the most general abstractions arise only in the midst
of the richest possible concrete development, where one thing
appears as common to many, to all...Individuals are now ruled
by abstractions, whereas earlier they depended on one another.

Marx, *Grundrisse*

Whether we are concerned with unmasking commodity fet-
ishism, the formalization of surplus value, or discourse on
alienation, it is difficult to ignore that much of the force of
the Marxian matrix—when compared to contemporary dis-
courses of abstraction, with their frequent reliance on notions
of complexity and information—is based on its depiction of
capitalism as the culture of abstraction *par excellence*, as a
society that, *pace* many of the more humanist denunciations of
the dominant ideology, is often really driven by abstract enti-
ties traversed by powers of abstraction.[1] A particular modality
of social abstraction can thus be identified as the *differentia
specifica* of capitalism vis-à-vis other modes of production. As
Italian Marxist phenomenologist Enzo Paci wrote, "The fun-
damental character of capitalism...is revealed in the tendency
to make abstract categories live as though they were concrete.
Categories become subjects, or rather, even persons, though
we must here speak of *person* in the Latin sense, that is, of

1 Alberto Toscano, "The Culture of Abstraction," *Theory, Culture
& Society* 25: 4, 57–75.

masks…'Capitalist' means a man transformed into a mask, into the *person* of capital: in him acts capital producing capital… The abstract, in capitalist society, *functions concretely.*"[2]

The debate on Marxian uses of abstraction often orbits around one of the few explicit methodological prescriptions bequeathed by the author of *Capital*, the 1857 Introduction to *A Contribution to the Critique of Political Economy.*[3] Specifically, it centers on the interpretation of a passage on the dialectics of the abstract and the concrete, whose core is as follows:[4]

> The seventeenth-century economists, for example, always took as their starting point the living organism, the population, the nation, the State, several States, etc., but analysis led them always in the end to the discovery of a few decisive abstract, general relations, such as division of labor, money, and value. When these separate factors were more or less clearly deduced and established, economic systems were evolved which from simple concepts, such as labor, division of labor, demand, exchange-value, advanced to categories like State, international exchange and world market. The latter is obviously the correct scientific method. The concrete concept is concrete because it is a synthesis of many definitions, thus representing the unity of diverse aspects. It appears therefore in reasoning as a summing up, a result, and not as the starting point, although it is the real point of origin, and thus also the point of origin of perception and imagination.[5]

The first point to note is that Marx promotes in these pages a theoretical break and an empiricist or neopositivist use of the

2 Italics in original. Enzo Paci, "Il filosofo e la citta'," *Platone, Whitehead, Husserl, Marx*, ed. S. Veca, Milan: il Saggiatore, 1979, 153.

3 Karl Marx, *A Contribution to the Critique of Political Economy*, New York: International Publishers, 1970.

4 Evald Ilyenkov, *The Dialectics of the Abstract and the Concrete in Marx's Capital*, Moscow: Progress Publishers, 1982.

5 Marx, *A Contribution to the Critique of Political Economy*, 206.

terms "abstract" and "concrete." He underscores a distinction between sensibility, perception and sense data, on the one hand, and speculative form or theoretical concept, on the other.[6] Marx then reformulates the distinction such that the sensible and the empirical appear as a final *achievement* rather than a presupposition-less starting point.[7] As I suggest, the Marxian stance on abstraction, as intimated in the 1857 Introduction, cannot easily be mapped onto customary distinctions between empiricism and rationalism, or even materialism and idealism. This is evident, too, in the "twisted" genesis of Marx's concept of abstraction, which begins with a Feuerbachian critique of Hegel, moving through a Hegelian surpassing of Feuerbach, and finally resulting in a political and philosophical overcoming of the very terms of Hegel's *logic* of abstraction.

To the extent that Marx's methodological conception of abstraction is diagonal to Feuerbachian sensualism and Hegelian logicism, different authors have concurred in seeing the 1857 Introduction as a move to a generic, humanist or anthropological concept of abstraction: the passage to a notion of *real abstraction*—abstraction not as a mere mask, fantasy or diversion, but as a force operative in the world.[8] Thus, Roberto Finelli writes of a "generic" abstraction that, prior to 1857, Marx inherited from Feuerbach. This generic abstraction *presupposes* the genus "humanity" and regards all political, religious and economic abstractions (the State, God and private property) as fictitious hypostases of a positive,

6 Gérard Bensussan, "Abstrait/concret," in *Dictionnaire critique du marxisme*, eds. G. Labica and G. Bensussan, 3rd ed. Paris: PUF, 1999, 4–7; for a dissenting evaluation, see Rafael Echeverría, "Critique of Marx's 1857 Introduction," in *Ideology, Method and Marx*, ed. A. Rattansi. London: Routledge, 1989.

7 Paolo Virno, "The two masks of materialism." *Pli: The Warwick Journal of Philosophy* 12 (2001), 167–73.

8 Roberto Finelli, *Astrazione e dialettica dal romanticismo al capitalismo (saggio su Marx)*, Rome: Bulzoni Editore, 1987; Jacques Rancière, "The concept of 'critique' and the 'Critique of political economy'," in *Ideology, Method and Marx*, ed. A. Rattansi, London: Routledge, 1989.

underlying generic essence that is not itself prey to histori-
cal or logical becoming.[9] The crucial theoretical revolution
would then be the one that passes from this fundamentally
intellectualist notion of abstraction—which presumes libera-
tion as a "recovery" of the presupposed genus (putting man
where God, qua distorted humanity, once stood)—to a vision
of abstraction that, rather than depicting it as a structure of
illusion, recognizes it as a social, historical and "transindi-
vidual" phenomenon.[10]

Commenting on the idea of the concrete as a synthesis
of abstract determinations, as a totality of thought (*Gedan-
kenkonkretum*), Finelli makes the following observation:

> The abstract is not a product of the singular human being but
> of a social whole which reproduces itself in accordance with
> a determinate relation of production...the abstract as mental
> is the result of an individual practice that moves from a pre-
> supposed totality with a concomitant, and aporetic, theory of
> alienation; the abstract as real is instead coterminous with a
> theory of totalization as historical making, where totality is
> not presupposed but posited and where it can therefore be
> assumed as a real, and not an arbitrary, presupposition, only to
> the extent that it is given as result.[11]

This real abstract movement of totalization is the movement
of capital qua substance becoming "Subject." This argument
for the synthetic character of the concrete (the process of cap-
ital's "concrescence," to borrow a term from Whitehead) is
also an argument regarding the nature of production. Accord-
ing to Finelli, production qua concrete totality is in fact to be
understood in terms of the interaction and combination (or to-
talization) of "simple" determinations (value, division of labor,

9 Finelli, *Astrazione e dialettica*; Cristina Corradi, *Storia dei marx-
ismi in* Italia, Rome: Manifestolibri, 2005.

10 Etienne Balibar, *The Philosophy of Marx*, London: Verso, 1995.

11 Finelli, *Astrazione e dialettica*, 118.

property) into historically specific, complex configurations. While "production in general is only the offspring of bourgeois ideological abstraction,"[12] the Marxian concept of production —which is, according to Finelli, a *relational* concept, first and foremost—is to be grasped, in Marx's terms, as the concrete "unity of diverse aspects." Society is above all a matter of relations: the role of these univocal simple abstractions— such as value, labor, private property—in the formation of the concrete must be carefully gauged so that they do not mutate back to those powerless and separate, not to mention mystifying, intellectual abstractions that occupied the earlier theory of ideology. But these abstractions are not mental categories that precede the concrete totality; they are real abstractions that are truly caught up in the social whole, the social relation.

Thus, against those who see abstraction as an intellectualist separation of general forms from concrete life or, conversely, as the extraction of an essential kernel of reality from the fleeting figures of historical development, Finelli identifies the specificity and uniqueness of the post-1857 Marx in a turn *away* from positing a real generic essence (which abstract forms would merely hypostasize by way of inversion) and, perhaps more interestingly, in the *differential* character of Marx's notion of abstraction, which is no longer, as in classical theories of abstraction,[13] a suspension of or subtraction from differences. Thus, he writes, "The real abstraction of capitalist society is not a logical abstraction, far away from differences, but rather an abstraction which is born from difference, from an entirely specific social determinateness, and it is therefore pregnant with difference, capable of articulating an entire society."[14]

It is significant that Finelli pulls back from the ultra-Hegelian solution that would see in this ascending from the abstract

12 Ibid., 121.

13 Alain De Libera, *L'art des généralités: théories de l'abstraction*, Paris: Aubier, 1999.

14 Finelli, *Astrazione e dialettica*, 127.

to the concrete[15] a strictly *logical* progression. Rather, the genesis of abstraction is *historical*.[16] The foremost exemplar of this historicity of the abstract is located in the real genesis of the category of abstract labor, which is treated by bourgeois ideologists as an unproblematic and timeless abstraction that can simply be applied to "production in general."[17] On the contrary, the historical genesis of abstract labor, which is regenerated in concrete thought by the synthesis of simple determinations into an internally differentiated complex, is a paramount case of the manner in which Marx is able to delineate *the reality of (concrete) universals* in a manner that breaks radically with the history of the philosophical disputes between nominalists and realists:

> In the society of capital, abstraction assumes the explicit contours of a matter of fact, of a state of affairs, it becomes a practically true abstraction, indicating that only here the universal is not mere form, whether logical or superficial, but, paradoxically, a universal capable of reality...The universal is real only when it is the fruit not of the logical intellect or even of theoretical ideation but of collective historical praxis.[18]

What has happened, one may ask, to the initial Feuerbachian *cri de cœur* that triggered the political theory of abstraction, taking its cue from the separateness of the individual? In the mature Marx, the theme of separation is withdrawn from the humanist and intellectualist matrix and reconfigured as an effect of the real abstraction of capital, of a capital that can only integrate and socialize via the atomization of workers, their separation from the means of production and their thoroughgoing domination.

15 Ilyenkov, *The Dialectics of the Abstract and the Concrete in Marx's Capital*.

16 Finelli, *Astrazione e dialettica*, 124.

17 Ibid., 191.

18 Ibid., 124.

Such an interpretation sees Marx moving beyond both the Feuerbachian theme of generic abstraction and the Hegelian notion of logical abstraction, and doing so by showing the properly *ontological* character of capitalist abstraction. This ontology of real abstraction—which is inextricably political, historical and economic—is, in Finelli's view, a *dual* ontology to the extent that it both affirms concrete reality as a "specific articulation of differences"[19] *and* reveals the void at the heart of *Capital*, as it were, the fact that the *real* of its abstraction—to speak in a Lacanian vein—is its absence of determinations, the fact that it has no historical or cultural *content* per se.[20] This duplicity of capitalism's ontological figure is founded on Marx's theory of the concrete and on the formal determination of capitalism's "reality principle":

> The peculiarity of the capitalist abstraction is...that precisely its absence of determinations makes it into a reality principle, a synthetic principle valid for constructing the whole out of its own partiality: *as surplus-value* generating the material survival of all the non-working classes...as *value*, constructing the social nexus of money and circulation...as surplus-value capable of producing the conditions for its own production.[21]

Though this dual ontology of abstraction might appear to slide into inconsistency by trying to hold together the differential character of capitalist society with its absence of determinations, Finelli is persuaded that capitalism as a totality is not a "generic essence, but is the historical result of a specific relation of production."[22] This is the crux of capitalism as a society of real abstraction for Finelli: it is woven of complex

19 Ibid., 123; Corradi, *Storia dei marxismi in Italia*, 389.

20 Deleuze and Guattari are led in this respect to define contemporary capitalism through the category of the axiomatic (see Alberto Toscano, "Axiomatic," in *The Deleuze Dictionary*, ed. A. Parr, Edinburgh: Edinburgh University Press, 2006).

21 Finelli, *Astrazione e dialettica*, 227.

22 Corradi, *Storia dei marxismi in Italia*, 393.

material and ideological differences, but the articulation of these differences gives rise to an impersonal "principle" that is devoid of determinations and cannot be led back to any of its constituents, and certainly not to the "economy" understood as a separate sphere whence abstraction would emerge.[23] Finelli's case for real abstraction as "the most original element of Marxian social theory"[24] is potent. By moving beyond logicist, empiricist and inductivist notions of abstraction and making abstraction *historically real*—indeed, defining capitalist society by its power of abstraction—Finelli brings us face to face with Marx's theoretical and methodological revolution, a revolution that ties the singularity of real abstraction to capitalism alone, a society "born from difference" but dominated by an empty reality principle.

In his contribution to the original edition of *Reading Capital*, Jacques Rancière had already indicated Feuerbach's "anthropological critique" as the first theory of abstraction against which Marx measured himself. Here, too, the Feuerbachian idea of abstraction as separation is deemed not to attain the threshold of real abstraction because of its inherent ambivalence and ultimate inconsistency: "It refers both to a process which takes place in reality; and at the same time to the logical steps which belong to a certain type of discourse. Abstract is in fact taken here in the sense of separated. The abstraction (separation) takes place when the human essence is separated from man, and his predicates are fixed in an alien being."[25]

23 A similar paradox is investigated in Moishe Postone's account of "abstract domination," according to which "Marx's theory of capital is a theory of the nature of the history of modern society. It treats history as being socially constituted and, yet, as possessing a quasi-autonomous developmental logic" (Moishe Postone, *Time, Labor, and Social Domination*, Cambridge: Cambridge University Press, 1993, 31).

24 Finelli, *Astrazione e dialettica*, 1.

25 Jacques Rancière, "The concept of 'critique' and the 'Critique of political economy'," in *Ideology, Method and Marx*, ed. A. Rattansi. London: Routledge, 1989, 78.

By denying both the reality and the necessity of abstraction, the anthropological critique undermines the possibility of any positive or transformative characterization of discourse. To the extent that all abstraction from the generic essence is viewed as distortion, all discourse, Rancière argues, is condemned to the status of *reduplication*, and critique turns into a "process of transformation which transforms nothing," "the caricature, the *begrifflose* [conceptless] form of theoretical practice." How might we then eschew this "ideology of the concrete"[26] that blights the elaboration of a Marxist science and attain the reality of abstraction?

This problem was, of course, the same one that, in his own take on the 1857 Introduction, Althusser had confronted in his theory of Generalities. Notwithstanding his later Leninist rectifications, much of Althusser's work can be regarded as one of the boldest attempts, starting from a Marxian framework, to produce a materialist theory of thought. And since, following the arguments we've already encountered with Finelli, the materialist balks at a theory of "thought in general," it is not surprising that Althusser's investigation aims at discerning the reality and specificity of what he calls "theoretical practice." How can we vouchsafe the truth and power of abstract thought without falling prey to an empiricist or reflexive image of thought? How can we formalize the labor of thinking when thought lays claim to the status of science? Using Marx's methodological reflections to quell the empiricist temptation, Althusser begins with what may seem a provocatively "idealist" move, albeit one that he regards as the only guarantee of the *reality* of theoretical practice: what thought works on are not things, but thoughts. In other words, we always already begin from abstractions, though these first abstractions, which Althusser places under the rubric of Generalities I (GI), are ideological, particular and unprocessed, so to speak. These

26 Ibid., 98.

abstractions, in the pejorative sense, are the "raw material" of the theoretical production process. Following the indications of the 1857 Introduction, Althusser wishes to hold true to the Marxian claim that thought does not begin with immediacy, with the concrete, the sensual, the given.

Althusser's ingenious solution, aimed at preempting any claim that Marx himself succumbs to empiricist temptation in the Introduction,[27] is to *split the concrete*. Althusser's interpretation of Marx's crucial formulation in the 1857 Introduction explicitly seeks to offset the ideological notion that "the *abstract* designates theory itself (science) while the *concrete* designates the real, the 'concrete' realities, knowledge of which is produced by theoretical practice." The point, rather, is not "to confuse *two different concretes*: the *concrete-in-thought* which is knowledge, and the *concrete-reality* which is its object." In lines that the later self-criticism would object to for their "theoreticism," Althusser argues that the "process that produces the concrete-knowledge takes place wholly in theoretical practice: of course it does concern the concrete-real, but this concrete-real 'survives in its independence after as before, outside thought' (Marx), without it ever being possible to confuse it with that other 'concrete' which is the knowledge of it."[28] The concrete-in-thought is thus Generality III (GIII), while Generality II (GII) is the theory itself. The aim of the split effected by Althusser is not to confuse this passage from the abstract-ideological to the concrete-in-thought (GI to GIII via GII) with the classical ideological opposition between abstraction (thought, science, theory) and the concrete (the essence of the real). The theory of Generalities is thus aimed at killing two ideological birds—Feuerbachian and Hegelian—with one theoretical stone. First, it denies the "ideological myth" at work in the sensualist-intellectual distinction

27 Echeverría, "Critique of Marx's 1857 Introduction."
28 Louis Althusser, *For Marx*, London: Verso, 1996, 186; Rancière, "The concept of 'critique' and the 'Critique of political economy.'"

between the concrete and the abstract. Second, by affirming the *discontinuity* between GI and GIII, between mere ideological abstraction and the concrete-in-thought, it counters the Hegelian autogenesis of the concept, which it regards as an elision of the difference in kind between the three generalities (all, in their own way, "real"): GI, qua ideological raw material; GII, qua theory; and GIII, qua concrete-in-thought produced by the work of GIII on GI.

By splitting the concrete (into real-concrete and concrete-in-thought), Althusser suggests that the only way to side with the concrete is not to denounce abstraction, but to undertake the real work of abstraction (GII) on abstraction (GI) to produce abstraction (GIII). Of course, Althusser is here straining toward another kind of "realism" and "materialism" than the one we may be accustomed to. It is only through abstraction—through theoretical work, that is—that the real as real-concrete can emerge and amount to something other than a "theoretical slogan." This is the only way to think together the two statements that Althusser wishes to combine in his understanding of theoretical practice: "the real is the real object that exists independently of its knowledge—but which can only be defined by its knowledge," and "the real is identical to the means of knowing it."[29] Without this work in and of theory, our opposition to ideological abstraction (like Feuerbach's opposition of real man to the abstractions of religion, politics and economics) will remain ideological. In Althusser's acerbic terms, "The 'concrete,' the 'real,' these are the names that the opposition to ideology bears in ideology. You can stay indefinitely at the frontier line, ceaselessly repeating concrete! concrete! real! real!...Or, on the contrary, you can cross the frontier for good and penetrate into the domain of reality and embark 'seriously in its study,' as Marx puts it in *The German Ideology*."[30] In the final analysis,

29 Althusser, *For Marx*, 246.
30 Ibid., 244–45.

something really *happens* when abstraction takes place. Abstraction *transforms* (and the fact that what it transforms is itself abstract does not make it any less *real*).[31] Does Althusser do justice to Marx's theoretical revolution in the study of abstraction? Revisiting a crucial text on real abstraction, Alfred Sohn-Rethel's *Intellectual and Manual Labour* (1978), Slavoj Žižek replies in the negative. Despite affirming the reality of theoretical practice as the production of concrete abstractions, and notwithstanding the attempt to rescue a concept of the real from any empiricist deviation, Žižek contends that Althusser cannot truly grasp the uniqueness of Marx's understanding of the relation between thought and capitalism. That is why, although Althusser is able to think of a real that is also abstract in the guise of theoretical practice, he cannot really accept the category of "real abstraction." As Žižek writes, "The 'real abstraction' is unthinkable in the frame of the fundamental Althusserian epistemological distinction between the 'real object' and the 'object of knowledge' in so far as it introduces a third element which subverts the very field of this distinction: the form of the thought previous and external to the thought—in short: the symbolic order."[32]

Without venturing into the beguiling link that Žižek proposes in *The Sublime Object of Ideology* and elsewhere between the Marxian and Lacanian frameworks and the precise sense in which the notion of the symbolic might relate to our theme of abstraction, I would like to pause on this—to my mind—crucial formulation: "the form of the thought previous and external to the thought." What might this mean within the context of Sohn-Rethel's own account of real abstraction?

Sohn-Rethel sets off from a bold wager: to repeat, without succumbing to analogy or resemblance, Marx's critique of political economy in the field of thought; to engage, as the

31 Echeverría, "Critique of Marx's 1857 Introduction," 269.
32 Slavoj Žižek, *The Sublime Object of Ideology*, London: Verso, 1989, 19.

subtitle of his book specifies, in a Marxian "critique of episte-mology." The critique is founded on a basic discovery, which Sohn-Rethel dates to 1921 and which was to be the object of numerous drafts, under thankless conditions, up to publica-tion of the first edition of *Intellectual and Manual Labour*:[33] to wit, that there obtains an "identity between the formal ele-ments of the social synthesis and the formal components of cognition."[34] The key to this identity lies in "formal analysis of the commodity,"[35] which is thereby able not only to unlock the (open) secrets of capital accumulation, but to reveal their articulation with the division between manual and intellectual labor as well as the commodity's centrality to any explanation of abstract thinking. Sohn-Rethel thus undertakes a veritable *expropriation* of abstract thought. We are not simply enjoined to move beyond the ideological habits of empiricism and to consider the social and material reality of cognition, or the solidarity between abstraction and capitalism. Sohn-Rethel is arguing—against any claim for the scientific autonomy of

33 "The work of my whole intellectual life until my 90th birthday was necessary in order to clarify and explain a semi-intuition that I had in 1921 during my university studies in Heidelberg: the discovery of the transcendental subject in the commodity-form, a guiding princi-ple of historical materialism. I could obtain a satisfying explanation of this principle only as the result of ever-renewed 'attacks,' which took the name of Exposes" (in Theodor Adorno and Alfred Sohn-Rethel, *Carteggio 1936/1969*, Rome: manifestolibri, 2000, 183). In 1936, Adorno himself hailed Sohn-Rethel's insight in the following terms: "Your letter has meant the greatest intellectual upheaval that I have experienced in the philosophical field since my first encounter with Benjamin" (ibid., 46). Alas, the rest of their correspondence testifies to Adorno's failure, in the context of Horkheimer's hostility to Sohn-Rethel, to be faithful to this upheaval.

34 Alfred Sohn-Rethel, *Intellectual and Manual Labour: A Critique of Epistemology*. London: Macmillan, 1978, 14. Despite his critique of Sohn-Rethel, Postone can be seen to share a similar problem—for instance, when he states: "The problem of knowledge now becomes a question of the relation between forms of social mediation and forms of thought" (Postone, *Time, Labor, and Social Domination*, 77).

35 Sohn-Rethel, *Intellectual and Manual Labour*, 33.

theoretical practice—that the fundamental forms of abstract
thought (as manifest in the structure of scientific laws, the pos-
tulations of mathematics, or the constitution of the Kantian
transcendental subject) all originate with the commodity form
and its introduction, into the social universe, of the principles
of abstract exchange and calculability. In Žižek's apt com-
mentary, "Before thought could arrive at *pure* abstraction, the
abstraction was already at work in the social effectivity of the
market."[36] While consideration of the historicity of abstraction
and its social and collective character, on the one hand, and the
Althusserian treatment of the abstract in theoretical practice,
on the other, both give us a sense of the fruitful, antiempiricist
directions in which the notion of abstraction may be taken, it
is above all in the writings of Sohn-Rethel that a truly materi-
alist investigation into real abstraction comes to unsettle our
very image of thought.

Anticipating Finelli, Sohn-Rethel begins from the unequiv-
ocal break between Marxian and traditional philosophical
abstraction. He writes, "In order to do justice to Marx's *Critique
of Political Economy*, the commodity or value abstraction
revealed in his analysis must be viewed as a *real abstraction*
resulting from spatiotemporal activity. Understood in this way,
Marx's discovery stands in irreconcilable contradiction to the

36 Žižek, *The Sublime Object of Ideology*, 17. The "apparatus of
categories presupposed, implied by the scientific procedure (that, of
course, of the Newtonian science of nature), the network of notions by
means of which it seizes nature, is already present in the social effectiv-
ity, already at work in the act of commodity exchange...The exchange
of commodities implies a double abstraction: the abstraction from the
changeable character of the commodity during the act of exchange and
the abstraction from the concrete, empirical, sensual, particular char-
acter of the commodity (in the act of exchange, the distinct, particular
qualitative determination of a commodity is not taken into account; a
commodity is reduced to an abstract entity which, *irrespective of its
particular nature, of its 'use value,'* possesses 'the same value' as another
commodity for which it is being exchanged)." Žižek, *The Sublime
Object of Ideology*, 301.

entire tradition of theoretical philosophy and this contradiction must be brought into the open by *critical confrontation of the two conflicting standpoints.* Here lies the "contradiction between the real abstraction in Marx and the thought abstraction in the theory of knowledge."[37] The reason for this irreconcilable contradiction is that in the Marxian schema, to put it bluntly, *abstraction precedes thought.* More precisely, it is the social activity of abstraction as commodity exchange that plays the pivotal role in the analysis of real abstraction. Though we cannot do justice to it, it is worth pointing out that Sohn-Rethel's attempt to look for real abstraction in the realm of exchange puts him at odds with the likes of Finelli, whose attention centers on the category of abstract *labor* and lays him open to Postone's critique of theories of capitalist abstraction that would separate distribution from production.[38] But for Sohn-Rethel, as he writes to Theodor Adorno in 1942, it is always necessary to keep separate the "critical liquidation of the economic fetishism of manual labor ('value')" and the "critical liquidation of the epistemological fetishism of intellectual labor ('logic')," only later to show the "genetic connection" of these two forms of fetishism.[39]

Unlike Finelli, for Sohn-Rethel, a Marxist critique of epistemology is complementary but not reducible to the critique of political economy, since the "fetish-concept of logic has a different social referent with regard to the fetish-concept of value. The latter refers to the antagonism between capital and labor, the former to the antithesis between intellectual and manual labor."[40] In order to understand this antithesis

37 Sohn-Rethel, *Intellectual and Manual Labour,* 21.

38 Postone, *Time, Labor, and Social Domination,* 177–79; L. Garzone, *Forme-merce e forma-pensiero: L'idea di una vita. Introduction to Carteggio 1936/1969,* by T. Adorno and A. Sohn-Rethel. Rome: manifestolibri, 2000.

39 Theodor Adorno and Alfred Sohn-Rethel, *Carteggio 1936/1969,* Rome: manifestolibri, 2000, 112. Translation by the author.

40 Ibid., 111.

within labor itself, however, Sohn-Rethel turns to commodity exchange. Here is the "thought previous to and external to the thought." It lies in the prosaic activity, the doing of commodity exchange, and not (in both the logical and historical sense) in the individual mind of the doer. In a point that clearly speaks to Žižek's own discussion of belief and ideology as symbolic matters that have more to do with disavowed action than with false consciousness, Sohn-Rethel declares that "it is the action of exchange, and the action alone, that is abstract."[41] Both intellectualism and theoreticism seem vanquished through the declaration that abstraction is produced in the fundamental social nexus of capitalist society. "The essence of the commodity abstraction, however, is that it is not thought-induced; it does not originate in men's minds but in their actions. And yet this does not give 'abstraction' a merely metaphysical meaning. It is abstraction in its precise, literal sense…complete absence of quality, a differentiation purely by quantity and by applicability to every kind of commodity and service which can occur on the market."[42]

It is Marx's notion of a social *form*—a notion incommensurate with the traditional understanding of *eidos* (idea), *morphe* (form) or *Begriff* (concept), as well as with any form that might be extracted from experience through cognition—that holds the key to his theoretical revolution, to the extent that it heralds an abstraction other than that of thought. This abstraction, moreover, can be used to unseat the pretensions of an ahistorical, anti-economic, philosophical apriorism—by publicizing, as Žižek remarks, "the disquieting fact that [the transcendental subject] depends, in its very formal genesis, on some inner-worldly, 'pathological' process—a scandal, a nonsensical possibility from the transcendental point of view."[43] It can also be used to account for specific historical

41 Sohn-Rethel, *Intellectual and Manual Labour*, 26.
42 Ibid., 20.
43 Žižek, *The Sublime Object of Ideology*, 302.

transformations within epistemology and the practical appli-
cations thereof: the passage, for instance, averred by the
history of architectural engineering, from Egyptian rope meas-
urement to Greek geometry, about which Sohn-Rethel writes:
"In order, however, to detach it from such application, a pure
form of abstraction had to emerge and be admitted into reflec-
tive thought. We reason that this could result only through
the generalization intrinsic in the monetary commensuration
of commodity values promoted by coinage."[44] Finally, it is
only through Marx's discovery of real abstraction that we can
confront some crucial social realities of capitalism to which
classical philosophy is simply blind: for instance, "'abstract
things,' like *money*, and 'abstract men,' like *bourgeois property
owners*,"[45] or, more precisely, as Sohn-Rethel wrote to Adorno
in 1937, "the derivation of subjectivity in money"[46] (which
was the topic of his book on money as the "a prior in cash").[47]

As Virno quips, "A thought becoming a *thing*: here is what
real abstraction is."[48] Sohn-Rethel's point is perhaps even
more radical: a real abstraction is also a relation, or even a
thing, which *then* becomes a thought. In all these instances
of the singular abstractions at work in capitalist society, we
should heed Žižek's chiasmic reading of the Freudian theory
of dreamwork and the Marxian analysis of the commodity:
"the 'secret' to be unveiled through analysis is not the content
hidden by the form (the form of commodities, the form of
dreams) but, on the contrary, *the 'secret' of this form itself.*"[49]
In other words, the secret of real abstraction is precisely *an
open secret*, one discernable in the operations of capitalism

44 Sohn-Rethel, *Intellectual and Manual Labour*, 102.
45 Ibid., 19.
46 Adorno and Sohn-Rethel, *Carteggio 1936/1969*, 61.
47 Alfred Sohn-Rethel, *Das Geld, die bare Münze des Apriori*,
Berlin: Wagenbach, 1990.
48 Paolo Virno, *A Grammar of the Multitude*, New York: Semio-
text(e), 2004, 64.
49 Žižek, *The Sublime Object of Ideology*, 11.

rather than in an ideological preoccupation with the concrete truth or hidden essence that the abstractions of capital supposedly occlude.

It is worth noting, then, that the problem of real abstraction has been carried over into an analysis of the historical specificity of contemporary capitalism, with the aim of capturing the lineaments of a knowledge-intensive, informationally driven, post-Fordist capitalism. Virno, for instance, who indicates Sohn-Rethel as a formative influence, mocks contemporary sociologists of knowledge production precisely for omitting the reality of abstraction from their denunciations of capitalism in the name of praxis. In challenging the belief that we should look for a living or "manual" content behind the veils of finance and fetishism, Virno resonates with Žižek in demanding that we pay attention to the open secret constituted by abstract forms of capital. A humanist or liberationist stance that would seek the warm life of praxis "under" these cold forms would thereby miss the specificity of contemporary, post-Fordist capitalism, which is precisely found in the abstract connections, or real abstractions, that bond society. That is why Virno, in an obvious, albeit inverted, reference to Sohn-Rethel, argues forcefully for the pertinence of philosophical categories for understanding contemporary capitalism:

> There is more history and "life" in the a priori categories of the *Critique of Pure Reason* than in Voltaire and La Mettrie put together. The greatest of separations is also the most concrete. In the figure of an imperturbable and autonomous intellect, the era of the commodity and its "theological niceties" resonates with a clarity unknown to those who think they can catch it with a fast hand.[50]

Virno also provides suggestive arguments for making sense of the last line in the previously quoted passage from Marx's

50 Virno, "The two masks of materialism," 168.

1857 Introduction, whereby concrete perception and sensibility are the *result* of intellectual synthesis. Against any turn to a vitalist materialism, or a primacy of praxis, he remarks, "Direct perception and the most spontaneous action come *last*. This is the historical situation that comes about once the split between hand and mind manifests its *irreversibility*; when the *autonomy* of abstract intellect conditions and regulates the social productive process, on the whole and in every one of its singular aspects."[51]

However, Virno distances himself from Sohn-Rethel in the identification of a historical transformation within the modalities of abstraction themselves. This is because, rather than looking for real abstraction in the commodity *form*, Virno, in line with a workerist and autonomist (or postworkerist) attention to the organizational mutations of labor and class composition, sees the most pertinent form of real abstraction *not* in the equivalential forms of value, but rather, in the centrality of intellect, innovation and cognition in the transformed patterns of work and production in contemporary capitalism. On this point, it is worth quoting him at length:

> Because it organizes the productive process and the "life-world," the *general intellect* is indeed an abstraction, but it is a *real abstraction*, endowed with a material and operative character. Nevertheless, since it consists of knowledges, informations, and epistemological paradigms, the *general intellect* distinguishes itself in the most peremptory manner from the "real abstractions" which were typical of modernity: those, that is, which give rise to the *principle of equivalence*. While money, i.e. the "universal equivalent," embodies in its independent existence the commensurability of products, labor, subjects, the *general intellect* establishes instead the *analytical premises* for every kind of praxis. The models of social knowledge do not equate the various laboring activities, but

51 Ibid., 171.

present themselves as "immediate productive force." They are not a unit of measurement but constitute the immeasurable presupposition for heterogeneous operative possibilities. This mutation in the nature of "real abstractions"—the fact, that is, that it is abstract knowledge rather than the exchange of equivalents which orders social relations—has important effects at the level of affects...it is the basis of contemporary *cynicism* [since it] occludes the possibility of a synthesis [and] does not offer the unit of measurement for a comparison, it frustrates every unitary representation.[52]

In other words, by turning our attention to the informational praxis that has become inseparable from the production of values in a supposedly knowledge- and affect-centered economy, Virno is suggesting that the "general intellect" (the collective potential for thought embodied in a cooperative multitude) qua real abstraction constitutes a *directly politicized form of abstraction*, which is beyond equivalence and beyond measure, directly addressing the cooperative and socialized character of abstract knowledge. In other words, what is posited here is a real abstraction beyond the commodity form: a real abstraction that is driven not by the fetishized reality of commodity exchange, but by the cognitive and intellectual cooperation within a "multitude." But is this not to lose sight of the radicalness of the thesis put forward by Sohn-Rethel and paraphrased by Žižek—to wit, that under conditions of capitalism, thought is, in the final analysis, external to thought?

Remaining closer to the Marxian paradigm, and eschewing the declaration of the collapse of the law of value that grounds Virno's discussion of the general intellect, Italian political economist Lorenzo Cillario, also sensitive to the

52 Paolo Virno, "General Intellect," in *Lessico postfordista. Dizionario di idee della mutazione*, ed. A. Zanini and U. Fadini. Milan: Feltrinelli, 2002, 149–50; Virno, *A Grammar of the Multitude*, 63–66.

historicity of abstraction, has attempted to renew the concept of real abstraction in light of the centrality of informational procedures within the contemporary capitalist organization of labor. He does so through the notion of "cognitive capitalism," and starts, like Sohn-Rethel, from abstraction as the precondition of "universal" measurements and equivalence.[53] He tries, however, to specify what such an abstraction might mean when it is no longer just a matter of commodity exchange in its bare form, but of the explicit centrality of abstract processes (of models of calculation, devices of measurement and generic procedures) within the production process itself. In an informational capitalism, what matters, according to Cillario, is the nexus between the singularity of the experience of cognition-knowledge and the universalization of this knowledge on the basis of abstraction. In a more orthodox reading of the socialization at work in Marx's notion of general intellect than the one provided by Virno, Cillario argues that the worker-knower can mobilize not only his capacities, but the store (capital) of scientific knowledge and practices historically accumulated by society. Thus, as a *scientific* mode of production, "cognitive capitalism" makes abstraction into an essential moment in the process of production. This promotion of abstraction allows for spatial integration, temporal compression and transmissibility in a way not permitted by concrete knowledge or labor. It is also closely linked to the transformation of the production process by "flexible specialization"[54]—the use of machines that, through programming, can adjust "just in time" to the production of seemingly incommensurate products. In other words, abstraction enters into the very materiality of the production process and does not just concern forms of exchange.

53 Lorenzo Cillario, *L'economia degli spettri: Forme del capitalismo contemporaneo*, Roma: Manifestolibri, 1996, 165.

54 Michael J. Piore and Charles F. Sabel, *The Second Industrial Divide*, New York: Basic Books, 1986.

Rather than the politicization of real abstraction that Virno gleans from the supposed collapse of labor qua measure, Cillario sees the current figure of real abstraction centering on the proliferation and production of new procedures and codes of production, of transmissible "hows" rather than measurable "whats." The organizational codifications of the processes in which incommensurate use values are produced become central, but the locus of abstraction becomes not labor per se, or commodity exchange, but the role of cognition within the laboring process. Even if procedures themselves are then subjected to the standards of exchange (that is, they in turn become products), their centrality to a capitalism that relies more and more on "flexible accumulation" marks a mutation in the character of real abstraction. As Cillario writes, "The incessant impetus aimed at the change in the methods and procedures of laboring activities is the generative nucleus of the abstractive process of knowledge."[55] This centrality of procedures also means that, in a way that is not necessarily pregnant with emancipatory possibilities, *reflexivity* is at the heart of contemporary capitalism. That is, it is not just the abstraction of capital's forms, but its colonization of cognition that is crucial to an understanding of the present: "The concept of abstraction which is adequate to the phase in which knowledge becomes capital stems from the reflexive character of the process of social labor."[56] In turning our attention to the specificity of real abstraction within cognitive capitalism, Cillario also distinguishes four levels within Marxian debates on abstraction: abstract labor (indifferent substance of commodities); real abstraction of the labor process (organizational control of production; Fordism-Taylorism); abstract domination (bifurcation into dominants and subalterns); and reflexive abstraction (explaining the mutations of

55 Cillario, *L'economia degli spettri*, 168–69. Translation by the author.
56 Ibid., 52.

production in the informational age)—the last being the privileged domain, in his view, for the concept of real abstraction. Real abstraction can thus be said to move beyond its formal or methodological characterization and to become both form and content of the process of production. "At every cycle, abstraction takes us farther from any concrete starting-points, and renders more interchangeable relative knowledges, to the extent that these are marked by the homogeneity of human activity with only minor contingent conditioning, less tied to the peculiarities of such and such an originary productive reality, or to such and such bonds, whether physico-natural (of nature) or psycho-subjective (of men); and it allows for the unceasing accumulation of these knowledges."[57] Abstractions operating on abstractions—this seems to be the key to cognitive capitalism.

What is at stake in these debates? Without retreading the same path, I will indicate two key questions that polarize attempts to come to grips with real abstraction.

The first has to do with the philosophical matrix in which the notion of real abstraction is formulated, and this is made entirely explicit in *Intellectual and Manual Labour*. Sohn-Rethel's thesis regarding the identity between commodity form and abstract thought is aimed, as he puts it, at "a critical liquidation of Kant's enquiry," which he considers "the classical manifestation of the bourgeois fetishism of intellectual labor."[58] What's more, the manner in which Sohn-Rethel understands the concept of form in Marx—which is taken from Marx's treatment of the commodity in Chapter 1, *Volume 1* of *Capital*, not from the methodological reflections of the 1857

57 Ibid., 172.
58 Sohn-Rethel, *Intellectual and Manual Labour*, 16. Bearing witness to his unremitting attention to the *idée fixe* of real abstraction, Sohn-Rethel had already entitled his Paris Exposé of 1937, spurred by his discussions with Walter Benjamin, "On the Critical Liquidation of Apriorism" (Adorno and Sohn-Rethel, *Carteggio 1936/1969*, 50).

Introduction—makes him hostile to any attempt to consider real abstraction as in any way indebted to a Hegelian process of determination. The opposite verdict applies to Finelli, for whom the dialectic between the real abstraction of capitalist society and the theoretical synthesis of the concrete is mediated by the category of totality. This tension between form and totality might thus be said to mark a first division at the heart of the Marxian theory of real abstraction. On the one hand, we have the attempt to delve into (and "liquidate") Kantian apriorism in order to excavate the role of the commodity form in giving rise to a fetishistic perception of logic and intellectual labor; on the other, the attempt to reveal Marx's reduction of the all-encompassing operations of the Hegelian Subject to the historically *specific* identification of a society that is subjected to, and constantly reproduces, an impersonal principle of abstract domination.

The second issue concerns the point of application, as well as the historical and logical sources of the concept of real abstraction. While, as we've noted, the commodity form is the crux of Sohn-Rethel's pioneering investigation—which also touches on money and property as "abstract things"—for Finelli, among others, real abstraction can only be understood in terms of the dialectic of the abstract and the concrete operating within the concept of abstract labor. As he writes,

> the most specific characteristic of the mature thought of Marx is...precisely the claim of the fully objective standing, within contemporary society, of the abstract, which, through its most specific content, that is *labor without qualities*, is capable of building an entire social ontology, articulated, in the network of its differences, precisely by the scansions and motions of that principle—which is not logical but terribly real—of abstraction.[59]

59 Finelli, *Astrazione e dialettica*, 1–2; Postone, *Time, Labor, and Social Domination*.

A second division then—which in many respects overlaps the first—would thus concern which aspect of Marx's analysis of capital serve as the primary support for a theory of real abstraction: the momentous effects of the very form of commodity exchange, on the one hand, or the totalization of a society mediated by "labor without qualities," on the other. While Sohn-Rethel's approach would claim relative autonomy for the critique of epistemology vis-à-vis the critique of political economy, a position such as Finelli's—which seeks to develop in an ontological direction the consequences of Marx's methodological indications in the 1857 Introduction (unlike Althusser, for instance)—cannot, given its Hegelian matrix, concede a foundational role to the separation of intellectual and manual labor. This juxtaposition of a commodity- and labor-centered take on real abstraction is inevitably complicated, of course, by reckoning with the issue of cognitive and immaterial work foregrounded by the likes of Cillario and Virno—with the latter seeking to shift the terrain beyond both abstract labor and the commodity into that of the "general intellect."

The aim of this inevitably limited survey has been to outline some of the ways in which, setting out from crucial moments in the Marxian corpus, the relationship between abstract thought and capitalist reality has been investigated. Any sustained confrontation with this theme will, to my mind, have to traverse the work of these contemporary authors and some others (Chris Arthur, for example), and along the way make some crucial decisions as to its own philosophical fidelities and some fraught choices regarding how to portray the conjuncture of contemporary capitalism—be it in terms of immaterial labor, cognitive capitalism, or other operative figures of abstraction. If nothing else, the debate on real abstraction tells us why philosophers should be passionately interested in Marxism, and Marxists deeply concerned with the most recondite ontology and metaphysics.

The Rules of Abstraction: Methods and Discourses of Finance

Leigh Claire La Berge

In 2009, *Forbes* magazine ran an article that was one of a collection of postmortems on the 2007–08 credit crisis and its persistent aftermath. Whether we call this economic event the Great Recession, following the work of Carmen Reinhart and Kenneth Rogoff, or the endless crisis, as termed by John Bellamy Foster and Fred Magdoff, the incredible expansion and seismic contraction of global credit between 1992 and 2007 has necessitated a serious review of the technologies and ideologies that enabled it.[1] This particular *Forbes* article was concerned that finance had become so complex that basic regulation of it was no longer possible. Not only, the writer worried, might patrons cease to trust financial institutions, but financial institutions might also cease to trust each other. "Without trust," the article claimed, "the necessary fictions of finance cannot function."[2] *Forbes*'s readers never learned what those necessary fictions of finance were (or are). Indeed, adjectives such as fictitious and complex, the two that predominate in this article and many others like it, would seem less to elucidate

1 Carmen Reinhart and Kenneth Rogoff, *This Time is Different: Eight Centuries of Financial Folly*, Princeton: Princeton UP, 2009; John Bellamy Foster and Fred Magdoff, *The Endless Crisis*, New York: Monthly Review Press, 2012.

2 Quentin Hardy, "How Tech Killed Finance," *Forbes*, November 6, 2009, Forbes.com. See also: Daniel Altman, "Contracts So Complex They Imperil the System," *New York Times*, February 24, 2002, B12.

financial operations than to obfuscate them. The article reveals an important trope in academic and popular writing about finance—that of the complex or abstract—and it deploys that trope to familiar ends: to call forth an immediately knowable and representable world of institutional financial transactions, and then to suspend knowledge and description of that world by claiming its mechanisms are beyond our collective cognitive, linguistic and epistemological reach.

I want to argue that the form of capital under consideration here amplifies the problem of interdisciplinarity and encourages a methodological consideration of the tropes that scholars use to analyze this economy. At the moment, finance might be the interdisciplinary object par excellence, perhaps second only to digital humanities. In working groups and conferences around the Anglo-sphere one now hears the terms "critical studies of finance" or "cultures of finance" being used to indicate some kind of emerging, proto-disciplinary coherence. Yet because "critical studies of finance" (or however we designate it) is composed of anthropology, sociology, English, history and political economy, an exhaustive account of its key terms is beyond the scope of this essay. Instead, I will limit myself to a selection of texts from the fields of critical theory, political economy and literary/cultural studies, as well as popular discourses. Through these works, I argue that the most powerful and organizing tropes of analysis may be grouped under four logics: risk/speculation, narrative/futurity, class/wealth and abstraction/complexity. And of these hermeneutics—and this claim itself deserves some attention—the least used seems to be class and wealth; the most, abstraction and complexity.[3]

3 I will restrict myself to a few key sources for these larger trends. For risk, see Randy Martin, *An Empire of Indifference: American War and the Financial Logic of Risk Management*, Durham: Duke University Press Books, 2007. For abstraction, see Fredric Jameson, *The Cultural Turn: Selected Writings on the Postmodern, 1983–1998*, New York: Verso, 1998. See also: Edward LiPuma and Benjamin Lee, *Financial Derivatives and the Globalization of Risk*, Durham: Duke University

One could go even further and claim that the problem of method revolves around the problem of abstraction and the abstract entities and processes of which finance is supposedly composed. For scholars interested in translating financial objects and practices from one field to the other, abstraction has provided a crucial site of exchange.[4] Yet the word itself has so many varied meanings, and the concept so many varied theoretical traditions, that its casual, adjectival deployment makes its precise meaning almost impossible to ascertain. More intriguingly, Giovanni Arrighi's *The Long Twentieth Century*, which is a field-defining text for critical studies of finance, rarely deploys the term.[5] Greta Krippner's "The Financialization of the American Economy," one of the most cited articles in this proto-field, does not once describe the scene or value of finance as abstract.[6]

Press, 2004. For class, for example, see Lendol Calder, *Financing the American Dream: A Cultural History of Consumer Credit*, Princeton: Princeton University Press, 2001. In general, however, it is rare to find a work in cultural or literary studies of finance that does not deploy the term "abstract" or "complex," and it's even more rare to have a conference or paper where these terms do not form a common currency of discussion. Many of the people with whom I've had these discussions are colleagues, and I have made similar points in conversation with them— namely, that we need a robust account of financial abstraction or we need to reconsider using the term as promiscuously as we do. I am fairly certain that I will be understood here, but I am going to refrain from citing specific texts because I am trying to note a quite general trend.

4 Perhaps the most incisive in that it uses the abstract of finance to call for a return to the potential concreteness of it is to be found in Richard Godden, "Labor, Language, and Finance Capital," *PMLA* 126: 2 (2011), 412–21.

5 Giovanni Arrighi, *The Long Twentieth Century: Money, Power, and the Origins of Our Times*, New York: Verso, 1994, 167. Arrighi does use the term, but not to qualify finance as abstract. For example, "The Rothschilds were subject to no one government; as a family they embodied the abstract principle of internationalism."

6 Greta R. Krippner, "The Financialization of the American Economy," *Socio-Economic Review* 3: 2 (2005), 173–208. See also Greta R. Krippner, *Capitalizing on Crisis: The Political Origins of the Rise of Finance*,

In this chapter, then, I want to explore the problem of abstraction as it has been theorized in some key texts of Marxist and critical theory. Mine will be a rather symptomatic reading because I examine theories that are seldom used but could be (critical theoretical abstraction) to criticize and engage a term that is used to describe finance but perhaps should not be (generic abstraction). Then I transition to a very different set of discourses of finance, those of popular journalism. In the same period that academics began to describe finance as abstract, the popular press began to describe finance as complex. That contemporaneity, while interesting, offers little in the way of causality. I include it here because the same journalism—what I have elsewhere defined as "financial print culture"—that described finance as complex also began a contradictory trend of describing it as simple, and I believe this dichotomy offers an example, if not an archive, for scholars interested in finance's disciplinary development. It requires us to track how and when finance is both experienced and critiqued as pivoting between representable/unrepresentable, simple/complex and concrete/abstract.[7]

What I want to do, then, is break this essay into two parts. The first is an examination of the trope of abstraction: what is gained and lost from it, what is telescoped and obfuscated. The second part of the chapter moves from theory to archive and produces a kind of allegory (to be literary about it) of a different mode of describing and nominating finance: on one hand, as too complex to be represented and, on the other

Cambridge: Harvard University Press, 2011, which includes the previously cited article and expands upon it to consider larger social and institutional trends. Still, Krippner does not consider finance to be essentially abstract.

7 Financial print culture includes all printed material about finance, from its advertisements to its stock-tickers. See Leigh Claire La Berge, "The Men Who Make the Killings: American Psycho, Financial Masculinity, and 1980s Financial Print Culture," *Studies in American Fiction* 37: 2 (2010), 273–96.

hand, as so facile that even a baby can do it. In moving through the discourses of abstraction, complexity and simplicity, I ask after our own critical language of finance, about how it functions ideologically within our ever-expanding moment of financialization. I pose these questions to explore how scholars' available methodologies for criticizing finance might be addressed through a theoretical and discursive analysis of the lexicon of abstraction to which scholars interested in finance and financialization resort. The notion of abstraction in this emerging field requires further attention and specification, as do those aspects of finance that are not abstract, but rather surround us in myriad quotidian forms.

Abstract and Abstraction

In humanities-oriented academic discourse, "abstraction" is perhaps the most commonly employed category used to describe finance and "abstract" the most common adjective. This is such a broad and multidimensional claim that it immediately calls for clarification. Foremost, what do we refer to with "finance," and what do we refer to with "abstraction"? For expediency's sake, I am going to rely on the definition of finance offered by Greta Krippner. She claims that finance refers to demarcations of manifest, structured time and that its operations "refer to activities relating to the provision (or transfer) of liquid capital in expectation of future interest, dividends, or capital gains."[8] What do a credit card, a derivative contract, a ten-year treasury bill and a layaway account at JCPenney have in common? They all participate in this temporal displacement and recuperation, and they all are mediated by an expectation of future payment and future profit.[9] Indeed,

8 Krippner, "The Financialization of the American Economy," 174.
9 In selecting a generic definition of finance as opposed to a specific financial instrument such as the derivative, I hope to gain in flexibility

many of these instruments transform future value into present payment streams. David Harvey has said, broadly, that finance designates capital's temporal dimension. Robert Guttman claims that the temporal possibilities of financial practices are used to bridge "the real temporal disjuncture between intention, production and consumption" and make the credit-based "time aspect crucial to economic activity."[10]

In humanities discourses, however, one could also say that what defines finance is its "abstract" character. The adjective is used regularly in conversation, at conferences, and in writing. While anthropologist Karen Ho has cautioned against the term's overuse, her call has gone unheeded in the humanities, if not in economic anthropology.[11] With regard to finance, the trope of the abstract has been employed to mediate between humanities writing and economic writing and between humanities-based approaches and social-scientific approaches. While the word *finance* itself may be catalogued and defined, even if unsatisfactorily, we will have no such luck with the twins of "abstract" and "abstraction." In aesthetics, abstraction denominates an aesthetic mode of non-figurative representation. In philosophy, it denotes something not realizable in time and space. In social theory, it indicates something not fully realizable by a particular. These orientations share a particular habit of thought, to be sure, but they are marked by a divergence of aims, too. In aesthetics, the abstract highlights a perception; a certain immediate figuration is lost so that other properties of the medium may be brought into sharp relief. Here, abstraction provides medium

what I lose in exactness. Elsewhere, I have called this construction a "financial form." See Leigh Claire La Berge, *Scandals and Abstraction: Financial Fiction of the Long 1980s*, New York: Oxford University Press, 2014.

10 Robert Guttman, *How Credit Money Shapes the Economy*, Armonk, NY: M.E. Sharpe Press, 1994,12.

11 Karen Ho, *Liquidated: An Ethnography of Wall Street*, Durham, Duke University Press, 2009, introduction.

specificity.[12] In an abstract painting—think of a Mark Rothko color-field painting, for example—color itself is deracinated from figure. In social theory, abstraction indicates a metonymic reach in which an incomplete representation stands in for something larger that cannot be represented. Timothy Mitchell, for instance, argues that "the economy" itself is a recent historical abstraction used to designate a diversity of local and global actions and transactions.[13] However, as abstraction, "the economy" differs from the kind, as in philosophy, that describes the unrealizable, unattainable, timeless model of a Platonic form.

Yet none of these instances seems to be what scholars have in mind when they describe finance as either abstract or an abstraction. Rather, the designation is employed as a trope that organizes and structures but that itself eludes definition and representation. Abstract/abstraction instead appears as a strange amalgam, a kind of quilting point. For example, in an article tracking precisely the representation of finance over several centuries, Crosthwaite and his co-authors begin with the assumption that "the financial marketplace has played an integral role in the development of capitalism and yet is often perceived as elusive and mysterious, since it deals primarily in abstractions that complicate and resist figurative representation."[14] While this quotation has the benefit of pairing the abstract and figurative, it also reveals that the authors conceive finance as already assumed to have a certain character prior to its representation. That is, finance has an essentially abstract character. Caitlin Zaloom positions this abstract character a bit differently by pairing it with narrative.

12 The most famous example is Clement Greenberg's modernist argument that abstraction expression is the ultimate realization of the medium of paint itself in its orientation toward "flatness."

13 Timothy Mitchell, *Carbon Democracy*, London: Verso, 2012, Chapter 5, especially.

14 Paul Crosthwaite, Peter Knight and Nicky Marsh, "Imagining the Market: A Visual History," *Public Culture* 24: 3 (2012), 601–22, 601.

"Fashioning a social narrative for abstract information helps traders create understandings of market fluctuations that direct their decisions to enter and exit the market," she explains.[15] Alison Shonkwiler, in her own work on representation, assumes an "idea of capitalism as increasingly abstract, limitless, and virtual," which is itself different from Katherine Biers's assumptions of the "linguistic abstractions of capital."[16]

Indeed, to specify how a certain economic form participates in the discourse of abstraction, we must turn to Marxist theory. It is within Marxism that abstraction serves as a conduit and hindrance to economic knowledge, and it is there that the term has been most theorized and differentiated. In both its critical theoretical and political economic traditions, Marxist abstraction maintains a specificity and critical poise.[17] Within this discourse, we can delimit a series of kinds or instances of abstraction that finance might be said to participate in or to reconfigure. In other words, finance is positioned as subject to certain processes of abstraction, including Marx's and subsequently Alfred Sohn-Rethel's "real abstraction," Dick Bryan and colleagues' "lived abstraction," Fredric Jameson's "second-order abstraction" and Moishe Postone's engagement of "the abstract dimension of value" (each of which I consider herein). Or those processes themselves might be said to have been reconfigured through their imbrication in

15 Caitlin Zaloom, "Ambiguous Numbers: Trading Technologies and Interpretation in Financial Markets," *American Ethnologist* 30: 2 (2003), 258–72, 264.

16 Katherine Biers, "Frank Norris's common sense: finance as theatre in The Pit," *Textual Practice* 25: 3 (2011), 513–41, 525; Alison R Shonkwiler, *The Financial Imaginary: Dreiser, DeLillo and Abstract Capitalism in American Literature*, PhD Thesis, New Brunswick: Rutgers University, 2007, 2.

17 Alberto Toscano's work has been crucial to me in understanding the philosophical heritage and stakes of the abstraction debates and of the problem of real abstraction in particular. I am indebted to the genealogy he offers in Alberto Toscano, "The Open Secret of Real Abstraction," *Rethinking Marxism* 20: 2 (2008), 273–87.

financial operations, in which case we would need to define abstraction anew, perhaps by locating those "powers of incorporation and interdependence that finance bears but does not disclose," as Randy Martin succinctly puts it.[18] Marx deploys the unqualified term "abstract" regularly, although not regularly in relationship to interest-bearing capital or fictitious capital (both terms might very roughly be said to correspond to our term, "finance"). "Individuals are now ruled by abstractions," he says in the *Grundrisse*. One could counter that the "individual" itself is precisely the kind of abstract social form of which Marxism promises us a critique. And that rejoinder only hints at the myriad history of Marxist discourses of abstraction. Nonetheless, while Marxist theorists have long studied the abstractions of capitalism, they have not noted the abstractions of finance capital per se.[19] Lenin approvingly cites Rudolf Hilferding's claim that "finance capital wants domination not freedom," and in doing so posits a directness and an immediacy to finance that is far from abstract.[20] In contrast, Fredric Jameson, has, in his reading of Arrighi, claimed that we need a "new account of abstraction" to understand our financialized present.[21]

While abstraction rarely provides a method when it is deployed in contemporary critiques of finance, it was a methodological problem for Marx, who repeatedly sought to categorize what makes the concrete concrete, the abstract abstract, and on which of these levels any theoretical investigation should begin. The stakes are beguiling in their simplicity.

18 Randy Martin, "A Precarious Dance, A Derivative Sociality," *TDR/The Drama Review*, Volume 56 | Issue 4 |Winter 2012 p.62–77, 63.

19 Social theory explores abstraction as much as anthropology concretizes it. This divergence seems to me a question of method more than anything else. I'm thinking of Karen Ho as well as the work of Bill Maurer.

20 V.I. Lenin, *Imperialism, the Highest Stage of Capitalism: A Popular Outline*, New York: International Publishers, 1969.

21 Jameson, *The Cultural Turn*, 161.

If we begin with too abstract a concept to orient our investigation, then we preclude our own access to the quotidian, material, perceptible world. And if we begin with too concrete a term, then we may be unable to understand its organization within a larger social totality. For Marx, the concrete is a metabolized result and the abstract a social intuition capable of leading to the concrete. "The concrete concept is concrete because it is a synthesis of many definitions, thus representing the unity of diverse aspects. It appears therefore in reasoning as a summing up, a result, and not as the starting point."[22] Conversely, "as a rule, the most general abstractions arise only in the midst of the richest possible concrete development, where one thing appears as common to many, to all."[23] "Finance," then, must be able to be engaged in a manner that is both concrete and abstract simultaneously, and both dimensions must be in productive theoretical and material tension with their opposite. Indeed, this is a trend I will locate in political economic scholarship that I suggest should be replicated within humanities scholarship.

In Marx's own Marxism, abstract and concrete are not mutually exclusive positions; each is possible only in its realization of the other, and "finance" is not necessarily abstract. Indeed, when Marx does discuss "interest-bearing capital," his language is not that of considered abstraction. Rather it is of opportunistic malfeasance and full of references to "swindlers," "stock jobbers," "misrepresentation," "irrational behavior," "fictitiousness" and so on. The M-M' sequence, money begetting money without the mediation of commodities, is for Marx the "height of misrepresentation."[24] To claim that finance is abstract without showing its concrete dimension may enhance this misrepresentation. Yet to reduce finance to a series of

22 Karl Marx, *Grundrisse*, accessed online, Marxist.org, notebook 1, "Production."
23 Ibid.
24 Karl Marx, *Capital, Volume III*, New York: Penguin, 1971, 519.

techniques and transactions—precisely the project, it seems, of the "social studies of finance"—without locating its abstract dimension would likewise circumscribe the investigation.[25] Within the Marxist corpus proper, the commodity form, the money form, and so on are not more or less concrete. Rather, it is labor that is centrally expressed in both concrete and abstract dimensions, and that tension is replicated and externalized in other forms, such as money. In its concrete dimension, the daily activities of social reproduction are value producing. But this is possible only because they are necessarily abstract, too. Richard Godden notes that "for labor power to become value, it must be subsumed within abstract labor, or else its qualitatively diverse forms could not be quantitatively compared."[26] Money exists as a representation of this relationship. Marx explains that "qualitatively or formally, money is independent of all limits...it is the universal representation of material wealth," and that "world money is a realization of human labor power in the abstract."[27] As an expression or representation of abstract labor power, money may be said to be abstract. But as an expression or representation, a symbol, it is not abstract, but material, and thus "thingly." This

25 This new field includes the work of Michel Callon, Donald MacKenzie and Alex Preda. Its organizing rubric is one of "performativity." Appropriately, Judith Butler herself has joined this conversation and engaged this notion of economic performativity. See Judith Butler, "Performative Agency," *Journal of Cultural Economy* 3: 2 (2010), 147–61. David Bholat summarizes this approach: "Social studies of finance is arguably the most influential strand of economic ethnography and sociology today. Its research program consists in showing how markets are constructed by physical surroundings and cognitive calculative tools." David M. Bholat, unpublished paper delivered at the University of Chicago and cited with permission. We might note one species of this "too concrete" tendency in the increasing trend of financiers themselves being invited to critical studies of finance engagements, where they perform the role of a "native informant" who can deliver unmediated access to the truths of their profession.

26 Richard Godden, "Labor, Language, and Finance Capital," 419.

27 Marx, *Capital, Volume I*, 230, 241.

necessary vacillation between abstract and concrete is crucial because, according to Postone, it is the polarity itself and not the exclusive contents of either pole that structures the form and experience of value. Nonetheless, certain forms overly represent certain dimensions: the commodity, made valuable by abstract labor, seems overly thingly; money appears overly abstract.

Several critics, including Fredric Jameson and, following him, Max Haiven, ignore money's concrete dimension in order to posit its abstract character as a staging ground for what they describe as finance's additional abstraction. Jameson is able to categorize finance as a "second-order abstraction," because he has categorized money as a "first-order" one; he defines finance as a play of monetary entities.[28] Haiven argues that "finance is the redoubling of the complexities and abstractions of money."[29] In this initial path from money to finance, in which abstraction somehow intensifies or increases, we may discern an implicit yet critical move: Haiven and Jameson posit an increase in abstraction as money's abstract character is consolidated and heightened through finance. They suggest, then, that as capitalism progresses, one of its products is more abstraction. For the moment, I will confine this question of quantitatively greater abstraction to the relationship between money and finance, but I do want to mark it as a generic problem to which I will return.

Conversely, one could argue that abstraction has been and remains an important concept through which to analyze the development of capitalism. Regarding abstractions of money in particular, Dick Bryan and Michael Rafferty provide one example of what such a critical move might look like. They argue that finance, which they specify in the form of the

28 Jameson, *The Cultural Turn*.

29 Max Haiven, "Finance as Capital's Imagination? Reimagining Value and Culture in an Age of Fictitious Capital and Crisis," *Social Text* 29: 3 (2011), 93–124, 93.

derivative, becomes money. Functioning now as money, this instantiation of finance "expresses a form of capital that we have hitherto thought of only as an abstraction." [30] According to this argument, finance instantiates a new concreteness. The difference between these two approaches to money demonstrates that abstraction may be positioned as the object of money's operation or as a process to which money is subject. Critics themselves must be self-conscious about how they position their own discourse of abstraction, whether it operates as an object or a subject. For example, in an article on the relationship between knowledge production/knowledge commodities and financialization, Rodrigo Teixeira and Tomas Rotta explain that in their approach "financialization [itself] is conceptualized at a higher level of theoretic abstraction" than in heterodox economic models. [31] In doing so, their claim specifies the precise location of the "increase" or change in level and intensity of abstraction: whether in the theoretical approach or the object being critiqued.

Allowing that financial devices also instantiate a new concreteness, I want to return to my primary interest and to specify further how finance might be said to be abstract. To that end, I want to consider different modes of abstraction that have been refined within critical theory and political economy. [32]

30 This essay is not the place to make a specific argument about derivatives; I am more interested in discourses of abstraction. Yet the argument is there to be made. "If all different forms of asset are being measured against each other on an on-going basis, derivatives markets create (express) a form of capital that we have hitherto thought of as only an abstraction (an 'essence,' a sort of DNA of capital, that all particular capitals share in common). By providing a process of capital commensuration, there is an on-going measure of all capital, in all forms, at all locations and across time. There is, thereby, a measure of a unit of capital: and this can readily be seen as a primary monetary function." Dick Bryan and Michael Rafferty, "Financial Derivatives and the Theory of Money" *Economy and Society* 36: 1 (2007), 134–58, 142.

31 Ibid., 455.

32 Bryan et al. note that "conventionally Marxists have been inclined

As explicated by Alfred Sohn-Rethel, the central category of abstraction is that of real abstraction. "While the concepts of natural science are thought abstractions, the economic concept of value is a real one," he claims.[33] Having done more than any other critic to invigorate Marx's concept of the "real abstraction," Sohn-Rethel stakes his critique on the distinction between Marxian abstraction as a materialist operation and those forms of ideal abstraction to be found in the bourgeois sciences of philosophy and mathematics.[34] Indeed, Sohn-Rethel goes so far as to argue that the abstract categories of natural science are symptomatic of a society dominated by the commodity form and its familiar division between use value and exchange value, in which certain things appear overly "thingly" and certain concepts overly abstract.[35] The real abstraction interrupts this dichotomy; it is "purely social in character and arises in the spatio-temporal sphere of human interactions," particularly commodity exchange, where it is

to resolve these different takes on capital by reference to different levels of abstraction: fluidity and universal competitive calculation are abstract characteristics of capital, and the means of production are a concrete manifestation of capital in the form of the corporation." I would distinguish, however, between their concern with static "levels" of abstraction and what I argue are dynamic modes of abstraction; in the latter, the critic undertakes an operation as opposed to the identification of a category. Dick Bryan, Randy Martin and Mike Rafferty, "Financialization and Marx: Giving Labor and Capital a Financial Makeover," *Review of Radical Political Economics* 41: 4 (2009), 458–72, 465.

33 Alfred Sohn-Rethel, *Intellectual and Manual Labour: A Critique of Epistemology*, London: Humanities Press, 1983, 20, 22.

34 For me, the oddest thing about Sohn-Rethel's study is that the exchange abstraction precedes wage labor and begins with the earliest articulations of human sociality itself: the Bronze Age, pharaonic Egypt and the Greece of Pythagoras all come into his purview. That is, the abstraction precedes capitalism itself in the Marxist sense of it as a generalization of the wage structure and private property relation.

35 This forms the basic tenet of Sohn-Rethel's critique; namely, a division between mental and manual labor. This distinction is important to real abstraction, but I do not pursue it here. See Sohn-Rethel, *Intellectual and Manual Labour*, 69.

materialized as money. As Sohn-Rethel famously declares, the real abstraction "exists nowhere other than in the human mind but it does not spring from it...it is not people who originate these abstractions but their actions." In a recent article on what he calls "Real (Software) Abstractions," Robert W. Gehl contextualizes the possible implications of Sohn-Rethel's project: "regardless of the primacy of one real abstraction (say, the money-commodity) over another (say, abstract labor power), the effects of any real abstraction include material consequences...real abstractions express themselves in social organization and are expressions of social organization. They are real because they are actions; they are abstractions because they become part of the immaterial constitution of a whole way of life."[36]

Real abstraction seems to me a potentially useful concept for critical studies of finance in that it necessarily links actions such as exchange or the giving of credit (which includes both the immediacy of exchange and a potentially unlimited duration) to a larger social structure that appears divorced from the actions that constitute it. As such, finance may appear abstract, but as a real abstraction, it is concrete as well. The concept's difficulty arises, however, from the fact that a real abstraction—or a "lived abstraction," to borrow a term that goes undefined in the work of Bryan, Rafferty and Martin—seems to preclude the category of representation: the real abstraction does not represent another object or process in a signifying chain, it just is. I introduce the problem of representation here because I suspect that one meaning critics attempt to impart when they argue that finance is abstract is that, for them, finance represents larger social forms of abstraction. This could suggest methodologically that finance represents various capitalist processes of abstraction in a manner similar

36 Robert W. Gehl, "Real (Software) Abstractions: On the Rise of Facebook and the Fall of MySpace," *Social Text* 30: 2 (2012), 99–119, 104–5.

to the way that money represents abstract labor power. But then again, one could rejoin that finance represents money, which represents abstract labor power, so the specific abstraction that finance represents would still need to be specified.

The difference between finance essentially being abstract and finance socially representing an abstraction constitutes another crucial methodological divergence within emergent scholarship in critical studies of finance. The argument for discourses of finance existing as sites of excess representation is certainly one for which we can find tangential support. Moishe Postone, for example, claims that "the specific characteristics attributed to Jews by Modern anti-Semitism—abstractness, intangibility, universality, mobility—are all characteristics of the value dimension of the social forms analyzed by Marx." Postone draws a connection between the two based on how certain people and objects may represent the abstractions that constitute capital as a social system. [37] Indeed, critics as diverse as Postone, Colleen Lye and Michael O'Malley have noted that critiques of finance often pair racist or anti-Semitic, nationalist sentiments with anti-capitalist sentiments.[38] These critiques isolate finance exclusively, as opposed to other economic constellations such as industrialism or monopolies.[39] In the case of German anti-Semitism, Postone argues that explanation may be found in the fact that Jews became associated with the abstract dimension of capital through their participation in financial activities, among other things. "This form of 'anti-capitalism,' then, is based on a one-sided attack on the abstract," he argues. One could locate a similar critique today

37 Moishe Postone, "Anti-Semitism and National Socialism: Notes on the German Reaction to 'Holocaust,'" *New German Critique* 19: 1 (1980), 97–115, 108, 112.

38 Michael O'Malley, *Face Value: The Entwined Histories of Race and Money in America*, Chicago: Chicago University Press, 2012.

39 Colleen Lye, "American Naturalism and Asiatic Racial Form: Frank Norris's The Octopus and Moran of the 'Lady Letty,'" *Representations* 84: 1 (2003), 73–99.

in the rhetoric around Chinese "currency manipulators" or Japanese real estate investors in the United States in the 1980s. Yet today, one could claim that it is financiers themselves who represent finance. If that is true, then it is a state of affairs that collapses one of the most important poles for the assignation and distribution of meaning in discourse analysis—namely, the distinction between metaphor (financiers possess a quality of finance) and metonymy (they are a part of finance).

The exchange abstraction, the lived abstraction, the real abstraction and the historical embodiment of abstraction are modes of analysis to which the generic adjective "abstract" hardly does justice. This incredible archive of abstraction should be used, explored and broadened, a project already begun by the scholars I have mentioned here, including Randy Martin, Richard Godden and Fredric Jameson. Furthermore, all of the examples that I have used call into question whether we can track *more* abstraction or *increasing* abstraction, both terms of quantity that belie the kind of abstraction that these thinkers encourage.[40] We should also pursue the theoretical implications of altogether divorcing abstraction from Marxism in discussions of finance.[41] Doing so would necessarily lead to the question of why finance demands the specificity of its own discipline, however nascent its stage of development may

40 We can tease out support for this position from Postone, who says, "what seems to be historical unfolding is actually a progression backwards…based on a logical reconstruction of the dynamic character of capitalism…only when it is developed." Moishe Postone, *Time, Labor, and Social Domination: A Reinterpretation of Marx's Critical Theory*, Cambridge: Cambridge University Press, 1993, 285. Yet on page 213, he does describe the late Middle Ages as a time of increasing abstraction. We could extrapolate the former quotation to claim that abstraction can only be reconstructed after its instantiation is complete.

41 Foucault argues that the "free market" has the features of a Kantian regulative idea—that which orients experience but cannot be experienced directly. God and Freedom are Kant's examples. If we settled on the Foucauldian approach, we could sidestep abstraction altogether.

currently be. Finally, it should be noted that in their engagement with Edward LiPuma and Benjamin Lee's oft-cited *Financial Derivatives and the Globalization of Risk*, a text that designates finance as a form of "abstract symbolic violence," Dick Bryan and colleagues suggest that financialization produces a new concreteness.[42] They claim that "financialization gives capital a concrete liquidity and fungibility that is more commonly conceived only in abstraction. This is a starkly different perspective on financialization from that found in the pervasive focus on speculation, debt, and crisis."[43] To restate their point: finance concretizes what was heretofore abstract.

In my presentation of this theoretical archive and its lexicon, I have tried to stress how abstract and concrete cannot be separated, and how finance, however defined, has multiple intersections with both. In addition to asking for a specification of financial abstraction, then, we must also be concerned to locate a specification of financial concreteness. If Enzo Paci is correct and "the fundamental character of capitalism is revealed in the tendency to make abstract categories live as though they were concrete," then we are likely already among this concreteness and now need to categorize and catalogue it.[44] That project will remain a limited one, however, if we continue to dwell in a discourse of unspecified abstraction.

Discourse and Representation

If historical and contemporary political economic scholarship offers some of the language and concepts with which to specify

42 There are two articles co-authored by Bryan. The first (2007) hints at this claim; the second (2009) makes it directly. Financial concreteness is something that Godden suggests we need to conceptualize but does not fully articulate this in his already cited article.

43 Bryan, Martin and Rafferty, "Financialization and Marx," 464.

44 Enzo Paci quoted in Toscano, "The Open Secret of Real Abstraction," in this volume, pp. 17–18.

abstraction, then current representations and discourses of finance provide a testing ground, as it were, to think through how we might deploy the language of abstract and concrete together and in what other vocabulary these concepts might appear. Part of the problem with generic abstraction is that the assumption of scholarship seems to follow the etymology of the word: literally, to draw away. In positing finance as abstract, there is a tendency not to notice that in addition to finance existing as a concrete presence, we ourselves are the subjects who do the concretizing.

The engagement of two particular objects of finance demonstrates how in specifying our object, we necessarily articulate the relationship between the abstract and the concrete. For example, in the case of unsecured student loans and credit card debt, we are both signatories and collateral to our own indebtedness. How should we locate the abstract and the concrete in such a scenario? Artist Cassie Thornton's aesthetic interventions may serve as a useful example of how to mitigate different forms of abstraction through representation. Thornton has claimed that she works in the medium of debt.[45] Whether in performance, sculpture or video, it is the manipulation of debt, she argues, that constitutes her practice.[46] Compare debt to the medium of paint. A painter may

45 Her work was exhibited at the Elizabeth Foundation for the Arts' "To Have and To Owe," New York City, Sept. 21–Oct. 26, 2012, curated by Leigh Claire La Berge and Laurel Ptak.

46 Thornton uses "debt as a medium" in order that it might become "materialized," "collectivized" and "change forms." Ultimately Thornton's practice itself coheres around the "debt visualizations" that she conducts with MFA students. She explains the process using a vocabulary appropriate to the plastic arts: "I am in the process of interviewing every MFA student about the financial liabilities they've accrued while attending CCA. Each is asked to describe the essence of their debt as an expression of texture, aura, scale, material composition, etc, from within a meditative state." Conducted in a private space ritually purified by the burning of sage, Thornton invites her fellow debtors to free associate to the word "debt" and to imagine approaching their own debt from a distance.

use paint to create an abstract or a figurative work. By claiming debt as her medium, Thornton invites her audience to see how debt functions as both abstract—we are *in* debt—and as concrete—we *are* debt—thus uniting aesthetic and political economic registers. This seems to me a powerful articulation of what Dick Bryan and colleagues call, without explaining, a "lived abstraction." Thornton's work also entails a useful rejection of locating the anxious abstractions of capital on *others*, which Postone and Lye also caution against. She invites us, rather, to locate the concrete and the abstract of this form of finance called debt within our immediate ambit, even within ourselves. Thornton's artistic practice prefigures some of the emerging theoretical work on finance, including that of Randy Martin, whose recent work on "derivative sociality" attempts to transform the derivative, that specific object of so much discursive speculation, into a site of mediation by an analysis of contemporary dance practices. His method reveals that the aesthetic abstractions of dance—"its vocabulary is as abstract as that of financial derivatives"—may be "grounded in a few practices that will make tangible the operation of a derivative logic in dance, and that allow us to see the ways in which dance fleshes out what a derivative might do."[47] In Martin's work, then, the derivative is posited as an interlocutor, a way to mediate aesthetic abstraction. In different registers, both Thornton's expression and Martin's analysis avoid fetishizing the abstract dimensions of finance.

Yet another instructive archive is the discourse of the financial services industry—where the vernacular equivalent of the abstract/concrete dyad exists in the language of simple/

What results from these dialogues is a new verbal, visual, aesthetic —and specifically art historical—discourse through which MFA students trace their own path to artistic professionalization and indebtedness. See Leigh Claire La Berge and Dehlia Hannah, "Debt Aesthetics: Medium Specificity and Social Practice in the Work of Cassie Thornton," *Postmodern Culture* 25: 2 (2015), DOI: 10.1353/pmc.2015.0009.

47 Martin, *A Derivative Sociality*, 68–9.

complex. In the chapter introduction, I suggested that the language of finance in financial print culture might be read as an allegory of academic discourses of finance. If anything, in popular financial discourses, one finds an ironic commitment to representing finance with a broader range than in academic discourse. There exists another parallel, too: the discourse of complexity in the popular press mirrors that of abstraction in academic discourse. My aim in introducing this particular archive, then, is twofold: first, and this will remain a speculative claim, to suggest that one unrecognized model for discourses of abstraction in some humanities scholarship is that of complexity in the popular press; and, second, in a different context, to show how the "non-representability" of finance appears and may be reconfigured in representational space. It seems an entirely reasonable although ultimately unprovable hypothesis that many critics of finance have been informed by these popular discourses and their own positioning within them, even if they do not directly account for this exposure in their work.

This exposure is one effect of what *New York Times* columnist Joseph Nocera, following Robert Schiller, introduced as "the democratization of finance," and what Martin has called "the financialization of everyday life." [48] The democratization of finance acknowledges those who have chosen to become more imbricated in institutional finance, such as those who invest in mutual funds; the financialization of everyday life qualifies that, in an era in which much social reproduction has been privatized and defunded, for many people, financial services such as payday loans and the acceptance of debt are not a choice but a necessity. However we nominate this expansion

48 Joseph Nocera, *A Piece of the Action: How the Middle Class Joined the Money Class*, reissue, Touchstone, 1995. Conversely, Martin has called the same trend the "financialization of everyday life." See Randy Martin, *The Financialization of Everyday Life*, Philadelphia, PA: Temple University Press, 2002.

and entrenchment of the financial industry, its growth has been staggering.[49] In the realm of "democratization," we may note that in 1978, 22 percent of Americans were invested in the stock market. Today, that number, according to the New York Stock Exchange is 62 percent. Likewise, according to the US Federal Reserve, outstanding consumer debt was around $1.8 trillion in 1980, and it is around $14 trillion today. These overlapping processes of "democratization" and "financialization" have succeeded in enveloping more and more of the American population in their fold, in part through a discursive infrastructure of knowledge, inducement and excitation. Part of both processes, then, has been the financial reeducation of the American public about how to live a flourishing life as an investor and/or a debtor. This education has relied on the circulation of financial logics and narratives, including media such as the A&E series *Flip This House* (2005–2009), the spread of publications such as *Money* magazine (founded in 1973) and *Investors' Business Daily* (founded in 1984), the visual dominance of the television network CNBC (launched 1989) and the spread of finance-based charitable enterprises, such as the microlending website Kiva. Each of these has presented various financial transactions as easy, available, fun, civically minded and humanitarian (in the case of Kiva).

While one could select any of the above for analysis, a particularly apt example of the instantiation of both the democratization of finance and the financialization of everyday life is the representation of "the stock market" as a site of social and individual gain and loss.[50] The discourses of personal brokerage accounts through companies, including E*Trade and Ameritrade, seek to transform the customer into

49 See Julia Ott, *When Wall Street Met Main Street: The Quest for an Investors' Democracy*, Cambridge: Harvard University Press, 2011.

50 The "stock market" has no single referent, of course. Rather, the phrase represents an amalgam of stock indexes and is usually refers to the Dow Jones Industrial Average, specifically.

a stockbroker who may now monitor the market hourly and adjust their portfolio accordingly. An exacting language of financial simplicity has accompanied these accounts. Indeed, in business sections of newspapers, it is not uncommon to see one article about how "complex," and thus unable to be regulated, certain financial transactions are, opposite an advertisement for how simple, and thus able to be sold en masse, other transactions are.

I will focus on E*Trade's use of a stock-trading baby, which was consistently cited by news and advertising publications for its efficaciousness during its run from 2007–2014.[51] In these ads, a prelinguistic infant ventriloquizes an investor and explains from his crib how easy and simple it is to trade stocks from a Blackberry or an iPad.

In the image on the next page, the E*Trade baby does just that. He uses an adult-male voice to explain that "making an investment is as easy as a single click. I just bought some stocks. Boom. More stocks. See?" The E*Trade Baby offers multiple, possibly competing, interpretations. Is this an insult to potential consumers—that amateurish stock trading is an infantile pursuit? Or is it a naturalization of trading as somehow an innate physical teleology, like crawling, sitting, standing and eventually walking? While this advertisement may be the most popular of its genre, the discourse of financial simplicity is hardly limited to advertisements for companies that directly benefit from it. Financial print culture is filled with profiles of a new kind of financial amateur who has been dubbed a "day trader." In a profile of "one of thousands of college students who fit online stock trading into already busy schedules of lectures, exams and keg parties," the *Times* notes that the new "ease" of accessing financial information and the simplicity of

51 For an interesting memorialization of the ad campaign, see Reuters Wire Service, "E*Trade Bids Goodbye to Its Iconic Baby," March 21, 2014.

*"E*Trade Baby" by E*Trade*

trading on it had produced a new generation of such traders.[52] One could easily understand the language of simplicity as a sales pitch (which is no doubt its manifest aim), but I want to place it in conversation with a larger collection of popular financial discourses in order to show that the diversity of this discourse might in fact have something to contribute to academic theorizations of it.

Crucially, then, the same process of democratization has also transpired through a second discourse in which the simplicity of finance is replaced by its precise opposite, its complexity. I want to suggest that "complex" might be the vernacular equivalent of abstract.[53] It is a placeholder for a process that cannot be represented in its entirety for some unknown, and perhaps unknowable, reason. During moments of financial crisis—whether the savings and loan crisis of 1985 through the early 1990s, or the tech-bubble bust and Enron collapse of 2001–02 or the 2007–08 credit crisis—the dominant trope of finance in journalistic discourse becomes one of complexity.

52 See Eric Quinones, "Personal Business: The On-line Trader Is Becoming the New Big Man on Campus," *The New York Times*, Sept. 26, 1999.

53 Sometimes abstract and complex are used together as in this example from *Financial Times* columnist John Gapper, "The Best Books on Financial Speculation," an Amazon "Five Books" post in which notable critics review new books. Available only online at fivebooks.com, accessed Sept., 2018.

Complexity has a dual function. On one hand, it is causal: this is why the crisis happened, because finance is so complex that no one can understand it. Thus, it serves an immediate exculpatory role. On the other hand, it functions as representational: whatever you are reading/viewing/hearing cannot be rendered sensible enough to explain the financial crisis' causes because finance is so complex that it is beyond representation. The antagonistic fluidity between the two discourses is nicely demonstrated in a pair of articles form the *New York Times*. In a March 19, 2008, article the newspaper queried its readers: "Can't Grasp the Credit Crisis? Join the Club."[54] This story strikes a quite different pedagogical tone than *Times'* columnist Nicholas Kristof assumed the previous year in a celebratory column on the simplicity of microfinance. In hailing Kiva's straightforwardness as a lending organization, Kristof reached out to his readers through this invitation: "You, too, can be a banker to the poor."[55]

This productive deployment of certain discourses can be measured systematically. As one example, I have charted the term "complex deal" (shown on the next page) as it appears in major financial publications in the United States against the percentage of Americans invested in the stock market.[56] Complex deal is the term used in financial journalism to engage and simultaneously to refuse the representation of financial transactions. Its use marks that something has transpired, namely a deal, and that it has had real effects. Yet the term's use also communicates that the contents of the deal cannot be fully explained. That is, it's a term that obfuscates rather than provides understanding. In times of crisis,

54 David Leonhardt, "Confused over the credit crisis? You're not the only one," *New York Times*, March 19, 2008, A1.

55 Nicholas Kristof, "You, Too, Can Be a Banker to the Poor," *New York Times*, March 12, 2007, A24.

56 Chart designed by Brendan Griffiths, Zak Klauck and Mylinh Trieu Nguyen based on my research of American stock ownership and the repetition of the phrase "complex deal" in financial print culture.

*"Complex Deal." The black line shows frequency of the
phrase "complex deal" in financial print culture. The white
blocks show the percentage of Americans investing in stocks,
what has been called the "democratization of finance."*

the repetition of "complex deal" markedly increases. In one
quotation describing Enron's failure, the *Chicago Tribune*
wondered, "Were Andersen's accountants and consultants
involved in the complex deal by which Enron bought out
its JEDI partnership by creating a new one called Chewco—
one of the off-balance-sheet deals that greatly contributed to
Enron's collapse?"[57] In another, the *New York Times* noted
that "though trading in those devilishly complex financial
tools known as derivatives did not contribute much to Enron's
collapse, the contracts did allow the company to conceal the
aims of its financial dealings."[58] An older *Times* article from
the Savings and Loan Scandals-era explained that, "while
what Sunbelt [Bank] did in principle was simple, in practice
the deals were exceedingly complex."[59]

57 David Greising, "Berardino's Testimony Is No Account," *Chicago
Tribune*, February 6, 2002.
58 Daniel Altman, "Contracts So Complex They Imperil the System."
59 Leslie Wayne, "Showdown at Gunbelt," *New York Times*, A1,
March 12, 1989.

What are we to make of this discursive contradiction and how does it relate to the modes of abstraction in which finance might be said to partake? The immediate conclusion to be drawn from reading the discourses of complexity and simplicity together is that one of the ideological demands of a financial era is that anyone can master financial transactions because they are simple, but this rule does not apply in times of crisis, when even professionals cannot master financial transactions because they are complex. Thus the financial industry can grow and indemnify itself simultaneously. While this is no doubt true, it is a less than satisfying resolution. I would proffer that rather than identify modes of abstraction, many critics of finance have resorted to the discourse of complexity without including those of simplicity. Consequently, "abstract" and "abstraction" denote something crucial and real that necessarily remains unexplained. If that is true, and it will remain a conjecture, one could interpret the mixing of abstraction and complexity in several ways. It could be that one ideological requirement of finance is that its subjects understand it as an abstraction. Or it could be that abstraction is itself a metonym for something undefined in this emerging field of critical studies of finance. Or it could be that finance is abstract, in which case, the onus falls on us scholars to attend to its specifications. Or it could be that finance constitutes yet another kind of abstraction, what Marx called a "rational abstraction," or simply a conceptual shortcut. Any of these may be true with proper citation and consideration, and that is a project this emerging field must undertake.

Conclusion

From Marx to discourses of "the market," the scope of this essay is broad indeed, as it juxtaposes two radically different

archives: the first, of abstraction itself, and how variations of the concept may or may not enhance our understanding, description and analysis of finance; the second, of the tension between discourses of complexity and simplicity in popular media. I hope readers will understand my invocation of the discourses of financial complexity and simplicity as a potential methodological intervention into the discourse of abstraction. Finance's so-called complexity only becomes meaningful in conversation with its simplicity and within the context of its own event-based historicization. A similar reorganization and contextualization of meaning is required of financial abstraction, too. I have attempted to contribute to that process in this chapter. Not doing so threatens to make abstraction function in the manner that a deracinated complexity now does. Used by progressives and neoliberals alike, complexity quickly leads us into an adjectival aporia, where both camps end up delivering the same message: namely, that no one understands finance because it is too complex.

One can see why so many forms of abstraction coalesce around work on finance, given its over-presence and lack of presence, its simplicity and complexity. And many abstractions are necessary to think through finance. But just as we must ask whether finance represents the abstractions of capital, labor or money, or all of these, we must also ask what abstraction itself might represent. Some critics, including McKenzie Wark, have stated that Occupy Wall Street succeeded politically in its critique of our global financial system by replacing one abstraction with another.[60] "How do you occupy an abstraction? Perhaps with another abstraction," Wark writes. They suggest that a lack of plan, coherency and

60 See "McKenzie Wark on Occupy Wall Street" on the Verso blog at versobooks.com, accessed 16 October 2018. For a brief treatment of Occupy Wall Street and its relationship to aesthetic abstraction in particular, see Gregory Sholette, "After OWS: Social Practice Art, Abstraction, and the Limits of the Social," *E-flux* 31 (2012), e-flux.com.

demand in Occupy Wall Street should be read as a counter-abstraction to the abstraction of finance itself. While their overall social and historical analysis of Occupy Wall Street's lack of demands is interesting, I want to note that in their analysis, both their object and their critique transpire through a discourse of undefined abstraction. I would caution, then, that in the case of "Wall Street," itself more a metonym than an abstraction, the concern of critics should not be to locate more abstractions, but to suggest what it is that abstraction designates and why. What if it were being used to designate, not an abstract entity, not even a lack of figuration, but something else?[61] Something still unimaginable? Can the discourse of undefined abstraction help us locate new assignations and contestations of meaning? To pursue such questions, we must now work to create an archive of "counterfinance" in which abstract and concrete remain identifiably interrelated.

61 See Jasper Bernes's excellent consideration abstract and concrete at Occupy Wall Street, "Square and Circle," at thenewinquiry.com, accessed 16 October 2018.

3

Artist's Research Project: Extracts from THE MARKET (2010–)

Mark Curran

The Market Has a History, But No Memory

from a recorded conversation with a senior financial analyst (name withheld), restaurant, The City, London, England, May 2013

JP Morgan (formerly Lehman Brothers)
Canary Wharf, February 2013 London, England

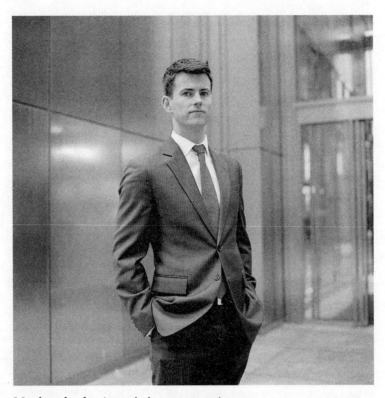

Matthew, banker (negotiation, two years)
Canary Wharf, March 2013 London, England

...fear is central to how we operate...it pushes everyone to perform...I have to say personally, without that insecurity, I couldn't work, not the way I do...

from a recorded conversation with a banker (name withheld)
Café, The City, London, England, March 2013

...you know, just before last Christmas (2012), 1,200 workers at (name of bank) found out they had lost their jobs, when they showed up to work in the morning and discovered their security cards wouldn't let them in the building...simple as that...

from a recorded conversation with a banker (name withheld)
Café, The City, London, England, March 2013

Jennifer, Markets Marketing manager (negotiation, 1.5 years)
The city, July 2013 London, England

Credit Suisse (access denied)
Canary Wharf, March 2013 London, England

...what people don't understand...is that what happens in the market is pivotal to their lives...not on the periphery...but slap, bang, in the middle...

from a recorded conversation with a senior trader (name withheld)
Café, The City, London, England, March 2013

According to a report (2012) by the British Government Office for Science, *algorithmic trading will replace most human trading in the global market within a decade.*

The same report states: *algorithms will eventually be able to self-evolve* through ability to experience—i.e., building upon previous market experiences and requiring no human intervention.

However, they also warn that within such a framework exists the potential for what they describe as the *Normalization of Deviance—unexpected and risky events come to be seen as ever more normal until disaster occurs.*

The Future of
Computer Trading
in Financial Markets

An International Perspective

FINAL PROJECT REPORT

Markets are instant...maybe the biggest globalization is through markets...you know, worldwide twenty-four-hour trading...people expect responsiveness...and that extends to the market...the *now* is all important...

from a recorded conversation with James, operations manager, decommissioned trading floor, Irish Stock Exchange, Dublin, Ireland, April 2012

James, operations manager (negotiation, one year)
Irish Stock Exchange, April 2012 Dublin, Ireland

Bell, decommissioned trading floor
Irish Stock Exchange, July 2012 Dublin, Ireland

...they are the future...they are the reliable system...only twice has it gone down...a small exchange like Ireland... when you look at the rest of Europe, most other exchanges were electronic... for us not to do that...we were competing with the London Stock Exchange for market share...because, that was life...so not to do that would have been practical suicide for the market...

from a recorded conversation with the head of Public Affairs & Communications, decommissioned trading floor, Irish Stock Exchange, Dublin, Ireland, July 2012

```python
3
4    ⊖from Tkinter import *
5     import numpy as np
6     import matplotlib.pyplot as plt
7     import matplotlib.dates as mdates
8     import csv
9    ⊖from tkFileDialog import askopenfilename
10
11
12   ⊖class TkApp():
13
14   ⊟    def __init__(self, root):
30
31   ⊟    def showGraph (self):
32          # open a csv.dictreader, grab the last col, read it into 'data' list and graph it
33          inpFile = "Market.csv"
34          dat, adjcl = np.loadtxt(inpFile, delimiter = ',', skiprows = 1, usecols = (0, 6), unpack = True,
35                                  converters = {0: mdates.strpdate2num('%Y-%m-%d')}})
36          plt.plot_date(x = dat, y = adjcl, fmt = "r-")
37          plt.title("Market Data")
38          plt.ylabel("Adj Close")
39          plt.grid(True)
40          plt.show()
41
42          x = [1, 2, 3, 4, 5, 6]   # x axis plot points
43          y = [1, 2, 4, 3, 6, 5, 7, 8]   # y axis plot points
44          N = len(y)
45          x = range(N)
46          plt.plot(x, y, ':rs')
47          #plt.axis([0, 40, 0, 50])   # x=0-10, y=0-6
48          plt.xlabel("Dates")
49          plt.ylabel("Adj. Close")
50          plt.show()
51
52   ⊟    def openFile (self):
53          self.filename = askopenfilename(filetypes = [("allfiles", "*"), ("csv Files", "*.csv")])
54          self.fil = file(self.filename)   # get file handle from filename
55          self.txt = self.fil.read()   # read text from file handle into var
56          self.fil.close()   # kill file handle
57          self.txtBox.insert(0.0, self.txt)   # insert the file text into textbox
58          self.txtBox.pack(expand = 1, fill = BOTH)   # show txtBox object
```

Algorithm & Sound Composition
Ken Curran

Through the application of an algorithm identifying the words *market* and/or *markets* in public speeches by relevant national ministers of finance, the data is then transformed to create an installation soundscape.

...if ECX were working for a profit, the whole situation would be different... the risk ECX take would be different... ever since I was a little girl, I wanted to be part of some revolutionary moment...so ECX has a price fixation...at the upper and lower level and this assures both the traders and the suppliers are protected...it regulates over-speculation...so protecting the exporters and the small farmers...this is revolutionary...

from a recorded conversation with Meron, clearing house officer,
Ethiopian Commodity Exchange,
Addis Ababa, Ethiopia, September 2012

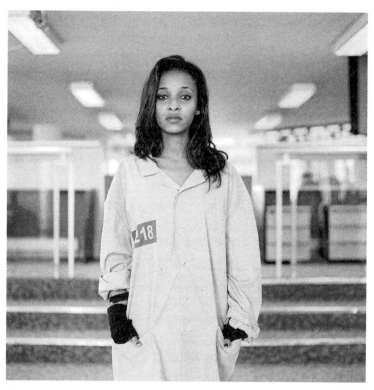

Bethelem, trader (negotiation, 1.5 years)
Ethiopian Commodity Exchange,
September 2012 Addis Ababa, Ethiopia

Untitled, trading pit (negotiation, 1.5 years)
Ethiopian Commodity Exchange (ECX), September 2012 Addis Ababa, Ethiopia

...we still need human traders here...
but this element will decrease in time...
but not eliminated...this trading floor
is still new to us...the traders still only
get used to this...but yes, in time we will
go to technology and in time we will
dismantle these trading floors...in time...

from fieldnotes of conversation with Dawid, information officer,
Ethiopian Commodity Exchange,
Addis Ababa, Ethiopia, September 2012

Algorithmic translations of Michael Noonan (Ireland), George Osborne (United Kingdom), Pierre Moscovici (France) and Jeroen Dijsselbloem (Netherlands & Eurozone Group president) have been included in exhibitions in those countries. Disrupting the popular graphic representation of such circumstance, the visualization of the soundscape represents contemporary financial capital functioning through the conduit of the financialized nation state.

The Economy of Appearances 2015
(Jeroen Dijsselbloem, minister of finance, Netherlands and
Eurozone Group president) (4:51, Single Channel Projection, 16:9,
HD Digital Video Animation, Looped, Floating Screen)
Data Visualization: Damien Byrne

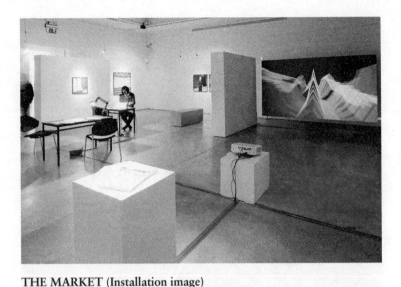

THE MARKET (Installation image)
Limerick City Gallery of Art (LCGA), Ireland, 2015
(Photographs, *Algorithmic Surrealism* (Film), Transcripts in folders, Tables,
Chairs, Clip desklamps, Artifacts/TV Reports (Deutsche Börse AG, Frankfurt/
Eschborn), *Systematic Risk* (A4 Colour Paper Readymades), *The Economy of
Appearances* (3D Data Visualisation of algorithmically-generated soundscape))

In the evolutionary aftermath of the global economic collapse and absence of sus-
tained audio-visual engagement with the central locus of this catastrophic event,
the ongoing multisited project THE MARKET critically addresses the functioning
and conditioning of global markets. It is the continuation of a cycle of long-
term research projects, beginning in the late 1990s, focusing on the predatory
context resulting from flows of global capital. After an extensive process of nego-
tiation, averaging one and a half to two years, to access strategic sites and/or
individuals, the author created ethnographically informed work that incorporates
photography, film, soundscape, artifacts, data visualization and verbal testimony.
The project takes the financial sphere out of abstraction and positions it as a
pervasive force that is central to our lives; its themes include the algorithmic
machinery of financial markets, central innovators of this technology, absorption
of crisis as normalization of deviance, and long-range mapping and consequences
of financial activity distanced from citizens and everyday life. Profiles include
traders, bankers and financial analysts, and documentation from London, Dublin,
Frankfurt, Amsterdam and Addis Ababa. THE MARKET critically addresses the
functioning and condition of the global markets *and the role of financial capital..*

4

Art, Systems, Finance

Victoria Ivanova

Preamble

Jack Burnham's essay-manifesto "Systems Esthetics," published in the September 1968 issue of *Artforum*, was both prophetic and ambiguous. Speculating on the evolution of art in an increasingly technologically mediated society, Burnham reflected on the implications of the rise of mass media and integration of computational technologies into all facets of life. The one-time art theorist, critic, curator and sculptor asserted that what was entailed by these larger developments was a "transition from an object-oriented to a systems-oriented culture." For Burnham, the prospect of this newly crystallizing ecology highlighted the "problems of organization" that were to emerge and proliferate given the speed and scale by which circulation-based systems have the capacity to order the world, in turn fundamentally recoding the function of discrete entities and localized experiences—not least, in the sphere of art: "Progressively the need to make ultrasensitive judgments as to the uses of technology and scientific information becomes 'art' in the most literal sense." What Burnham recognized through the prism of techno-social advancement is none other than the rise of the logics of abstraction and circulation, in which management of systems that organize flows set the direction for productive processes. As I will show, the shift that Burnham described so succinctly and prophetically

does not just concern the sphere of information technology and its effects on the social, but, just as critically, the transition from an industrial to a financial economy. Simultaneously, the ambiguity of Burnham's proposition lies in his projection for art: there is an underlying slippage between his notion of "systems esthetics" as a transformed aesthetic regime—as indicated by his seminal exhibition *Software* (1971), in which new technologies were deployed as artistic medium and became subjects of conceptual reflection—and "systems art" as a transformed operational regime that actively partakes in the changes that "emanate from the way things are done."

Viewed from the perspective of the historical evolution of art since modernism, Burnham's "systems esthetics" dovetail with the logic of conceptual art as culmination of craft-based deskilling, cognitive re-skilling,[1] destabilization of object-based criteria and as the beginning of a new ontological order based on the inherent instability of material relations. In other words, what some strands of conceptual art and systems aesthetics have in common is a desire to move away from art as a closed system composed of discrete entities to art as an open system that channels and shapes informational flows. For Jacob Lillemose, conceptual art is "an imaginative and speculative mediator between the political codedness and aesthetic potency of materiality" that has the capacity to "[generate] a meta-consciousness of how [systems work]."[2] Here again, Burnham's slippage is made evident in the disjuncture between an open systems art that has the capacity to represent a critical reflection of systems based on abstraction and circulation (as per Lillemose), and systems art as decision-making that impacts the management and governance of systems at large. What follows is an attempt to think through the problematic

1 The turn of phrase is owed to artist Alexandra Pirici.

2 Jacob Lillemose, "Conceptual Transformations of Art," Curating Immateriality: The Work of the Curator in the Age of Network Systems, ed. Joasia Krysia, New York: AUTONOMEDIA, 2006, 117–121.

of art as a meta-system that, on one hand, *re-presents* systems and, on the other hand, is *representative of* systems from the perspective of the shift to circulation in the economic realm.

Abstraction and Circulation in the Financial Turn

At its core, the critical shift that Burnham inferred from the increasing reliance on technological mediation in the ordering of the social manifests a newly crystallized relationship between the logics of abstraction and circulation; this likewise characterizes an equally fundamental transition from an economy driven by industrial output to one reliant on financial flows. Insofar as burgeoning technological infrastructure allowed for an unprecedented standardization of informational inputs, the discrete and localized production processes that animated industrialization are uprooted and folded into the sphere of continuous movement and dispersion within a financial(izing) regime. In other words, abstraction as a vehicle for extraction of value is no longer confined to workers' labor power, but instead becomes a generalized instrument for any integration into the circuitry of information and capital flows.

From the perspective of the economy as a dedicated realm where the social organizes its claims on resources, the significance of moving away from organization based on industrial output to one guided by the financial realm lies in the institution of new codes for circulation-based practice.[3] As Michel

3 The shift is historically pinned to the change in US-led economic policy from post–World War II demand-side economics, which boosted American domestic consumption by subsidizing key industries (in part through military action abroad) and thus lowered domestic unemployment, to the supply-side/monetary economics of the early 1970s, which favored the regulation of inflation by adjusting interest rates (which in turn affected borrowing and consumption). The turn to monetary policy came as a response to stagflation—an unprecedented coupling of

Feher traces in his series of lectures entitled *The Neoliberal Condition* (2013–2015), in corporate culture, this spurred a reorientation from profit maximization to raising capital value—that is, the shareholder value of stock.[4] To this extent, financialization explicitly places the power into the hands of the investor, who selects what *can* be produced by either opening or blocking access to the realm of circulation; it also implicitly empowers those who have the capacity and scaleability —here, echoing Burnham—to shape and normalize the criteria of accreditation for investment-worthy ventures, such as rating agencies (but also governments). In other words, while illiquid subjects/entities that don't hold capital are least capable of achieving influence due to their relatively marginal power as investors, Feher suggests that today's most urgent collective project is to produce agencies (in both meanings of the term) that can determine what credit-worthiness means, and to actively compete with existing players. Since the only leverage that illiquid investees hold is their status as

sluggish growth and inflation—that hit the US in the early 1970s. The collapse of the Bretton Woods system in 1971 (and with it the removal of the gold standard and introduction of free-floating exchange rates) was in effect a relatively successful attempt at salvaging/reforming American global domination (with the dollar functioning as the key global reserve currency). The bond market responded to the free-floating exchange rate by placing greater emphasis on the credit-worthiness of sovereign debt, with governments entering a playing field that was previously the domain of corporations. This meant that states' investment worthiness (and their ability to borrow) became a key priority for governments. The criterion of "credit-worthiness" started operating as the cornerstone of the financial economy and the political landscape more generally, unifying the previously distinct entities embodied by such categories as "the state," "the company" and "the subject." See Michel Feher, "Investee Activism: Another Speculation is Possible," in "The Age of Appreciation: Lectures on the Neoliberal Condition (2013–2015)", accessed November 15, 2017, gold.ac.uk.

4 Michel Feher, "Investee Activism: Another Speculation is Possible," in "The Age of Appreciation: Lectures on the Neoliberal Condition (2013–2015)," accessed November 15, 2017, gold.ac.uk.

stakeholders, meaning that they are somehow implicated or affected by the activities of the firm without holding its shares, Feher suggests that this is the leverage they should exploit. After all, for corporations, stakeholders are assets, despite and due to the fact that they are a liability/cost.[5] Feher argues that stakeholders should/must enter the "mental gambling space of investors" at this precise juncture, where they (stakeholders) are both a risky asset and a condition for maintaining and hopefully increasing the stock's capital value. By emphasizing the contradictions of this position, what Feher is asking of the new activist stakeholders is to steer the speculation on themselves as an asset, and thus become a force that can "alter the conditions of how investors valuate stock."

Contemporary Art as a Quasi-Financial Regime

There is an important parallel between the restructuring of the economic realm through financialization and the restructuring of art's ontology through conceptualism that brings us back to the problematic of art as systems aesthetics versus art as systemically representative.[6] From the position of the latter, the transition reveals a coextensive reorganization in the logics of the product (as economic output) and the object (as an art output) that pivots on new mechanics of valorization.

5 In other words, while within the welfare model, the state takes care of the interests of stakeholders (citizens) and mediates their relationship with business, under the financialized neoliberal model, the state retreats from this function (in part in order to make itself more attractive to investors), and companies take over a large part of this function through corporate social responsibility (CSR). While CSR contributes to the capital value of a company, it is also a cost.

6 As will be made clear in this subsection, the view that the organizational dynamics of the art system are *representative* of other societal domains opens up an under-explored realm for strategizing operational modalities within the art system with a view for setting larger societal precedents.

As Feher shows, with financialization, valorization becomes a crucial mechanism for validating the value of all productive processes, by using capital value ratings and investor confidence as gatekeeping valves to access the realm of financial circulation. With the rise of conceptual art—which was notoriously preempted and schematically encapsulated by Marcel Duchamp's *Fountain* in 1917, and may therefore be taken as a generic reference to art that no longer relies on material foundations to determine its "artness"—there is a similar deferral of valuing something as art to the institutional gatekeepers of the art sphere: art critics, curators, museums and collectors. While art critics and curators may be approached as rating agencies, collectors (and more generally, sponsors)—both public and private—are clearly investors.[7] From this perspective, the issue surrounding the increasing privatization of previously publicly funded contemporary art exhibition spaces and museum collections may be reformulated as an issue of transferring the right to select (investment-)worthy capital. Meanwhile, the criteria according to which capital value is determined and assigned is a back-and-forth between the norms—explicit and implicit—that are produced by art critics (today, theorists), curators and art institutions through

7 In contrast to institutionalized rating agencies of the financial sphere, contemporary art's rating agencies are distributed across myriad actors such as important curators, dealers, institutions, publications, collectors (with the latter also being investors) and artists, of course (some of them being weightier than others). They are the ones defining and maintaining criteria for accreditation that deem anything made inside the microcosm of contemporary art worthy of investment (financial, but also cultural and political). On the surface, the distributed nature of contemporary art's rating agencies may appear to be a positive phenomenon that would guarantee diversity and constant back-and-forth on the criteria of accreditation. In fact, lack of financial diversification (in terms of funding sources and models) is leading the field in the opposite direction. The safest (lowest-risk) route for survival under such conditions is to amplify the activity of weightier actors, which, as mentioned, is a positive feedback loop that can only mean more conservatism.

discourse and operational protocols, and sponsors who finan-
cially underwrite the art sphere. Yves Klein's *Zone de Sensibilité Picturale Immatérielle*
(1959–62) neatly captures this dynamic. In this work, the artist
issues certificates of ownership for air, which he sells to inter-
ested collectors for gold. Yves Klein then invites the purchasing
collector, art critics and curators to witness a performance in
which part of the gold is dispersed into the air at the river Seine
in Paris. Here, Yves Klein is not so much interested in the size
of profits drawn from the sale of successful artwork (or in the
value of gold as a precious metal) but in the work's capital value
that is raised through the eccentric ritual. Thus, the gold that is
dispersed across the Seine cedes being interesting solely as a con-
crete amount of profit, while the act of dispersal raises Klein's
investment-worthiness in the eyes of witnessing stakeholders
and shareholders. In the words of a venture capitalist featured
in the HBO series *Silicon Valley*, a reference that Feher points to
in a similar attempt to capture the spirit of financialization: "It is
not how much you earn, but how much you are worth."

 Klein's artwork could easily come under the rubric of
systems aesthetics—a performative renegotiation of material-
ity that presents the "meta-consciousness" of financial systems
and in the same gesture, critically responds to materiality's
"political codedness." The very fact that the financial system
is a construct that requires the confidence and consequent val-
orization of its participants through ritual is made glaringly
evident by Klein's mise-en-scène, and thus functions as a criti-
cal representation of the financial regime. Yet, just as *Zone de
Sensibilité Picturale Immatérielle represents* the latter, it simul-
taneously *embodies* the art system—mapping one system onto
the other, performing the confluences in their operative logics.

 What Klein mobilizes through his work may then be said
to not just *represent* financial systems but to be *representative
of* a financial system. The reason this distinction matters turns
on the question of how contemporary art's relationship to the

financial regime is framed and how it can in turn be mobilized. If viewed through the prism of critical representation, financialization is something that *happens to* contemporary art through such processes as increasing commodification of artworks and art practices, increasing use of art as financial vehicle (e.g., collateral on loans, speculative instruments) and increasing "usurpation" of art's institutional field by players from the financial sphere. On the other hand, if contemporary art is approached as *systemically representative* of finance, then it is necessary to concede—and, I would argue, to affirm—that since conceptualism, art has functioned as a quasi-financial regime.

There are two major consequences that follow from adopting the latter stance. First, if the regime of contemporary art— understood as transnational postconceptual art and the direct "inheritor" of the conceptual overhaul of modern art—[8]is a quasi-financial regime given the consonances between its circulation-based codes and those of the financial sphere, systems art is both confined by the inbuilt limitations of those codes and, following Burnham's "systems art," may also be a vehicle for modulating their logics. Using Feher's framework as a schematic sketch of possible strategies for such modulation, this could mean deploying systems art to produce agencies that modify "criteria for accreditation"—that is, the underlying values that construct capital value. Vis-à-vis the future of art, this could mean reshaping the expectations that are placed on art and hence the values that the regime of art represents explicitly or implicitly. It would mean working not just at the level of aesthetic or discursive reform (that is, art representing systems) but also at the layer of valorization mechanisms that are largely considered part of the infrastructural back end of the art system: market relations, institutional and legal protocols (art as representative of systemic reform).

8 Peter Osborne, *Anywhere or Not at All: The Philosophy of Contemporary Art*, London: Verso, 2013.

Markets Are Social

The second consequence of the proposition that the sphere of contemporary art is a quasi-financial regime concerns the ongoing struggle to anchor the "financial market" in its sociality and to subjugate its operations to a progressive social agenda. The fact that the (repressed) sociality of financial markets is today increasingly automated gives this project an additional urgency. Since the 1970s, the economic discipline has been very successful at creating conceptual/mental barbed wire around the realm of finance, positing itself and its developing quantitative and computational framing as the rightful guardian/interpreter of the financial order. While the neoclassical dogma[9] that ran through economic theory between World War II and the financial crash of 1987 actively isolated the financial realm from the rest of the social, the evolution of the financial field on the one hand defied and deviated from its commonplace assumptions and, on the other hand, deployed these assumptions to give financial markets a sense of autonomous totality that distanced them from responsibility over their social impact.

Analyzing the mechanics of the latter, Edward LiPuma claims that the object totality known as the financial market is an economic construct and a site of work constituted through

9 Most closely associated with such thinkers as Milton Friedman and Friedrich August von Hayek, the key postulates of neoclassical economics are based on a series of idealized conditions: all economic actors are rational and hence use information to minimize costs and maximize returns; markets always strive for equilibrium between supply and demand, adjusting prices up or down; markets reflect all available information through prices and hence there can be no informational asymmetries. While these postulates have been crucial in serving as basic principles for econometric modeling (which has in turn directed economic policymaking worldwide), they have been widely criticized for inaccuracy and incoherence. See Frederic S. Lee and Steve Keen, "The Incoherent Emperor: A Heterodox Critique of Neoclassical Microeconomic Theory," *Review of Social Economy* 62, no. 2 (2007): 169–199.

a "ritualized imaginary" performed by its agents.[10] In other words, "it is the continually iterated rituality inscribed in the everyday practices of the markets' agents that breathes life into [the] fiction" of the totality called "the market." Given the circulatory logos of finance, LiPuma argues that "constitutive performativity" is simultaneously that which secures the presumed totality of the market against disintegration through suppression of its sociality and also a site for intervention and modulation (once again, because of its inherent sociality).

Insofar as "the market" is framed to be exogenous to contemporary art's socio-institutional ecology proper, reverberations of neoclassical dogma are also felt in this realm—even if, on the surface, the issue seems to be inverse to the one described by LiPuma vis-à-vis financial markets. Whereas in the financial sphere, the social is disavowed just as its movements provide the necessary inputs for market activity, under the neoclassical view of "the market" in contemporary art, the economic nature of transactions must be repressed in order for the sociality of contemporary art as an object to be performed and reproduced.[11] Under this lens, the problem of financialization is formulated as an *encroachment* of the previously external space of financial logics identified with "the market" onto the *social* space of contemporary art, which threatens contemporary art's "ritualized imaginary" and hence its integrity. Yet, per LiPuma and others who argue that, contrary to the

10 Edward LiPuma, "Ritual in Financial Life," in Derivatives and the Wealth of Societies, eds., Benjamin Lee and Randy Martin (Chicago: University of Chicago Press, 2016), 37–82.

11 This is reflected in the typical descriptions of actors engaged in art-related transactions as the antiheroes of rational market actors, because they are driven by "emotion" and "passion" for art; the art market as one characterized by stark informational asymmetries; inability to analyze the art market from the perspective of movement toward equilibrium due to lack of commodity standardization and price opacity. These assumptions are just as flawed as the ones used in relationship to "normal" markets and, at closer inspection, it becomes evident that the art market reveals a lot of dynamics that are suppressed in other markets and vice versa.

neoclassical view, the market is *already* social—albeit, its sociality may be organized and managed differently, as per Feher's description of the transition from production-led to finance-led logics—then it begs the question: what kind of market transition, and hence reconstitution of the social processes of valorization, is the contemporary art sphere undergoing through what is dubbed as financialization?

Taking the view that since Burnham's time contemporary art has functioned as a quasi-financial regime, given its reliance on circulation-based valorization, capital value and investor confidence, then what is at stake is a competition among actors for setting the agenda vis-à-vis criteria of accreditation. The transition from a state-mediated to an investor-mediated model of market governance took place in the art sphere through public funding cuts and increasing reliance on private money, making art institutions, curators and to some extent critics/theorists—that is, the "rating agencies" traditionally responsible for criteria of accreditation—reliant on proving their credit-worthiness to investors. In many ways, these entities have failed to recognize the inbuilt leverage of contemporary art as a quasi-financial regime capable of developing the parameters on which capital value is to be constructed and the manner in which returns on investment lubricated by institutional capitalization are to be distributed—hence, tying finance back to the social. Instead, the institutionally progressive strategy has been to boost the capital value of art that is redemptive in its sociality but cut off from achieving systemic efficacy as far as its effects on market logics, thereby making contemporary art a low-risk asset for pro-status quo investors seeking to diversify their portfolios. As a result, the so-called encroachment of financial actors onto the sphere of contemporary art is nothing other than the desire of competing rating agencies (such as the ones from the financial field proper) to take over the functions of their weakened and badly leveraged contemporary art counterparts.

The issue today is whether we can still develop an alternative set—and, crucially, an alternative-minded set—of rating agencies capable of reigniting the potential of art as a systemic project that steers the development of parameters for societal organization—or in Burnham's words, art that actively partakes in the changes that "emanate from the way things are done." It seems that such a project is only possible if the relevant stakeholders[12] recognize their de facto market positions and the leverage they hold in steering investors' speculation. Likewise, it seems that contemporary art's ritualized invocation of the social as a precondition for its sense of integrity is precisely that "mental gambling space" in which a project that aims to cohere the critical insights of art with market logics is both an asset and a liability. Ultimately, it might be in playing one off the other—working with the ambiguity between systems aesthetics and systems art—that could offer the key to using art's representativeness as a vehicle for setting decision-making parameters in a manner that aligns with Burnham's vision.

12 "Relevant stakeholders" is a collective reference to those actors who are affected by the art field's current structure and understand that the field needs to reform itself, if not for ideological reasons, then for its sustainability. Despite the fact that the most widely referenced stakeholder group within the art field is "the public" or "the audience," we should remember that this stakeholder paradigm is inherited from industrial modernism and the role of the public museum in shaping modern subjects (see Tony Bennett, *The Birth of the Museum: History, Theory, Politics*, Abingdon: Routledge, 1995). At the same time, if we take the argument of this essay seriously, and hence understand financialization as a sociocultural transformation and not just an economic one, then we could also say that with it, museums (or let's just call them spaces for art) have transformed into vehicles of socioeconomic valorization for financial elites. To this extent, the institutional valorization function is not limited to the art world but extends into politics and geopolitics proper. Therefore, for the sake of pragmatic efficacy, it is possible to delimit the stakeholder subgroup with infrastructural capacity to produce alternative rating agencies to producers within the art field (artists, curators, writers, etc). The fact that this subgroup intersects with existing rating agencies is both a challenge (in countering established criteria of accreditation) but also an advantage.

5

Speculation in a Sense: Aesthetics and Real Abstraction

Marina Vischmidt

In an era dominated by technologies of automation and virtualization, this essay will examine the financial logic of abstract risk as a key dynamic in the valorization of capital. Further, it will consider how abstract risk also emerges in art as one node of valorization on this digitalized plane. Both instances subsume labor to value, and result in confusion between being a commodity and having a commodity. The question then could be: what antagonisms recur in such a valorization schema—which Marx discussed in the ironic terms of the "automatic subject" of value—and how may they be extended?

The overall theme of my ongoing research into the relationship between finance and subjectivity in contemporary art is encapsulated in the title "speculation as a mode of production." This title was chosen for its capacity to bring together the characteristic valorization processes of art and financialized capital as two social forms that show their internal logical relations in how they pattern our relationship to time. Financial speculation is an intensification of capital's intrinsic tendency for future-oriented growth. Financialized capital operates to capture in the present value that has not yet been produced, by means of instruments such as debt, options and derivatives. The management of risk—through algorithmic formulas such as Black-Scholes and other standardized and specialized mathematical applications, as well as the now-predominant

automation of trades—underlies a speculative mode of val-
orization. And it is abstract risk we are talking about here,
since it is risk that can be abstracted from different scenarios
—currency and market movements, commodity shortfalls,
political events, weather phenomena—that may present to an
investor and be quantified into tradable instruments. Thus, in
finance, risk acts as a stabilizing factor, insofar as it becomes a
commodity that can be acquired or disposed of using devices
such as hedges—a profitable or perilous exposure, depending
on where the counterparty is sitting. In an era of financial-
ization, abstract risk plays as important a role as abstract
labor in the production and distribution of value for capital,
although the mediations that position these at different points
in the value chain need to be kept in mind, lest a historically
determined entanglement be taken for a progressive substitu-
tion. But these two forms of abstraction should be thought
of together since in both cases money is the instrument that
makes particular and unlike things equivalent and hence
exchangeable. The instrument here also needs to be seen as
a social mediation, one which is key to both implementing
and justifying the social relations between commodities that
encompass more and more of our everyday.

Art can be said to feature "speculative practices" in three
principal ways, which combine to forge a speculative ontology
for art, rather than just to descriptively signal its proximity to
speculative commodity markets. The first involves the manner
in which art speculates on its territorial or institutional claims
to expand or displace its space of possibility. The second is the
way in which we can see artistic practice as akin to specula-
tive thought—in the sense Theodor W. Adorno imparts to his
"negative" revision of Hegelian speculation—in that art is
not identical with its objects. Art materializes the experience
of non-identity in how it performs a volatile break between
material and structure, subjectivation and reification. The
third involves the speculative subjectivity that artistic practices

perform, assume and model as part of the social effectiveness of the institution of art, as it is reproduced by self-identified artists. More concretely, the artist, like the financial instrument, can gather all kinds of data and material to reproduce as art, just as derivatives gather all kinds of empirical phenomena and reproduce them as profit.

While speculative thought is a constant feature of art, particularly in critical practices that relate to the conditions of their own material production, "financial speculation" can be more broadly defined as the self-expanding, or self-valorizing, dynamic of capital as such; this is highlighted in the value-form analysis of capital as a general social relation, rather than the subset of it named "the financial industry," although this more specific focus is not excluded, as we have seen. My primary focus here will be how such speculation both aligns itself with the "open-ended speculation" of thinking and art, but ultimately seals the available horizons on other levels of the totality.

If art harmonizes with finance on the level of subjectivity and a value structure geared toward a future that can only be verified speculatively (or retroactively, as with the avant-garde), would it be possible to say that art as structurally mediating the future—or, more precisely, the elsewhere in space and in time —must itself change in the present when financial operations increasingly make this futurity radically inaccessible, socially and ecologically? It is problematic to distinguish the social from the ecological, admittedly; not due to the simplifications of the Anthropocene hypothesis but, rather, because the material conditions for human life cannot be detached from the conditions for planetary life in general, as well as the indifference of capital accumulation to the life of its resource bases. Finally, as noted, the technologies of abstract risk even out the distinction between the social and the natural too, a distinction that until very recently would have seemed to carry some rule-of-thumb political logic. Can art do anything more

than perform a mimesis of this speculative voracity, or can it respond with a politics of alterity that is capable of putting itself into question as one, but not the terminal, of its own future orientations?

In a number of ways, the institution of art—that is, a global miasma of idioms, practices, pedagogies and diffusion lines—can seem to have this much in common with the Western neoliberal horizon within which it is nested: the conditions that allow it to survive and maintain its legitimacy are both profoundly transformed by crisis and austerity, and in large part continuous with pre-crisis conditions. Such a "disjunctive synthesis" can be observed at a general level that accounts for art's unchanged or even enhanced status as a safe harbor in a risky investment climate, its forced and unforced proximity to private wealth, and the ongoing positioning of art as an engine of conceptual accumulation and speculation on a sociality rendered significantly more fragile and polarized by years of austerity. It is this latter condition, perhaps, that opens a generative chink in the consensual stability of the institution of art as it is reproduced in crisis conditions, and in showing the imprint of those conditions as a pervasive affect of conservative, querulous futurism. Something has in fact changed for art in this landscape, and this has to do with an erosion of the mediations that once constituted both its own semantic conditions and made up the substance of its interface with publics and support structures.

Here I am thinking of the previous decade's discussions of the "instrumentalization" of art, which saw "socially engaged practice" funded by erstwhile social democratic states and municipalities, frequently function as boosts to place marketing and regional competitiveness agendas. As culture and regeneration budgets were slashed in places where such mobilizations of the arts were particularly in vogue, such as Britain, philanthropy is enjoined to pick up the slack while government money is funneled into digital economy hubs. The

social engineering approach to "place-making" is replaced by unapologetic speculative development and unfiltered social cleansing policies in inner cities, justified (if at all) by the "bad investment climate" and the flight to property as a safe haven. Property, like artwork, is acquired mainly for warehousing purposes, as a hedge. Here the mediation of art by the state to fulfill specific policy objectives has fallen away, as has art itself as a mediation of such objectives to the populace. Both reflect a shift to a new kind of brutality in the deployment of market mechanisms that no longer seek justification or create diversion elsewhere in the social. Urban redevelopment no longer needs to mediate itself as improvement for all, while art reverts to luxury good—however, often enough still with social democratic pretensions—financed by private wealth, which is better able to support the "autonomy" of art than a bureaucratic market-disciplined state.

Another example would be the overt conflation of critique with valorization as an adaptation to a hostile and competitive terrain for artists, curators, critics and academics alike. Mediations such as even a temporary alienation from a field of hegemonic professional productivity—with the fiction of self-organization recently standing in for career-building outside the marketplace—no longer have a place in a field of "emergence" that has been irreversibly transfigured by massive debt and slender employment options. Art students nowadays often deem positions arguing for antagonism to be conservative and privileged, as full immanence to the dominant situation yields, though somewhat paradoxically, the only acceptable space where critique can be formulated—so long as this critique is careful to register its own adorable futility. In this sense, it is professional infrastructures that have lost their former character of unwanted mediation and have simply blended in with the natural background formed by capital to any endeavor and any thought—a natural landscape constantly reinforced by the solid sea of social media.

Given all this, how do we think of the attenuation of mediation between art and capital as chiefly a more direct encounter with capital's valorization imperatives for art, similarly to how the loss of these mediations has registered elsewhere in the social landscape? As with so much else that appears to be new and unprecedented in the post-crisis condition, we are dealing less with a lack of mediation than with the expansion of brutalization, which comes with its own set of mediations— mediations that we are just beginning to recognize insofar as they are relatively unfamiliar to us after the nominal welfare states of the past half-century. Cultural entities that have come into prominence in the "post-internet" milieu over the past half-decade, including collectives such as as K-Hole or DIS or individual artists such as Daniel Keller or Simon Denny both internalize and reflect back the increased "subsumption" of art to capital's valorizing imperatives for forecasting, while performing this entrepreneurial ontology in the way these projects and practices operate and the kinds of rhetoric they employ. In *Absolute Vitality* (2012–ongoing), Daniel Keller uses the post-Internet vogue for sculptural works to foreground and combine an aberrant and synthetic materiality with the respectable conceptual stratagem of allegorizing art objects as exotic financial instruments. Marketing is the logical grammar that unites these entities, all of which operate in art as trend-forecasting agencies, capturing future value in the present.

But does speculation as a mode of production in art necessarily play out so crudely or so tautologically? We might propose then that one of the core issues for an analysis using the optic of speculation is how to make both distinctions and connections. As an example, Steven Shaviro's proposal that we keep in view an "open" and a "closed" form of speculative practice, with the former attendant on the activities of speculative philosophers and the latter on the activities of finance professionals, is an intriguing distinction insofar as it points to

the closed horizon of valorization that no amount of capitalist mythography can transfigure. In other words, it is a horizon perhaps better reflected in Marx's ironic term "automatic subject" than in financial analyst and theorist Elie Ayache's breathless attempt to place quants and speculative realists on the same side of historical creativity.[1] However, we might further propose that when it comes to the speculative gesturality of art more generally and the until recently market-making "post-Internet" practices more narrowly, one further step must be taken: to show how art's "open" speculation is materially and socially conditioned by "closed" speculation. One way to do this is to trace allegories with real effects between the speculative subjectivities of artists, especially ones who see only a flat continuity between capital, their selves, their friends and their work, saturating this machinic continuity with affect, and the self-valorization imperative for capital. This would be one way of narrating the end of the previously mentioned mediations—a subjective investment in capital's valorization imperatives as post-critical survival, captured well in the eloquent title of Lizzie Homersham's recent article in *Art Monthly*, "Artists Must Eat."[2] Here we encounter —as participant observers—the relatively new and distinct mix of pragmatism and sentimentality that characterizes the inescapably reified subjectivities that see no relationship between political practice and professional advancement, and, in the post-Internet's proximity to positivist solution-oriented discourses such as "stacktivism," actively performs a technocratic utopianism which makes the codified interrogations of an earlier generation's institutional critique, including Net Art, seem positively insurrectionary by comparison. The

1 Steven Shaviro, "Speculative Realism—A Primer," *Texte zur Kunst* 93 (2014), 40–51. For Ayache, see *The Blank Swan: The End of Probability*, Chichester: Wiley & Sons, 2010.
2 Lizzie Homersham, "Artists Must Eat," *Art Monthly* 384 (2015), 7–10.

sentimentality requires more comment, however. Social media-propagated trends in sociality and group formation intersect with the premium placed on taste as the operative interface of artistic subjectivity, and as the aggregated capital that supports gestures of authorship in a milieu of relationality. This implies the recasting of algorithm as expression—often even as feminist or anti-capitalist critique, as in the work of Amalia Ulman or Jesse Darling and a number of their contemporaries. Or we can turn to practices such as that of artist, curator and solutionist Ben Vickers, specifically *unMonastery*. This is an NGO think tank located in an impoverished Italian hill town (recently branching out to Athens) that collects funding from the likes of USAID and collaborates with engineers latterly in the employ of UK intelligence services with the agenda of generating technocratic fixes for enjoying perma-austerity as a return of authenticity and community. This is social practice with a vengeance, or perhaps, more justly, an institutionalization of "risk management" that platforms out of art and into a world dismally filtered through the entrepreneurial subjectivities that now coexist with an increasingly dystopian milieu of forward-planning do-gooders. The *unMonastery* evokes Adorno's "paradigm of good health": "which smashes the forces of the psyche before a conflict can even occur, and the later state of unconflictedness reflects the predetermined social being, the a priori triumph of the collective instance."[3]

Now the lineaments of the cybernetic base shared by art and crisis capitalism start to acquire greater definition. Art that reflects on its digitally mediated and networked condition shares the recursive quality of digitally mediated contemporary finance. Creativity and control are generated by the same mechanisms to one exclusive end: the valorization of a so-called automatic subject, be that the highly differentiated and

3 Theodor W. Adorno, "The health unto death" in *Minima Moralia: Reflections from Damaged Life*, trans. E.F.N. Jephcott, London and New York: Verso, 1978, 36.

affective brand of the artist—always at risk of being replaced by a social media algorithm and apotrapaically emulating one— or the expansion of invested capital sums. The risk of being replaced by an algorithm in art, I would venture, is interesting given that automation has been reliably used by capital throughout its history to devalorize labor. As artificial intelligence advances the development of the social graph and accumulation of big data, we might not be looking immediately at the singularity but certainly at highly specialized luxury subjectivities in different fields, including art, joining in the market shrinkage that other labor markets are undergoing —irrespective of whether or not art is structured like a labor market, which of course it isn't. Yet artists and artworks come with certain maintenance costs—costs that soon enough no one but the most erratic of wealthy collectors will be willing to sustain.

A note might be apposite here: the reason I talk about cybernetics rather than a digital condition or digitalization is that cybernetics outlines a principle of governance, of management and control, and thus of power and production, whereas one can say that digitalization signals a homogeneity of technological platform but without a specific form or determinate content, though perhaps with tendencies in the social field that take on a certain pattern. In essence, I would see digitalization as a cybernetic mediation of reflexive, object-oriented command and control, which, with reference to Alfred Sohn-Rethel, I would locate at the level of the present "social synthesis." Cybernetics gives us a variant of exploitation that involves soliciting and modulating abstract risk, rather than suppressing it, and it tends toward the automation of these functions at macro and at micro levels.

So, artists, like finance professionals, struggle with the repercussions of the technology they swim in: social currency must be constantly traded and upgraded (e.g., Ben Vickers building up then disavowing certain brands of socially validated,

networked post-Internet art phenomena, then using the art
institution as a platform for other, more dubious internation-
ally connected "stacktivist" ends such as *unMonastery*), just
as automated trading takes over more of the market, render-
ing finance workers increasingly irrelevant except to write
the formulas, which will surely be automated as soon as eco-
nomically feasible. From another angle, art can also hew too
closely to present-day forms of commodification and fungi-
bility embodied by finance in material and theme. We can see
this in the work of Goldin & Senneby or Daniel Keller, or
even the accelerationist art experiment *Real Flow*.[4] This close-
ness both risks and hedges the risk of being simply a one- or
even nondimensional iteration of the formal properties of the
financial matrix in which commodities like art can be de- and
re-materialized. It is "demonstration" art of this type that
starts to develop a well-rehearsed niche in the market, both
for objects and critique, at which point its riskiness, either
as an asset or as a proposition to or against the institution,
starts to precipitously drop. I dwell on institutions here since
the producers of *Real Flow* believe that Contemporary Art
is a genre irredeemably saturated by "neoliberalism," which
they deem necessary to exit and construct new institutions.
Real Flow, however, would likely be orthogonal to such
institutions, insofar as its producers designate themselves as
"institutions of negation," and the project at hand is tastefully
representational at best.

4 *Real Flow* is glossed on its website as "offering tailor-made financial
solutions for contemporary art by crossing the now wholly permeable
and artificially maintained barriers between art's markets, markets in
general, and art's flexible and porous semantics. Re-engineering the art-
work's commodity form, this venture tactically integrates art into its
diverse channels of exhibition, circulation, and marketization. Finan-
cialization's futurity is operationalized by *Real Flow* to reconstitute art's
future present and open up new vistas through and beyond capital." The
project consists principally of paintings on canvas that are constructed
according to algorithms drawn from the visually exciting vicissitudes of
financial markets." See diannbauer.net/real-flow.

But here I'd like to return to affect and taste, as these are the main vehicles whereby artistic subjectivity is reproduced in the cybernetic plenum of digitally mediated or, to import a term that signals the avowed redundancy of the digital, "new materialist" art. Taste becomes directly "productive" in the non-eventful horizon of an art world substantially recontoured both by social network technologies and digitally empowered and increasingly autonomous trading systems, which can be seen as another angle of the speculative theoretical object: "speculation as a mode of production." The future is subsumed to the profit imperatives of the present, hammering the last of many nails to Bourdieu's analytic framework on the multiplicity of capitals (symbolic, social and so forth), which emerged from an era of a "mixed economy" of legitimation processes—or mediations, as I have referred to them. To do a bit of forecasting here, you may find more of the same: instead of the multiplicity, we transition to a situation where Adorno's mimesis of the hardened and alienated as a modernization tactic for art is not anymore a mimesis—art is simply the refined expression of human capital valorizing itself with more "risk" than the reliably degraded and devalorizing job market—a fairytale of risk all too familiar from the idiom of job creators and *arbeitsnehmer* that has accompanied capitalism from its earliest narrations of naturalized exploitation.

Another way to think of the relationship between art and speculative finance is to discuss the stability introduced into capital's risk-management strategies by the derivative on one side, and the grip of repression and ideology (as we have latterly witnessed with the UK election and constantly are exposed to with Greece) on populations targeted for impoverishment on the other. This involves examining how the institutional and market bottom line of the category of art itself and its bearer, the artistic subject, serves to buffer abstract risk for artistic practices, rendering all equivalent and exchangeable as art—the activity of selection, the demonstration of taste, the

affirmation of the subject-object of speculation. The stability of this institution cannot be seen in isolation from the consolidation of class relations that arise from deepening austerity, political polarization and the possibly temporary but very objective setbacks for social movements contesting them. Art's capacity to be reflexive about these conditions may be necessary, and sufficiently rare. Its capacity, however, remains far from sufficient, either when it comes to grasping this historical moment as a disjunctive unity or to articulating immanent negations out of its own, really abstract resources.

The Distribution of the Insensible

Nathan Brown

Nicolas Baier, Vanitas, *2012, installation shot*

Tools, machines, factory buildings and containers are only of use in the labor process as long as they keep their original shape, and are ready each morning to enter into it in the same form. And just as during their lifetime, that is to say during the labor process, they retain their shape independently of the product, so too after their death. The mortal remains of machines, tools, workshops etc., always continue to lead an existence distinct from that of the product they helped to turn out.

Karl Marx, *Capital, Volume I*

Jacques Rancière theorizes the relation between politics and aesthetics in terms of "the distribution of the sensible."[1] In what follows, I want to consider *the distribution of the insensible,* and I want to argue that it is the specificity of this problem that allows us to think of the relation between the history of capital and the history of mimesis. Crucially, I want to show how the relation between those two histories is mediated by another: the history of technology. The relation between the history of capital and the history of mimesis is mediated by the history of technics. And it is through this history, this mediation, that art takes up techniques that throw us back outside the history of capital, outside the history of mimesis—indeed, outside the history of the human, of thought and of sensation. Art comes to do so within and through the technical means to which the linked histories of capital, mimesis, and technics give rise.

These are my positive claims—my theses, if you will—that I eventually want to develop and illustrate through the recent work of a contemporary Montréal artist, Nicolas Baier.

But I also want to register an implicit critical dimension of this argument, a critique of Rancière and of his presently immense influence, which I view as unwarranted. I could summarize this critique as follows: if Rancière were more inclined

1 Jacques Rancière's clearest exposition of what he calls "the distribution of the insensible" (*le partage du sensible*) can be found in *The Politics of Aesthetics,* trans. Gabriel Rockhill, London: Continuum, 2004, 12–45. On page 12, Rancière writes: "I call the distribution of the sensible the system of self-evident facts of sense perception that simultaneously discloses the existence of something in common and the delimitations that define the respective parts and positions within it. A distribution of the sensible therefore establishes at one and the same time something common that is shared and exclusive parts. This apportionment of parts and positions is based on a distribution of spaces, times, and forms of activity that determines the very manner in which something in common lends itself to participation and in what way various individuals have a part in this distribution...The distribution of the sensible reveals who can have a share in what is common to the community based on what they do and on the times and space in which this activity is performed."

to focus his attention upon the distribution of the *insensible*, he might think more perspicuously not only about the relation between politics and aesthetics, but also about the relation between political economy and aesthetics. That is, focusing on the specific problem of the distribution of the insensible is the key to thinking about the relation between aesthetics and politics in a materialist way, in a manner properly responsive to the exigencies of Marxist historical materialism.

First Approach

By way of a first approach to what I mean by "the distribution of the insensible," let's recall some basic passages from *Volume I* of *Capital*, on the transformation of materials. Marx analyzes the process of production from two perspectives: the labor process and the valorization process. He tells us that

> Labor is first of all a process between man and nature, a process by which man, through his own actions, mediates, regulates and controls the metabolism between himself and nature. He confronts the materials of nature as a force of nature. He sets in motion the natural forces which belong to his own body, his arms, legs, head and hands, in order to appropriate the materials of nature in a form adapted to his own needs. Through this movement, he acts upon external nature and changes it, and in this way he simultaneously changes his own nature.[2]

Humans transform materials and, by doing so, transform themselves. Moreover, we transform materials into *tools*, instruments of labor, *with which* we transform materials. This is part of what changes the nature of the human: "nature becomes one of the organs of his activity, which he annexes to his own bodily organs." The earth supplies us with "stones for throwing, grinding, pressing, cutting," so that "the earth

2 Karl Marx, *Capital*, *Volume I*, trans. Ben Fowkes, New York: Penguin, 1990, 283.

itself is an instrument of labor." As soon as the labor process has undergone the slightest development, Marx tells us, "it requires specially prepared instruments." Thus, he writes, "we find stone implements and weapons in the oldest caves."[3]

Nicolas Baier, Vanitas, *2012, installation shot*

What distinguishes capitalism as a mode of production, however, is the peculiar manner in which the transformation of materials through the labor process is shadowed by the process of valorization. The transformation of materials produces objects with use value, but it also produces commodities with exchange value. Objects of utility are the bearers of value; but value is also independent of them. It is independent because the exchange value of a commodity is entirely determined by the average socially necessary labor time required to produce it, not by the materials of which it is composed. *Labor time* is that abstract, universal equivalent that will find its answer in the universal abstraction of the money form, and value is not a material thing but a *social relation*. Thus, Marx will tell us that "not an atom of matter enters into the

3 Marx, *Capital, Volume I,* 285.

objectivity of commodities as values; in this, it is the direct opposite of the coarsely sensuous objectivity of commodities as physical objects."[4]

We can thus view the process of production either from the *perspective* of the labor process or the valorization process. But insofar as it is specifically *capitalist*, the process of production produces value, and a particular kind of value: surplus value and its reintegration into the production process as capital. To grasp the significance here, Marx pushes it to its limit. As he tells us in Chapter 8 of *Volume I*, "the means of production on one hand, labor-power on the other, are merely the different forms of existence which the value of the original capital assumed when it lost its monetary form and was transformed into the various factors of the production process."[5] Both the means of production and the labor-power of bodies are *different elements* of capital in its own valorization process. This is what we mean when we speak of the "subsumption" of labor by capital. The concrete process of transforming materials through labor, aided by tools, is subsumed by the abstract process of valorization.

So, this brief summary of Marxist fundamentals is our first approach to the distribution of the insensible. The critique of political economy is bound up with the Marxist analytic of value and valorization: the production, self-presupposition and expanded reproduction of capital that is called "accumulation." With regard to the critical dimension of my argument, then, we can say first that the vulgar empiricism of Rancière's approach to the figure of "the worker" proceeds exclusively from the perspective of the labor process, ignoring the valorization process. This is why Rancière is not a Marxist. He does not think the distribution of the insensible, the movement of valorization, and thus he misses entirely the dimension of political economy in his thinking of politics. Consequently,

4 Marx, *Capital, Volume I*, 138.
5 Marx, *Capital, Volume I*, 317.

he has no rigorous means to account for the relation of his history of art and artistic regimes to the history of capital—to structural changes in the contradiction between capital and labor. In my opinion, this is a problem substantial enough to render his history of aesthetics more or less irrelevant.

Second Approach

In *Intellectual and Manual Labour*, Alfred Sohn-Rethel argues that the social abstraction of the value-form and exchange relation gives rise to the abstract forms of thought that characterize modernity. This argument constitutes a materialist critique of Kantian idealist epistemology. For example, according to Sohn-Rethel, the purely formal character of the Kantian forms of intuition—space and time—can be understood as *genetically* related to the abstract formalism of the value-form and the exchange relation. The fetishism of the commodity involved in the exchange relation means that "time and space are rendered abstract under the impact of commodity exchange":

> The exchange abstraction excludes everything that makes up history, human and even natural history. The entire empirical reality of facts, events and description by which one moment and locality of time and space is distinguished from another is wiped out. Time and space assume thereby that character of absolute historical timelessness and universality which must mark the exchange abstraction as a whole and each of its features.[6]

In Sohn-Rethel's account, the exchange relation gives rise to a *social* genesis of those abstract forms of knowledge Kant theorizes as *transcendental* and *a priori*. This social genesis is

6 Alfred Sohn-Rethel, *Intellectual and Manual Labour: A Critique of Epistemology*, trans. Martin Sohn-Rethel, London: Macmillan, 1978, 48–49.

at once material and abstract, since the exchange value of a commodity is borne by its use value, and since exchange (like the labor process) is a *physical act* also requiring abstraction from all physicality:

> In exchange, abstraction must be made from the physical nature of the commodities and from any changes that could occur to it…On the other hand, the act of property transfer involved in the transaction is a physical act itself, consisting of real movements of material substances through time and space. Hence the exchange process presents a physicality of its own, so to speak, endowed with the status of reality which is on a par with the material physicality of the commodities which it excludes. Thus, the negation of the natural and material physicality constitutes the positive reality of the abstract social physicality of the exchange processes from which the network of society is woven.[7]

In the act of exchange, the natural and material physicality of the *product* is negated by the abstract value of the commodity, and this negation constitutes the "positive reality" of the social physicality of the exchange process. This is what Sohn-Rethel, following Marx, calls "the real abstraction" of the value-form as a *social process* of exchange. This real abstraction constitutes a kind of "second nature," and Sohn-Rethel argues that this second nature of the real abstraction is "the arsenal from which intellectual labor through the eras of commodity exchange draws its conceptual resources."[8]

We can situate this analysis more broadly at the level of the whole process of valorization, or the accumulation of capital through circulation. The social process of valorization is the very medium in which we think, and to which thinking is applied through intellectual labor (management, for example). Insofar as intellectual labor is subsumed by capital, as is manual labor,

7 Sohn-Rethel, *Intellectual and Manual Labour*, 56.
8 Sohn-Rethel, *Intellectual and Manual Labour*, 57.

forms of thought themselves enter into a relation of dialectical genesis with the value-form. For Sohn-Rethel, the Kantian transcendental subject is the representative modern figure of this dialectic, though its status as such is occluded by the idealism of Kant's transcendental philosophy. But we can also recognize, as Catherine Malabou argues in *What Should We Do With Our Brain?*, that there is a structural homology between post-Fordist management discourse—which emphasizes non-hierarchical networks, self-organization, flexibility, and innovation—and contemporary neurological theory, which describes the brain as a decentralized network of neuronal assemblies and emphasizes neurological plasticity as the ground of cognitive flexibility and adaptation. According to Malabou, "neuronal functioning and social functioning interdetermine each other and mutually give each other form…to the point where it is no longer possible to distinguish them."[9] The structure of the real abstraction moves with the changing composition of the contradiction between capital and labor, which is the history of capitalism, and the structure of cognition moves along with it. This is a *historical materialist* account of conceptual abstraction, following from Sohn-Rethel's critique of idealist epistemology. This is a second approach to the distribution of the insensible. Simply put, the way we think—the form of thinking—is dialectically intertwined with the structure and the historical movement of capitalist accumulation. The movement of the concept is also the movement of value.

Third Approach

The history of modernity, which is to say the history of capitalism, is also the history of modern technology. And it goes without saying that the history of technics conditions the

9 Catherine Malabou, *What Should We Do With Our Brain?* trans. Sebastian Rand, New York: Fordham, 2008, 9.

history of thought. We need to supplement Sohn-Rethel's materialist critique of epistemology with a history of media technologies like the one carried out by Friedrich Kittler. And indeed, like Sohn-Rethel's critique of transcendental philosophy, Kittler's media-theoretical analysis of discourse networks should also be understood as a materialist critique of Kantian idealism. For Kittler, it is not transcendental categories but media technologies that determine the conditions of any possible experience. Media constitute the technological apriorism of thought, sensation and communication: this is what Kittler means when he says that "media determine our situation."[10] Thus, Kittler tracks transformations of this technological apriorism across epistemic shifts determining any access, in the first instance, to something like a history of modernity. In the discourse network of 1800, *the book* is the site of an encounter between reading and writing, wherein the romantic imagination produces a projection of the soul into what Novalis calls "a real, visible world," written into and read off of printed signifiers, emerging from the text as synaesthetic phantasmagoria in which all the senses are drawn together by the hallucinatory experience of literature.[11] In the discourse network of 1900, the gramophone, film and typewriter effect an analytic separation of this sensory synthesis, constituting distinct technologies of recording and transmission for sound, the moving image and the written word. What Kittler calls "media differentiation" carves up the Romantic imagination, sutured to the book, and parcels out its capacities among discrete technologies addressed to a segmented perceiver: an ear, an eye, a mind—a modernist collage of the formerly integral subject.

10 Friedrich A. Kittler, *Gramophone, Film, Typewriter*, trans. Geoffrey Winthrop-Young and Michael Wutz, Stanford: Stanford University Press, 1999, xxxix.

11 See Friedrich A. Kittler, *Discourse Networks: 1800/1900*, trans. Michael Metteer and Chris Collins, Stanford: Stanford University Press, 1992.

Nicolas Baier, Vanitas, 2012, process shot

Nicolas Baier, Vanitas, 2012, process shot

Nicolas Baier, Vanitas, *2012, detail*

And then, in the discourse network of the early twenty-first century, spawned by the cybernetic systems, information theories and encryption technologies of World War II, digital technology draws media differentiation back together through the synthetic resources of digital code, a universal medium traversing audio, video and textual recording. But this time, the synthesis is inhuman and computational—soulless. According to Kittler, "the general digitization of channels and information erases the differences among individual media," such that "inside computers themselves, everything becomes a number: quantity without image, sound, or voice."[12] Digital information technology destroys the image of humans as the subjects of knowledge and of its synthetic production. It communicates with itself, through its own data channels; consciousness is the epiphenomenon of communication.

This, then, is a third approach to the distribution of the insensible. In a materialist inversion of Kantian transcendentalism, media technologies constitute the a priori conditions of possibility *for* the sensible, such that the distribution of

12 Kittler, *Gramophone, Film, Typewriter,* 1.

the sensible already operates within these conditions. Thus, Kittler can write: "technologies that not only subvert writing, but engulf it and carry it off along with so-called Man, render their own description impossible."[13] Since the technological apriorism is itself the condition of any possible description, it cannot itself be described. This is Kittler's transcendental argument. Media technology is the unconscious of modernity.

However, we should recognize that just as Kittler's media theory offers a necessary supplement to Sohn-Rethel's account of the social genesis of conceptual abstraction, it is also necessary to submit Kittler's own work to Marxist inversion. From the industrial revolution to the production and networking of digital information technologies, the history of modern technology emerges from and responds to the demands and internal contradictions of capitalist accumulation. Marx offers the analytical resources to understand the dynamics of this history precisely, through the categories of formal and real subsumption.

What Marx calls "formal subsumption" is the initial subsumption of labor under the value-form, through wage labor and exploitation (the extraction of surplus value from surplus labor time). This early period of subsumption is merely "formal" because the production process itself (the subsumed labor process) remains primarily consistent with precapitalist techniques. Techniques of production are not yet specifically capitalist techniques. Thus, during the period of formal subsumption, the extraction of surplus value is primarily correlated to the length of the working day and the cost of labor power. The capitalist wants to *extend* the working day as much as possible and to *reduce* wages as much as possible. The rate of surplus value extraction depends primarily upon these factors (absolute surplus value). But labor power is not only productive; it has to be reproduced. Workers have to rest at the end of

13 Kittler, *Gramophone, Film, Typewriter*, xxxix.

the working day, and they require food and shelter. Thus, it is only possible to extend the working day *so much*, or to reduce wages to *so little*, because the reproduction of capital depends upon the reproduction of labor. This is a very basic aspect of what is called "the contradiction between capital and labor."

This contradiction bears upon the history of technology because it is by revolutionizing the means of production that capital attempts to overcome this contradiction. New technologies of production, and new techniques of production (assembly lines, for example) make it possible to increase productivity and thus increase the amount of surplus value that can be extracted in a certain period of time (relative surplus value). Without further increasing the length of the working day, one can increase surplus value. This is the purpose of automation and capitalist management techniques: what Marx calls "real subsumption" is this revolutionizing of the production process such that it becomes properly capitalist. Not only is labor subsumed under the value-form, but the very constitution of labor itself changes. Importantly, then, real subsumption requires and depends upon technological innovation: the capitalist process of production both needs and produces new machines because they increase productivity within a given period of time and thus compensate for limits on the length of the working day. The process of real subsumption, however, bears another contradiction. Capital invested in raw materials and the instruments of production is called "constant capital." Capital invested in the labor power of workers is called "variable capital." Through the process of real subsumption, the ratio between these aspects changes: relatively more capital is invested in the instruments of labor (technology) and relatively less capital is invested in labor power (wages). But Marx makes clear that the part of capital invested in constant capital does not undergo any alteration in the process of production; it does not increase. The part of capital turned into labor power does, however, undergo an

alteration: it reproduces its own value *and* produces an additional sum: surplus value. Thus, as *more* capital is invested in constant capital and *less* capital is invested in variable capital, less capital is available for conversion into surplus value. It is necessary to invest more capital in technology in order to increase productivity and sustain the valorization process. But doing so also proportionally decreases the amount of capital that can be invested in labor power and thus converted into surplus value. Due to forces of competition and technological innovation driving increased productivity, the rate of surplus value extraction tends to decline. Marx calls this the tendency of the rate of profit to fall.

The same process also generates a different problem: as automation increases, less labor power is required. This means fewer workers are being paid wages, and for less time. This means that less money is being paid out on the labor market for the consumption of commodities. So labor has to be *reabsorbed* into the labor market to support consumption and prevent overproduction. The process of real subsumption thus also requires the growth of the tertiary service sector, which produces both a new labor market and new fields of commodity production and consumption. The new regime of accumulation that accompanies this structural transformation is what Guy Debord theorizes as the Spectacle. He summarizes its relation to the process of real subsumption in *Society of the Spectacle*:

> Automation, which is at once the most advanced sector of modern industry and the epitome of its practice, confronts the world of the commodity with a contradiction that it must somehow resolve: the same technical infrastructure that is capable of abolishing labor must at the same time preserve labor as a commodity—and indeed, as the sole generator of commodities. If automation, or for that matter any mechanisms, even less radical ones, that can increase productivity, are

to be prevented from reducing socially necessary labor-time to an unacceptably low level, new forms of employment have to be created. A happy solution presents itself in the growth of the tertiary or service sector in response to the immense strain on the supply lines of the army responsible for distributing and hyping the commodities of the moment. The coincidence is neat: on the one hand, the system is faced with the necessity of reintegrating newly redundant labor; on the other, the very factitiousness of the needs associated with the commodities on offer calls out a whole battery of reserve forces.[14]

We could rephrase this by saying that Fordism both requires and paves the way for post-Fordism. Essentially, *Society of the Spectacle* is a book about the consequences of real subsumption, about the contradictions that it bears within its history and about the new regime of accumulation necessary to defer and compensate for the crises those contradictions contain. And behind the aforementioned passage, we can also read a commentary on the history of technology. The development of industrial automation both necessitates and creates the conditions of possibility for the invention of new media apparatuses, especially digital information technologies and networks. These not only enable the growth of the tertiary service sector and its forms of communicative labor and consumption, they also themselves produce new markets of goods and services. More importantly, they are also the technological ground for the massive growth of the speculative markets we call "financialization," which is predicated (in its contemporary form) upon the exchange of digital information. The tech boom and its implosion are the logical and necessary outcome of real subsumption, pushing beyond its limits into the society of the Spectacle.

So, to come back to Kittler: it is not strictly true that media

14 Guy Debord, *The Society of the Spectacle*, trans. Donald Nicholson-Smith, New York: Zone, 1995, 31.

determines our situation. We also have to recognize the extent to which capital determines our media-technological situation. The conditions of possible experience are themselves conditioned by the moving contradiction between capital and labor. The history of the sensible, the transformations undergone in the media-technological conditions of sensation and experience, is also the history of the insensible—the history of the process of valorization as it develops in relation to contradictions in the labor process. Shortly after he coined the term "immaterial labor," Maurizio Lazzarato renounced it, for the good reason that the term was impossible to reconcile with a materialist position.[15] He should have referred instead to "insensible labor." Information and cognition are not immaterial, but they are insensible. And the forms of affective labor that precisely *are* sensed are premised upon the *indistinction* of labor and leisure, the impossibility of distinguishing them under conditions of post-Fordist accumulation. It is labor itself that becomes insensible under these conditions, dispersed into networks linking neurons and screens, and indistinguishable from the most intimate gestures of our affective lives.

At the same time, however, we know that a commodity like an Apple computer is, in fact, produced by processes quite clearly identifiable as "labor." Despite the fact that every effort is made to keep this fact out of sight and mind, we know it because we read about it on Apple computers. A corporation like Foxconn, the largest manufacturer of electronic components in the world, is basically a distillation of the

15 In an interview, Lazzarato states, "the concept of immaterial labor was filled with ambiguities. Shortly after writing those articles I decided to abandon the idea and haven't used it since. One of the ambiguities it created had to do with the concept of immateriality. Distinguishing between the material and the immaterial was a theoretical complication we were never able to resolve." Quoted in Anthony Iles and Marina Vishmidt, "Work, Work Your Thoughts, and Therein See a Siege" in *Communization and its Discontents*, ed. Benjamin Noys, New York: Minor Compositions, 2011, 137.

entire history of the contradiction between capital and labor, the great movements of the industrial revolution, Taylorism, Fordism, the offshoring of manufacturing labor, and the simultaneity of deindustrialization and post-Fordist cognitive capitalism with the persistence of the most traditional forms of miserable factory work. Indeed, bearing the conditions of its production in mind, one might view a device like an Apple computer as a distillation of the entire history of modernity— of the manner in which modernity acts upon external nature and changes it, and in this way simultaneously changes its own nature, from the printing press to the steam engine to the silicon chip.

Nicolas Baier, Vanitas, *2012, process shot*

Fifth Approach

Consider this essay's images of a recent installation by Montréal artist Nicolas Baier. The main piece is a sculptural object titled *Vanitas,* a reproduction of the artist's office, or his studio. How was it made?

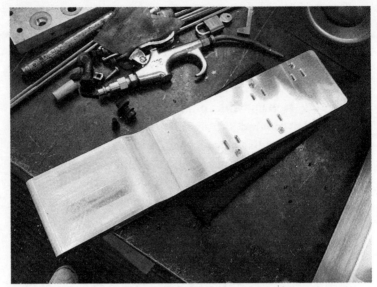

Nicolas Baier, Vanitas, *2012, process shot*

Composed of aluminum, nickel, steel, glass, vinyl and fluorescent lights, the production of *Vanitas* involves a virtuosic performance of mimetic exactitude. Every component of the artist's desk and of his tools is precisely rendered as either a three-dimensional drawing or a three-dimensional scan. Each object is then reproduced, at exact scale, by either machining in aluminum (in the case of drawn objects) or stereolithography (if objects were scanned). This process includes every electric or electronic plug and cord connecting Baier's computer, his monitors, his speakers, and his scanner. It includes the crumpled pieces of paper in his trash can and a book lying open beside his keyboard. Each of these reproduced objects is then plated in mirrored nickel before being rearranged, in a reproduction of their configuration, within a parallelepiped encased on all six sides in one-way mirrored glass and illuminated by overhead fluorescent light.

In a dark room, viewers look at the object, see into it, and see nothing of themselves (like a vampire in front of a mirror,

Baier says) while the object reflects its own interior infinitely in all directions.

The first thing we might note about this piece is its complex engagement with relational aesthetics. It mimics one of the primary gestures of that movement or style, bringing the artist's studio and living space into the museum. But in doing so, it forecloses the primary content of that gesture, radically separating this space from that of the viewer, encasing it within a *mise en abyme*, in which only images interact with one another. Although it draws the space within which the artist works and thinks into the space of the museum, the artist is pointedly absent. The piece is something like an anti-humanist negation of relational aesthetics: perfectly finished, enclosed, complete and pristine, it subtracts the viewer's participation precisely through the viewer's gaze, which is drawn into and lost within the reflexive auto-mimesis of the object.

Second, we can say that if *Vanitas* is a captivating work of art, much of what makes it so is money. Obviously, it is expensive to reproduce one's office in nickel-plated aluminum and to display it so dramatically. A *tour de force* of concept, design and execution, the piece is also nothing if not *resourceful*. It patently shows off the artist's mastery of that form of *technē* so crucial to contemporary art practice: the capacity to get funding. The artist *has* money. His studio is something like the Platonic form of so-called "immaterial labor"—designer furniture and designer devices, neatly arrayed with the precision of an architectural firm blessed with a particularly fastidious custodial staff. And the artist's work *costs* money. The materials, techniques and labor required to produce it do not come cheap. Look, the piece says: money, mastery, *technē*: art. It is an image of capital reflected back upon itself: the *mimesis* of capital. The labor of the artist is the transformation of money, through materials, into its own image. The piece is an image of this transformation. We should recall that this has always been the art-historical function of the vanitas.

Nicolas Baier, Vanitas, 2012, process shot

Capital circulates. But here it does so in a closed system. That is, it does not circulate; rather, it reflects. At his desk, thinking, communicating, representing, the artist enters into the circuits of capital, the movement of valorization—as do we all, one way or another. Now, these circuits freeze. Characters and images cease to appear on the screen. No information or electricity flows through these wires. No music plays through the speakers on the desk. Digital technology has produced its own negation. The precise transformations of materials it enables—its retentional exactitude—precisely negate all transformation. We transform materials into technologies that, in turn, transform materials. And here they are transformed back *into* materials. But this is also to transform them into an art object: neither tool nor raw material, neither instrument nor that to which it is applied. Rather, a worked form, presented, apparently useless and withdrawn from exchange—though of course it has its uses and cannot help but find its way back to market.

Nicolas Baier, Vanitas, *2012, process shot*

Nicolas Baier, Vanitas, *2012, detail*

Baier's piece instantiates the *problem* of the relation between materials and money, captured in the art object. The content of his piece is nothing other than a reflection upon that relation. And of course: this relation has a history, which is the history of modernity. This history, too, finds itself reflected in *Vanitas*. The distribution of the insensible: the movement of capital, the structural transformation of the contradiction between capital and labor, the circuitous courses of the process of valorization —all this is how a digital information system ends up inside a mirrored box in the company of fluorescent lighting and minimalist furnishings. But I want to argue that it is also what we are looking *outside of* from within. Baier's piece should be considered part of an installation, not merely a sculptural object, insofar as it relates with its surroundings, surroundings composed of digitally produced images and objects.

Behind *Vanitas*, a glass reproduction of Baier's eyeball at the center of a projected disc of light, gazing without seeing across the room at a mirrored box that does not reflect its image. In front of *Vanitas*, a meticulously composed compound photograph of the stone wall beside the earliest cave paintings, titled *Canvas*.

Beside *Vanitas*, a *fond de scène*—a reflector used in the background of photo shoots—which Baier placed in a template with a circular hole and left in a window for nine months. Not a reflection of the sun, but an indexical image of its absorption, marked by the circular discoloration of the black tissue. A perfect suprematist portrait.

Around the corner, a piece called *Projet Étoile (Noir)*, consisting of a graphite painting titled *Monochrome (Black)* and a sculptural replica of a meteorite recovered from Death Valley. Having held this meteorite in the palm of my hand three years ago, I can testify to the strangeness of encountering its inexistence, distributed between these two art objects. As he did with the objects reproduced in *Vanitas*, Baier made

Nicolas Baier, Untitled, *2010*

Nicolas Baier, Canvas, *2012*

Nicolas Baier, Photo, 2012

Nicolas Baier, Star (black), 2010, *installation shot*

Nicolas Baier, Monochrome (black), *2010*

Nicolas Baier, Reminiscence, *2012*

a three-dimensional scan of the meteorite and then repro-
duced it—at a much larger scale—through stereolithography.
He then melted the meteorite down and used the graphite of
which it was composed to paint the surface of *Monochrome
(Black)*. The matter of the object thus remains, and so does its
form, but the object itself has disappeared into an uncanny
splitting of formerly integral relation.

These are photographic pieces and sculptural objects that
Baier would have worked on at the computer in the center
of *Vanitas*. Instantiated as digital code, they were "in" that
computer, stored in its memory banks, transformed on its
screen. Now they surround its reflective mineral simulacrum,
exteriorized. They are images of an exterior. *Canvas* shows
us the primordial matter of mimesis: the substrate of inaugu-
ral images carved in stone, with stone. The inauguration of
exteriority. *Star (Black)* confronts us with an extraterrestrial
outside, encountered, vanished, recorded—at once absent and
yet uncannily present as residue and reproduction. These are
images of the deep time of human and cosmological history,
outside the limits of modernity, of capital and its enabling
technologies of representation. The installation asks us to
think, however, about the manner in which these technologies
of representation record this outside, drawing our attention to
it and making it manifest. This suggests a sixth approach to the
distribution of the insensible. Like Malick's *The Tree of Life*,
Baier's meteorite indexes a cosmological time and an inhuman
history never sensed, which was prior to sensation—though,
like Malick's film, Baier makes this history manifest through
the most sophisticated technological means of representation.
Baier's *Canvas*, a meticulous photographic recording of the
bare stone wall beside the first recorded images, situates this
indexical effort within the whole history of representation—
again, carrying us outside the modern technics of mimetic
exactitude that make the digital rendering of this stone wall
possible in the first place.

At the crux of materials and money—through the complex history that crux contains—the subject of Baier's installation is the relation between memory, recording and mimesis. This is why it also contains a photograph called *Reminiscence*. Baier's problem is not only the remembrance of things past, but, more specifically, the reminiscence of that which has never been sensed, the distribution of the insensible, recalled. At and through the limits of modernity, of capital, of mimesis, of thought, of sensation, and within their outside, his work draws us into that distribution.

Concrete Abstraction—
Our Common World

Sven Lütticken

In today's discourse on the commons, past and future appear to have traded places. As Peter Linebaugh has argued, back in the 1840s, communism "was the new name to express the revolutionary aspirations of the proletarians. It pointed to the future," whereas the commons belonged to the past. However, in the early twenty-first century, Linebaugh notes that the connotations of the two terms are the exact opposite, "with communism belonging to the past of Stalinism, industrialization and agriculture, and militarism, while the commons belongs to an international debate about the planetary future of land, water, and subsistence for all."[1] Moreover, the notion of the commons has returned to the fore precisely because it has become progressively clear that the enclosure of the commons, and in general the original or "primitive" accumulation analyzed by Marx, is not limited to the sixteenth century.[2] This primitive accumulation is in fact ongoing; it *has* to be permanent, since capitalism critically depends on the existence of a non-economic outside to the market. As

1 Peter Linebaugh, *Stop, Thief! The Commons, Enclosures, and Resistance*, Oakland: PM Press, 2014, 212.

2 Marx privileged the case of sixteenth-century England even while acknowledging that the process was more widespread and drawn out. See Karl Marx, *Capital: A Critique of Political Economy, Volume I*, trans. Ben Fowkes, London: Penguin, 1976 [1867], 895–913.

Nancy Fraser states, "capitalism is something larger than an economy," as the capitalist economy needs a "non-economic background" that is both external to it and potentially open to incorporation, to appropriation and expropriation—to abstraction.[3]

While some of the most brutal and deadly forms of primitive accumulation occurred in the colonies, the process was hardly devoid of violence in Marx's *locus classicus*, sixteenth-century England, or in Europe as a whole.[4] As men were forced into wage labor that offered little more (and sometimes less) than bare survival, women were forcefully relegated to the "private" sphere of reproductive labor.[5] In today's Western countries, exclusionary violence is mostly reserved for refugees and "illegal" immigrants (and, to some extent, for people of color in general), while, for the majority, the violence of accumulation has increasingly become symbolic and affective rather than physical. In their collaborative works of the 1970s and 1980s, Oskar Negt and Alexander Kluge already suggested that a process equivalent to primitive accumulation is now affecting intellectual workers, as the human brain becomes the most important raw material—a process that may also generate psychic resistances.[6] More generally,

3 Nancy Fraser, "Behind Marx's Hidden Abode," *New Left Review* 86 (2014), 66.

4 For Marx's acknowledgement (and scathing indictment) of the violence of colonial accumulation, see *Capital*, 915.

5 On primitive accumulation and the relegation of women to the domestic sphere in the sixteenth century, see Silvia Federici, *Caliban and the Witch: Women, the Body and Primitive Accumulation*, New York: Autonomedia, 2004.

6 Oskar Negt and Alexander Kluge, *Öffentlichkeit und Erfahrung: Zur Organisationsanalyse von bürgerlicher und proletarischer Öffentlichkeit*, Frankfurt am Main: Suhrkamp, 1972, 304–305, (English edition: *Public Sphere and Experience*, trans. Peter Labanyi, Jamie Owen Daniel and Assebja Oksiloff, Minneapolis: University of Minnesota Press, 1993). The "proletarian counter-publicess" theorized by Kluge and Negt is a manifestation of such resistance.

More recently, Antonio Negri and Michael Hardt have argued that

the psychological and behavioral "retooling" of laborers is crucial to twentieth and twenty-first-century capitalism. The expropriated workers have to appropriate new skills and characteristics. New demands are made on the worker, demands that become interiorized and reshape the subject, finding ways of diverting libidinal flows.[7] Capitalist expropriation and extraction are processes of abstraction. Commons are made productive by being abstracted from their status outside the capitalist *Wertschöpfungskette* (value-creation chain). As Negt and Kluge note, "Throughout history, progress above all seems to be made in the development of the principle of abstraction. Whenever it intervenes, a new dynamic is likely to emerge."[8] In their *History and Obstinacy*,

the original accumulation is ongoing in the form of a "postmodern primitive accumulation" that is largely informational: "informational accumulation (like the primitive accumulation Marx analyzed) destroys or at least destructs previously existing productive processes, but (differently than Marx's primitive accumulation) it immediately integrates those productive processes in its own networks." Antonio Negri and Michael Hardt, *Empire*, Cambridge, MA: Harvard University Press, 2000, 258 (italics removed). David Moore has rightfully criticized Negri and Hardt for privileging "informational" accumulation over other forms of contemporary primitive accumulation, which means that they effectively become complicit in the systemic obfuscation of these forms of labor: "Presto, we have globalised information workers. One wonders if the coltan diggers in the eastern Congo shoveling the essential mineral for cell-phones, Sony play-stations and NASA space-stations under the guns of Rwandan-backed warlords, are 'conscious' of their new power, and whether their subjectivity was the force behind this constellation of extraction, production and consumption." David Moore, "Hardt and Negri's Empire and Real Empire: The Terrors of 9-11 and After," *ACME* 2: 2 (2003), 112–31.

7 See Oskar Negt and Alexander Kluge, *Geschichte und Eigensinn*, Frankfurt am Main: Zweitausendeins, 1981, 87–220, 414–488, 541–709. English edition: *History and Obstinacy*, ed. Devin Fore, trans. Richard Langston et al., New York: Zone Books, 2014. Not all the passages I cite or refer to can be found in the English translation, which is a condensation of the sprawling original.

8 Negt and Kluge, *Geschichte und Eigensinn*, 553. Author's translation.

Negt and Kluge engage in a wide-ranging analysis of history on the basis of an evolutionary-anthropological notion of labor power. They study the expropriation and instrumentalization of this labor power (*Arbeitskraft*) in the form of specific labor capacities (*Arbeitsvermögen*) by successive economic regimes, as well as the resistances to such capture that are inherent in the subject's somatic memory. Differentiating between a transhistorical "principle of abstraction" (associated with nomads and expropriation) and a "principle of concretion" (associated with agriculturists and production), they assert that "capitalism rests on the principle, that—for the first time in history—its abstractions break through into the productive sector."[9] Production had always been chained to the concrete, but capitalism unchains production through abstraction.

This can be traced back to merchant capitalism in the sixteenth and seventeenth centuries, in which a newly capitalized and centralized textile sector absorbed the "liberated" labor power of commoners driven from the land, but it was with industrial capitalism that the reduction of workers to wage laborers was coupled with a progressive mechanization and "rationalization" of the production process—culminating in Fordism and Taylorism. Accumulation as abstraction liquidates or liquefies concrete particularities through monetary equivalence. In this sense, it is a *real* rather than a *conceptual* abstraction. Marx had criticized Hegel's philosophical notions because they remained philosophical concepts, in spite of their claim to concretion.[10] When Marx analyzes the fundamental role of abstract labor in capitalism, or when Alfred Sohn-Rethel takes pointers from Marx in analyzing money as a *real abstraction*, something else is at stake: the social and economic reality of abstractions, as opposed to

9 Kluge and Negt, *Geschichte und Eigensinn*, 522. Author's translation.

10 Karl Marx, *Grundrisse*, trans. Martin Nicolaus, London: Penguin, 1993 [1939], 100–102.

Hegel's philosophical abstract concepts.[11] In marked contrast to complaints about the increasingly abstract nature of the economy, of technology, of society as a whole, Marxists insist that the issue is not one of increasing abstraction, nor one of the failure of the abstract, but of the *becoming-real, becoming-concrete, becoming-productive of abstraction itself.* Labor itself becomes abstract labor power, sold like any other commodity—a real abstraction. The becoming-productive of abstraction in capitalism is a becoming-concrete of the abstract itself. This, effectively, *is our common world.* In a critical response to Michael Hardt's analysis of neoliberalism as entailing "a seizure of what is common —knowledge, language, images and affects," Jodi Dean has maintained that the concepts of the common and the commons have a potential for depoliticization by de-emphasizing division and antagonism within the "common."[12] If one looks at the use and abuse of commonist rhetoric in the neoliberal "Big Society" context, the point is well taken. As Dean maintains: "Division is common. We have to seize it."[13] Starting this process means identifying and intervening in current processes of "permanent primitive accumulation." These form a negated commons—a negative commonality of (unequally) shared expropriation and abstraction, of equivalence in the service of

11 Alfred Sohn-Rethel, *Geistige und Körperliche Arbeit. Zur Theorie der gesellschaftlichen Synthesis,* Frankfurt am Main: Suhrkamp, revised second edition 1972. Alfred Sohn-Rethel, *Intellectual and Manual: A Critique of Epistemology,* London/Basingstoke: MacMillan, 1978. This is an anglicizing reworking rather than a pure translation; it sometimes adds clarifications, but is in many ways an inferior digest of the original. I refer to the English version only when it contains a particularly apt expression of one of Sohn-Rethel's crucial points. I use the second (1972) German edition, which was revised and expanded in response to the book's critical reception.

The "versioning" of *Geistige und körperliche Arbeit* doesn't stop there: Sohn-Rethel published a revised German edition in 1989.

12 Jodi Dean, *The Communist Horizon,* London: Verso, 2012, 120.

13 Dean, *The Communist Horizon,* 156.

the expropriators. It is only by facing the ongoing extraction and abstraction of the extra-capitalist that the commons become a political *and* an aesthetic project.[14] Abstraction is common. We have to seize it.

Convergence and Concretion

What, if any, contributions can artistic or aesthetic practice make to a *praxis* directed against our current regime of accumulation and abstraction? The aim, of course, would not be to instrumentalize art in the name of a political project, but to sound out possibilities for an aesthetic contestation in conjunction with a political one. All too often, it appears that art today is held hostage by the (un)real abstractions of finance capital. A case in point was an Occupy protest in Chicago in 2011, which focused on the Art Institute of Chicago; the august institution, home to Georges Seurat's *A Sunday Afternoon on the Island of La Grande Jatte* (1884–1886), was hosting a cocktail reception for the futures industry.[15] *L'1%, c'est moi*: the profound implication of the contemporary art market in a financialized economy marked by a rising income and wealth gap makes the Chicago montage of artworks, futures traders and protesters symptomatic and significant. Yet art also provides tools for thinking through and acting in the deepening systemic crisis.

Modern "abstract" art and its discourse were in fact a problematization of abstraction. In the interwar period, so-called

14 See also Matteo Pasquinelli, "The Labour of Abstraction: Seven Transitional Theses on Marxism and Accelerationism," *Fillip* 19 (2014), matteopasquinelli.com.

15 Mary Wisniewski and Ann Saphir, "Thousands in Chicago Protest Financial Industry," *Reuters*, October 10, 2011. Brian Holmes discussed this episode in a lecture at the Stedelijk Museum Amsterdam on September 14, 2014, in the context of the lecture series *Aesthetics of Crisis*.

abstract artists were already well aware that their work constituted such a failure, and they modified or rejected the term "abstract art." Piet Mondrian called his neoplastic work "abstract-real" art, and Theo van Doesburg and others later preferred the term *art concret* or concrete art.[16] These are not just minor semantic squabbles. As Liam Gillick has claimed, one might well argue that modern art was actually marked by a failure of the abstract:

> By making the abstract concrete, art no longer retains any abstract quality, it merely announces a constant striving for a state of abstraction and in turn produces more abstraction to pursue. It is this failure of the abstract that lures and hypnotises—forcing itself onto artists and demanding repeated attention...It is the concretization of the abstract into a series of failed forms that lures the artist into repeated attempts to "create" the abstract—fully aware that this very act produces things that are the representation of impossibilities.[17]

For much of modernity, the bourgeois ideology of the aesthetic has glorified art as the realm of concretion in which the subject is reconciled with the object, in which reason is reconciled with the senses. These were art's gloriously failed forms: signifying too little and too much, they provided a refuge from the increasingly arid and abstruse abstractions of science.

Mondrian's or Wassily Kandinsky's paintings could be said to derive much of their power from failing to be abstract, as Gillick suggests, from siding with concretion. Mondrian's unfinished *Victory Boogie Woogie* (1944) is the epitome of assured yet tentative, unfinished work with concrete elements that refuse to settle into definite form. In 2014, when Barack

16 The first and only issue of Van Doesburg's magazine *Art Concret* came out in 1930, but the term was discussed and used widely in the years to come.

17 Liam Gillick, "Abstract," written for the project *Abstract Possible*, Museo Tamayo, 2011, liamgillick.info.

Obama posed in front of Mondrian's *Victory Boogie Woogie* during a "Nuclear Security Summit" in The Hague, accompanied by a curtsying museum director, Mondrian's unfinished final work was integrated into contemporary circuits of abstraction in a rather different, rather sinister manner. The victory over fascism, to which Mondrian's title refers, has become that of an Empire without external borders, but with plenty of internal conflict and contestation—contestation that in recent years has taken an increasingly neo-fascist turn, also due to many liberals' willingness to turn a blind eye to the violence of the exclusions, expropriations and appropriations and violence upon which the order from which they profit rests. For The Hague and its lickspittle museum director, the global security circus coming to town was a fine chance to promote tourism. What better PR than to have the master of "surgical" drone strikes and of global NSA surveillance pose in front of Mondrian's fragile collage grid? Abstraction has become a technoscientific reality in ways the pioneers of abstract art, with their fragile forms, could not have dreamed.

The division between art and science as grounded in an opposition between concretion and abstraction was repeated within the domain of science itself, within the university, by the division between natural science and the humanities, with the former being marked by "geometric formality," as Michel Serres calls it, and the latter by personal relativity.[18] But in reality, as Serres also acknowledges, the situation was more

18 Michel Serres, *Petite Poucette*, Paris: Le Pommier, 2012, 75; translated by Daniel W. Smith as *Thumbelina: The Culture and Technology of Millennials*, Washington, DC: Rowman & Littlefield, 2014. Unfortunately, Serres's perceptive analysis of the structural transformations of contemporary society is marred by an at times grotesque unwillingness to also see the information society as a society of control. In Serres's world, the Edward Snowden revelations are proof that everything is going swimmingly, since they demonstrate that a single man can "take on" the NSA and Silicon Valley. See Michel Serres, interviews with Martin Legros and Sven Ortoli, *Pantopie: de Hermès à Petite Poucette*, Paris: Le Pommier, 2014, 347.

complex. Serres notes that the French university was tradi-
tionally split between humanities, science, and medicine and
law. Serres argues that a "third subject besides that of science
and humanities is born in those medical and law faculties."[19]
In this sphere of thirdness, forms of operative rationality set to
remake reality. In medicine, science abstracts from the minu-
tiae, and accidental details of sense data are used to create a
feedback loop, to make incisions, and to make cuts in order
to heal the body. Abstraction saves lives. In recent decades,
medical and biological research has of course penetrated
increasingly fundamental mechanisms, with genetic cures
becoming a real possibility. Medicine, in short, stands for the
erosion between fundamental and applied research, between
science and technology. The resulting continuum is often
termed technoscience: the becoming-operative and becoming-
productive of scientific rationality. Law, as yet another strand
of real abstraction, provides the protocols that regulate the
operations of technoscience (intellectual property) as well as
those of finance (with the "liberalization" of financial markets
being of course itself a form of regulation).

Today's financial sector is in turn also crucially dependent on
technoscience in the form of high-frequency trading algorithms,
whose autonomous actions far outrun the human capacity to
react. This I call concrete abstraction: an ever-tighter inte-
gration of different vectors of "real abstraction"—monetary,
technoscientific and juridical real abstraction.[20] In Sohn-
Rethel's opposition between real abstraction and thought
abstraction, the latter covers not only idealist philosophy but
also science—or, at least, the ruling epistemology of modern
science.[21] But have the "thought abstractions" of techno-

19 Serres, *Petite Poucette*, 72.
20 See also Sven Lütticken, "Living with Abstraction," in *Idols of the Market: Modern Iconoclasm and the Fundamentalist Spectacle*, Berlin: Sternberg Press, 2009, 125–56 and "Inside Abstraction," *e-flux journal* 38 (2012).
21 The more general German phrase "*Begriffe der Naturerkenntnis*"

158 SVEN LÜTTICKEN

science not also demonstrated their operational potential? Scientific rationality has long been implicated in the productive sector—as Sohn-Rethel acknowledges in remarks on science and technology in the service of production capital. We can again trace this back to merchant capitalism, or "print capitalism," in Benedict Anderson's phrase.[22] Peter Burke has opposed the "bureaucratic organization of knowledge" in China with the "entrepreneurial organization of knowledge" in early modern Europe—noting that in the latter, "cognition was linked ever more closely to production via printing."[23] Industrial capitalism only intensified that process. While Sohn-Rethel considered the degree to which post-war production was shaped by "scientific intelligence" to be the first step towards a socialist reappropriation of the production process, the intensifying technoscientific becoming-operative and becoming-productive of science has given capitalism a new boost.[24]

Sohn-Rethel's key criterion for exchange being a "real abstraction" is that "in the exchange process, doing and thinking diverge on the part of the participants."[25] He clearly needs to maintain that this abstraction is not *just* conceptual but actually takes a real social form; however, he also seems to make a logical slip in suggesting that it is a lack of awareness that makes it real rather than "intellectual." Real abstraction certainly remakes the world—it is not some ontological "deep structure" disconnected from appearance, but a

becomes "the concepts of natural science" in the English edition; Sohn-Rethel, *Geistige und körperliche Arbeit*, p. 42; *Intellectual and Manual Labour*, 20.

22 See Benedict Anderson, *Imagined Communities: Reflections on the Origin and Spread of the Nation State*, London/New York: Verso, 1983.

23 Peter Burke, *A Social History of Knowledge: From Gutenberg to Diderot*, Cambridge/Malden: Polity, 2000, 176.

24 Sohn-Rethel, *Geistige und körperliche Arbeit*, 167–172; 179–182.

25 Sohn-Rethel, *Geistige und körperliche Arbeit*, 57. Author's translation.

constant pre-forming and in-forming. But does awareness—for instance an awareness fostered by reading Marx—make capitalist market relations any less "real"? Alberto Toscano and Brenna Bhandar have argued that "greater attention to the *legal* forms of property" problematizes "the unconscious character ascribed to commodity-exchange as a form of practical abstraction," as legal forms are of course consciously elaborated, while still being real abstractions that are operative in the social world.[26] Meanwhile, Christoph Menke has proposed an ambitious critique of the modern conception of rights as a *form* that needs to be understood historically.[27] Indeed, I would argue that we need to conceive of legal abstraction as a consciously elaborated form of real abstraction. The value form under capitalism is deeply dependent on the supposedly universal rights accorded to the abstract person, especially property rights.[28] In fact, of course, some persons have always been more equal than others—and artificial juridical persons increasingly outstrip and outperform natural persons, who sign away rights by agreeing with any and all Terms and Conditions.

The "vectorial" definition of concrete abstraction acknowledges that examples of integration, or at least collaboration and complicity, could already be found during the heyday of industrial capitalism: the very period marked by a progressive functional differentiation between, and relative autonomy of, different social spheres such as science, law and art (as posited by Weber, Habermas and Bourdieu).[29] Modern functional

26 Brenna Bhandar and Alberto Toscano, "Race, Real Estate and Real Abstraction," in *Radical Philosophy* 174 (2015), 9.

27 Christoph Menke, *Kritik der Rechte*, Berlin: Suhrkamp, 2015, especially part II.

28 See also my "The Juridical Economy: Notes on Legal Form and Aesthetic Form," *New Left Review* 106 (2017), pp. 105–123.

29 Habermas and Bourdieu have arguably developed the most influential late-twentieth-century elaborations on Weber's analysis of the differentiation between social spheres in modern society; Habermas

differentiation was productive in its own way. Autonomous science and an independent judiciary served a purpose—the former by producing fundamental research that could be translated into technological breakthroughs and the latter by ensuring a stable legal framework for corporate and natural persons alike. With its premium on information and brands, post-Fordist semiocapitalism is marked by a market- and technology-driven reintegration of those semiautonomous spheres. Such vectorial integration is never complete, and it produces interferences and contradictions that can be exploited—for instance, between the "enclosures" of intellectual property law and the deterritorializations of media and information technology.

What counts as the "productive sector" today? Production has increasingly become cognitive, semiotic and affective. In heavily financialized neoliberal economies, it is often here that the potential for accumulation seems to be located—though this accumulation is often a redistribution of wealth, as income and wealth disparity rise. Formerly ideologized as autonomous, art is now seen as being in the forefront of the "creative industries"; it has been turned into a financial product, one speculative tool among others in one's portfolio. The art market is becoming software-based almost as much as (other) financial markets. While some major collectors have their own custom-built algorithms, websites such as ArtFacts and ArtRank offer help to a larger group—with the latter site "[identifying] prime emerging artists based on qualitatively weighted metrics including web presence (verified social media counts, inbound links), studio capacity and output, market maker contracts and acquisitions, major collector and museum support, gallery representation and auction results."[30] Nonetheless, this market remains largely dependent on

stayed more closely to Weber, and Bourdieu created his own complex account of semiautonomous fields.

30 See ArtRank FAQ, artrank.com.

pre-digital and, in fact, preindustrial notions of authenticity and uniqueness, into which digital-born works are also squeezed (via limited editions and so on). The situation is rather different in publishing; it is always been a matter of mass (re)production, but digitization has disrupted old business models. Artist Paul Chan operates in both economies, making work for the gallery and museum circuit as well as having run Badlands Unlimited—a publisher of e-books as well as paper books—for a number of years. His artwork *Volumes* (2012) was actually conceived in response to criticisms he received for publishing e-books with Badlands Unlimited, and hence supposedly helping to "kill the book."[31] *Volumes* consists of gutted, mounted and painted-on book covers. One such cover bears the phrases "high-abstract" and "abstract critical."[32] "Abstract critical" is the name of an organization promoting neo-modernist abstraction, and this cover belongs to the catalog of a 2011 show they organized at the Poussin Gallery in London titled *High-abstract*. It is all bizarrely retrograde, and Chan clearly has fun appropriating this catalogue and integrating it into his own exploration of abstraction, which is much more wide-ranging. The gray rectangle he added appears to turn it into a modernist composition, but of course it is also a book, a reminder of the discursive side of art, a rejection of the idea of pure opticality. In any case, Chan is a devotee of Adorno rather than Clement Greenberg, and his take on abstraction moves in dimensions beyond the formal.

In his account of Adorno, a statement about the "absolute work of art" meeting "the absolute commodity," philosopher

31 See also my essay, "Rewriting the Book" in *Cultural Revolution: Aesthetic Practice after Autonomy*, Berlin: Sternberg Press, 2017, 89–113.

32 This particular *Volume* is not part of the *Volumes* installation in the collection of the Emanuel Hoffmann Foundation, which comprises 1,005 book covers.

Stewart Martin returns to Marx's analysis of commodity fetishism, arguing that it distinguishes between two forms of illusion: that of the commodity's sensuousness, and that of the autonomy of its value from labor. "Adorno's account of the autonomous artwork effectively mobilizes the first illusion (fetishism) against the second illusion (the autonomy of capital). The autonomous artwork is an emphatically fetishized commodity, which is to say that it is a sensuous fixation of abstraction, of the value-form, and not *immediately* abstract. This is what remains irrevocably aesthetic about the artwork for Adorno, despite its constitution by the non-aesthetic abstractness of value."[33] On the other hand, with Karel Kosík's terminology, one could stress that this remains precisely an illusion, and that while the artwork is not "immediately abstract," its sensuous appearance is itself pseudo-concrete.[34] It is not so much that "art no longer retains any abstract quality," but that its concretions are a matter of appearance only, for the artwork is really an abstract commodity, exchange value.

But, as Chan's practice demonstrates, it is hardly sufficient anymore to talk about "the artwork" in a general sense, as though it was not beset by ever-deepening contradictions, nor is it legitimate to isolate monetary and financial factors from other forms of concrete abstraction. Chan's large *Volumes* installation at the Schaulager Museum in Basel, Switzerland, has a compendium in the form of a massive Badlands publication called *New New Testament*, in which Chan accompanies images of the book covers with scrambled code poems. The *New New Testament* is available as a hardcover and as a series of e-books, which makes it possible to own and have access to

33 Stewart Martin, "The Absolute Artwork Meets the Absolute Commodity," *Radical Philosophy* 146 (2007) 22–23.

34 See Karel Kosík, *Die Dialektik des Konkreten: Eine Studie zur Problematik des Menschen und der Welt*, Frankfurt am Main: Suhrkamp, 1967.

what is in some ways a more complete version of *Volumes* than the installation itself; but of course the installation offers the senses something that the book(s) cannot, and its physical qualities and uniqueness give it the status of a potential investment that the paper book, let alone the e-books, can never attain.

Paul Chan, Volumes, *2012. Oil on fabric, paper and cardboard. Dimensions variable. Installation view, Paul Chan, "Selected Works," Schaulager, Basel, 2014. Courtesy of the artist and Greene Naftali, New York. Photograph: Tom Bisig, Basel.*

Paul Chan, Volumes, *2012 (detail)*

The capitalist value-form in all its versions presupposes the property form as defined and guaranteed by law, and administered by legal institutions and jurisprudence. However, what owning a book means is being redefined by the agreements one signs when purchasing e-books. Suddenly a book you thought you owned has melted into digital thin air. Ownership is becoming ever more partial and temporary, and complex and contradictory, as juridical abstraction seeks to exploit the affordances of digital technology. Aesthetic and political strategies within concrete abstraction need to engage with the fault lines and contradictions created by these ongoing and intensifying processes of accumulation and expropriation. Crucial for both these processes and for such critical interventions are design strategies. When abstraction becomes concrete, it takes the form of design. Modern art, specialized in the failure of abstraction, frequently allied itself with design as the discipline that concretizes the abstract into form.

Designification

In a famous cartoon by Ad Reinhardt, a little bourgeois man mocks an abstract painting for not representing anything; the painting then grows a face and asks the man: "What do *you* represent?"[35] The question, intended as a defense of abstract painting against philistine attacks, is more relevant than ever. We may be inclined to raise the question of abstraction and what it "represents" to artworks, or to clouds or financial algorithms, but it is echoed right back at us. To paraphrase Walt Kelley's comic strip *Pogo*: we have met abstraction, and it is us.

35 This little drawing showed up time and again as part of Reinhardt's collage cartoons on modern art from 1946 onward. The "what do *you* represent" punch line was originally by artist and theorist Wolfgang Paalen. See Wolfgang Paalen, introduction to *Form and Sense (Problems of Contemporary Art no. 1)*, New York: Wittenborn, 1945.

Insofar as we are subject to design, we *are* design. To be sure, we could argue that human evolution has always been a design process, of becoming-other through tools and prosthetics.[36] However, this was a slow and haphazard process compared to today's "self-design": the permanent optimization of one's performance.[37] This designing of the self is hardly only the work of the subject whose self is on the line. *Je est un autre.* Artist Natascha Sadr Haghighian's essay "Dear Artfukts, Look at My Curve: A Report to an Academy" (2013) was occasioned by her finding her profile on the site ArtFacts.net, which deploys an algorithm to rank contemporary artists. Looking at the (drooping) graph that showed her career, Sadr Haghighian reflects on the complicated relationship between herself and this graph in what is also a feminist meditation on a new form of objectivation (her "curve"): "I don't identify with what the image represents but I participate in it as much as it participates in me, drawing on its character and power as it draws on my character and power. The curve and I are entangled in a mimetic dance, imitating and becoming one another. Our shapes submerge into one amorphous thing as we interact, and in this process of participation I am not a subject looking at an object that represents me."[38]

In writing on "becoming a curve," Haghighian attempts to reclaim some degree of agency, fighting against her uncanny data-design doppelgänger. The graph clearly does not do justice to her life and practice in any way, yet its abstract-concrete representation of her career threatens to usurp her place. The abstracted, elegant version of the graph on the essay's title

36 See Beatriz Colomina and Mark Wigley, *Are We Human? Notes on an Archaeology of Design*, Zurich: Lars Müller Publishers, 2016.

37 On self-design, see Boris Groys, "The Obligation to Self-Design," *e-flux journal* 59 (2014) and "Self-Design and Aesthetic Responsibility," *e-flux journal* 7 (2009).

38 Natascha Sadr Haghighian, "Dear Artfukts, Look at My Curve: A Report to an Academy," *9 Artists*, Minneapolis: Walker Art Center, 2013, 9.

page turns it from an investment tool into something much less functional; something closer to the real abstractions of modernist art, sensuously concrete but far from "productive." On the other hand, artists ranging from Andreas Siekmann and Alice Creischer to Andrea Fraser are also engaging with information design much more directly.[39] Aesthetic practice becomes critical information design, an attempt to visualize the patterns, flows and divisions of concrete abstraction. Such practices suggest that Hal Foster's attack on "total design" in *Design and Crime* (2002) was, paradoxically, marred by an *insufficient* understanding of design. While Foster argues that everything from jeans to genes is now subject to design, he barely acknowledges that this also creates a field for critical appropriation.

Foster traced the roots of today's total design to modern attempts to reconcile art and life via design, in Art Nouveau and the Bauhaus; however, this current manifestation is obviously not the avant-garde version of such reconciliation, but its ghastly spectacular double.[40] "So, yes, the world of total design is hardly new—imagined in Art Nouveau, it was retooled in the Bauhaus, and spread through institutional clones and commercial knock-offs ever since—but it only seems to be achieved in our own pan-capitalist present."[41] That it only has been achieved in this present is very much due to the increasing integration and potentiality of different vectors of abstraction in the digital age. Design, of course, is first and

39 Relevant "information design" projects by or involving Fraser are the abandoned Artigarchy project, a collaborative proposal and website for collecting and visualizing data about powerful art world players' cultural, economic and political interests, and her book *2016 in Museums, Money, and Politics,* Cambridge MA/London: MIT Press, 2018. Creischer and Siekmann have a longstanding engagement with the "pictorial statistics" developed by Otto Neurath and Gerd Arntz in the interwar period.

40 Hal Foster, *Design and Crime and Other Diatribes*, London: Verso, 2002, 17–18 and 19.

41 Foster, *Design and Crime and Other Diatribes*, 19.

foremost a mediation and implementation of technoscience; an application of abstraction, as a mid-nineteenth-century instruction book called *The Practical Draughtman's Book of Industrial Design and Machinist's and Engineer's Drawing Companion* put it: "Industrial Design is destined to become a universal language; for in our material age of rapid transition from abstract, to applied, Science—in the midst of our extraordinary tendency towards the perfection of the means of conversion, or manufacturing production—it must soon pass current in every land. It is, indeed, the medium between Thought and Execution."[42]

The discourse here is one of engineering, of industrial design, but these remarks are highly suggestive also in relation to early twentieth-century graphic design, and indeed the progressive establishment of what Foster terms total design. Abstract art may have been marked by a failure of the "truly" abstract, but a more positive take on the matter might emphasize its implication in the formation of industrial and graphic design as vehicles of concrete abstraction—culminating in the product design of the Bauhaus and the use of photomontage as a tool for showcasing modern industrial products in the ads designed by the *neue Werbegestalter* of the interwar era.[43]

While design's modernist practitioners were intent on establishing it as a distinct discipline in its own right, emphasizing the autonomy of their practice by formulating strict design-aesthetic criteria and procedures, design is also a great equalizer and integrator, a destroyer of autonomy—including its own. As the universal agent of concrete abstraction, as the medium of its formal implementation, design is no longer one

42 Armengaud, Armengaud, and Amouroux; trans. William Johnson, *The Practical Draughtman's Book of Industrial Design and Machinist's and Engineer's Drawing Companion*, London: Longman, Brown, Green and Longmans, 1853, iii.

43 See Matthew Teitelbaum, *Montage and Modern Life, 1919–1942*, Cambridge, MA: MIT Press, 1994.

discipline, if it ever was. Design is a process of calibration; a practice that allows for the various vectors of real abstraction to congeal into form. As total design, it includes exhibition design, graphic design, information design, bio-design, self-design; everything and the kitchen sink. If there is a problem with Foster's take on total design, it is not that it is *too totalizing* but that it is *insufficiently total*. His analysis addresses design as commodity fetish but not as omnipresent process, as a productive operation that we all participate in willy-nilly—and that may at times be converted into critical aesthetic practice.

Beatriz Colomina and Mark Wigley note that the human "radiates design in all directions" and that this leaves its imprint on "the land, the oceans, the atmosphere, the plants, animals, organisms of every kind, chemicals, genetic makeup, and all frequencies of the mainly invisible electromagnetic spectrum."[44] The planet and its (former) commons have been remade by design. Our common world is now the negative commons of concrete abstraction, but it takes the distributed form of scattered hyperobjects—to use Timothy Morton's term—that do not fully manifest themselves to our senses and our understanding.[45] It is everywhere and nowhere. Having been overdesigned by too many cooks, the planet is acting up; total design breeds climatological chaos. If the "human is permanently suspended between being the cause and the effect, between designing living systems and being designed by them," then another wave of forceful redesign is already underway.[46]

For the time being, it is the fascists who reap the benefit of this, precisely by denying all complexity and offering simple Darwinian solutions for those who fear the loss of their

44 Colomina and Wigley, *Are We Human?*, 12.

45 Timothy Morton, *Hyperobjects: Philosophy and Ecology after the End of the World*, Minneapolis: University of Minnesota Press, 2013.

46 Colomina and Wigley, *Are We Human?*, 56–57.

privileges. Juridical and technological means are both used to repel migrants branded "economic refugees," while "globalism" is attacked in the name of "national sovereignty" in order to salvage privilege. Once more, everything needs to change so that everything can remain the same—only worse. The pressures will only intensify. As the artist Franz Wilhelm Seiwert put it in 1929, with fascism ascending: all stabilization is a con.[47] There is no way back to the consensus that Obama and his lackey were trying to uphold in The Hague in 2014.

The Cost of Value

Even as ArtFact's algorithm charts Sadr Haghighian's career, her drooping graph adds value to ArtFacts.net in an underhanded way. In the attention economy of the age of Facebook, users constantly generate value in ways that are hard to quantify. The Marxist notion of abstract labor was based on quantifiable forms of work, on statistical averages that could be expressed in the real abstraction of money. While repetitive industrial labor is largely farmed out to low-wage countries (or migrants from low-wage countries), "immaterial" laborers in advanced economies are no longer exclusively or primarily seen as purveyors of abstract labor power, but as people who bring unique qualities to the process.

Avant-garde critiques of capitalism and their attempts at defining value in non-monetary ways, or of challenging money in its existing forms, are intimately interlinked with their tendency to pit the qualitative against the quantitative. Art's relative autonomy in modernity was underpinned by the fact that art appeared as the sphere of concretion relative to other fields, such as science. At the origin of the modern aesthetic regime, Goethe's critique of Newton was an exemplary

47 "*Alle stabilisierung ist schwindel.*" F.W. Seiwert, "*es ist noch nicht aller tage abend,*" *a bis z* 1 (1929), 1. Author's translation.

manifesto for aesthetic concretion: Newton assumed that light was purely objective, that all colors were contained in white light and that their manifestation depended on the angle through which light passed through a prism; this was quantified light that did not need a human observer, and this Goethe found unacceptable. For him, colors only emerge when light and dark are mixed—in the human eye, in the human observer. Art defends quality and concretion against science's privileging of quantity and abstraction.[48]

Today, the oppositions are much less clear, as digital capitalism appears to present aesthetic practice with a warped realization of its time-honored program. We encounter not so much a negation of quality through a Taylorist *abstraction from all qualities*, but rather *the abstraction of quality itself*. Take medicine: a sphere increasingly subject to metrics, with vital functions being monitored in real time. For today's medical technoscience, the patient is neither abstract nor concrete, but a concrete-abstract *singularity* whose specific qualities can be mapped using datasets.[49] Google, Facebook and high-frequency trading on financial markets alike depend on algorithmic agents whose time is one of inhumanly fast actions. For Marx, machines themselves stored labor, which is why the increasing role in machinery did not negate the labor theory of value. Machines—constant capital—had to be actively used to transmit the dead labor stored in them, and were subject to wear and entropy.[50] But what of algorithms that plow on in relative independence, at a nonhuman pace, and don't need human oversight?

The notion of labor time is as problematic in relation to them as it is in relation to the Facebook users or Wall Street traders with whom they form complex amalgams. The

48 This example forms the point of departure of Wolfgang Paalen's essay *Form and Sense*, 58–64.

49 See Serres, *Pantopie*, 82–85.

50 See esp. Marx, *Capital*, Chapter 15, section 2, 508–17.

Marxian labor theory of value seems less applicable than ever. Human employees' specific qualities are packaged and ideologized—and measured, but untransparently—as "creativity," "teamwork," "initiative" and so on.[51] As Dean puts it, "Communicative capitalism seizes, privatizes, and attempts to monetize the social substance. It doesn't depend on the commodity-thing. It directly exploits the social relation at the heart of value."[52] Monetary real abstraction was based on equivalence, on commensurability, but now labor power has gone through the looking glass. It is as though we have gone from geometric abstraction to some non-Euclidian, N-dimensional, infinitely flexible form of the abstract. Time-as-measure erodes; "flexible working hours" means that all hours are potentially working hours, and every encounter becomes a potential form of networking and hence self-performance.

Dean discusses Metcalfe's Law: "The value of a communications network is proportional to the square of the number of its users."[53] Activists and artists have attempted to quantify the value produced by each Facebook user for this company, sometimes coupled with calls for a kind of wage for users, who effectively work for free.[54] Such attempts at "re-quantification" are important, yet the problems they run into are significant in their own right. If the value of a Facebook is indeed "proportional to the square of the number of its users," this means that the value of an individual's quasi-labor can and will fluctuate greatly. Thus, reestablishing the labor theory of value by widening the net—by including what was previously thought of as nonlabor—is not necessarily going to result in watertight calculations. It is a tactical move designed to at least reopen the discussion on adequate remuneration, on exploitation and inequality—and not just for First-World precarians.

51 See also one of Harun Farocki's last films, *A New Product*, 2012.
52 Dean, *The Communist Horizon*, 129.
53 Dean, *The Communist Horizon*, 129.
54 See Laurel Ptak's *Wages for Facebook* project/campaign.

The qualitative turn of abstraction serves not just to obscure exploitation on the one hand and inordinate profits on the other; it obscures the very criteria that would allow for such discriminations. In the process, commodity fetishism morphs from illusion to be shattered into an operational reality: value does indeed become the result of "theological whims," but those whims have been designed into the system.[55] Just as female reproductive labor was historically excluded from the calculations of production costs and value, so now clicking and liking are not factored into the equation. As Anselm Jappe has argued, the calculation of the labor invested in a single commodity becomes a *de facto* impossibility.[56] Even if one were to try to identify all constituent factors, the question would be what to include and what not. Is a fashionista who "likes" posts by Louis Vuitton *working* or not? Or both? Or neither? Calculating the hidden costs may still be a valid political tactic, but precisely in order to emphasize that value itself is in crisis. It is no longer about determining the "real source of value" (labor time) hiding behind the illusion of fetishism, but about showing how capitalism ends up wrecking all calculations; it comes at an unpayable cost, and has amassed unpayable debts.[57]

New financial products are designed to produce crippling debt for the many and huge financial windfalls for the few, and currency itself is a prime subject for algorithmic speculation —has been redesigned as a speculative investment before it is anything else, its value up for grabs. Money—Sohn-Rethel's real abstraction—was a key manifestation of the quantitative

55 See my article "The Coming Exception: Art and the Crisis of Value," *New Left Review* 99 (2016), 111–136.

56 Anselm Jappe, *Die Abenteuer der Ware. Für eine neue Wertkritik,* Münster: Unrast, 2005, 126.

57 On the "unpayable debt" of slave labor, see Denise Ferreira da Silva, "Unpayable Debt: Reading Scenes of Value against the Arrow of Time," in *The documenta 14 Reader,* ed. Quinn Latimer, Munich: Prestel, 2017, 81–112.

that avant-garde art sought to challenge and transform. In his *Critique of Political Economy* (1962), artist Asger Jorn lambasted Marx for creating confusion over value with his notions of exchange value and use value. Jorn, of course, rejected the Bauhaus, and the post-war New Bauhaus in Ulm (Hochschule für Gestaltung Ulm), for its siding with quantification and standardization; this was a betrayal of emancipatory aesthetics. Noting that money is pure convention, especially once the gold standard has been abandoned, Jorn predicted the end of money under "proper" communism, which would see the realization of the Situationist project of art becoming identical with the totality of life.[58] Life would therefore be ruled no longer by capitalist surplus value, but by a different surplus altogether: aesthetic surplus. With Jorn, then, we have a radical rejection of money as a quantitative abstraction, and art as the purveyor of ineffable qualitative sensations. However, as McKenzie Wark put it, mentioning avant-gardes from Futurism and Surrealism to the Situationists and beyond: "All these qualitative avant-gardes met their Waterloo: the quantitative rear-guard. The path to sustaining the commodity economy after the challenges of organized labor and the social movements reached its peak was a new kind of quantification, a new logistics, a new mesh of vectors for command and control."[59]

In the early twenty-first century, the "end of money" has been replaced by—or takes the form of—a proliferation of alternative currencies and cryptocurrencies. For all their high-tech dazzle, current cryptocurrencies have reactionary traits— but in the age of Silicon Valley, reactionary revolution is of course the *ordre du jour*. Bitcoin, the breakthrough cryptocurrency, was built on artificial scarcity and deflation. Bitcoin

58 Asger Jorn, "Value and Economy" [1962], in *The Natural Order and Other Texts*, trans. Peter Shield, Aldershot: Ashgate, 2002, 117–217.

59 McKenzie Wark, "#Celerity: A Critique of the Manifesto for an Accelerationist Politics," *Speculative Heresy* (blog), May 14, 2013.

almost works as a caricature of gold: like a precious metal, there is only so much Bitcoin that can be mined. Unlike gold, the exact amount had been set, which makes this neo-gold skyrocket in value and behave like "dotcom stock" rather than as a genuine currency.[60] As a speculative investment, Bitcoin exacerbates the neo-feudal tendencies of a society marked by ever more extreme forms of income and wealth disparity. Bitcoin mining is also extremely energy intensive, as has been getting more so over time; as a "decentralized waste heat generator," in 2015, the Bitcoin network already had an energy consumption comparable to that of Ireland.[61] A graphic designed by Alice Creischer and Andreas Siekmann as part of their *Atlas* project, which updates Otto Neurath and Gerd Arntz's "picture statistics," shows precisely the progression of this energy consumption. Unmoored from the state, from territory, from the earth, the digital vanguard is nonetheless wrecking the planet. The earthbound metaphor in Bitcoin mining was well chosen; on an even larger scale than with silver mining in the South-American colonies during the era of historical primitive accumulation, extractivism now lays waste to the global ecological commons. What is the cost of free-floating value?

Some activists have attempted "the radical reinvention of money itself" on the basis of a critical engagement with Bitcoin, other cryptocurrencies, and the blockchain technology behind them. In contrast to Bitcoin's privileging of the asset function of money over the exchange function, Tiziana Terranova and others have proposed a "commoncoin" that would lose value over time to counter this speculative aspect.[62]

60 For some fundamental critical comments on Bitcoin, see Andrew Osborne, "Chump Change: Decrypting Bitcoin & Blockchain," *Mute*, October 27, 2017.

61 Adam Greenfield, *Radical Technologies: The Design of Everyday Life,* London: Verso, 140–141

62 Tiziana Terranova and Andrea Fumagalli, "Financial Capital and the Money of the Common: The Case of Commoncoin," in *MoneyLab*

In a related move, Andrea Phillips has argued for "devaluation" as a political process through which "we dispossess ourselves of value as an economic and aspirational asset class." Focusing on contemporary art, she advocates a transformation of art education, and suggests that there may be uses of artistic skills that allow artists to make a living in ways "that do not necessitate individualized value as a form of capital expansion."[63]

This capital expansion in and through art goes hand in hand with shrinkage, with austerity and precarity. Capitalism's ongoing extractivist violence can no longer guarantee the "growth for all" that post-war Western nations promised their (and only their) citizens. With economic growth being concentrated in emerging economies and Trumpian "tax cuts" and other measures facilitating upward wealth redistribution (for instance through art market speculation), tensions intensify, and are expertly translated into ethnic and cultural terms. Meanwhile, rising CO_2 emissions constitute the one form of growth that seems like a truly global commons; however, the "slow violence" of climate change and environmental degradation affects populations and groups unevenly.[64] In this situation, aesthetic practice needs to find ways of engaging with the complexities of our negative commons of concrete abstraction—condensing the hyperobject in ways that are distinct from (and poised against) the false concretions of early twenty-first-century fascism. When refugees become scapegoats or when Senator James Inhofe "disproves" global warming by holding up a snowball, this amounts to a dramatic failure of abstraction —or rather, a deliberately misleading pseudo-concretion.

In a counterexample, Paul Chan has reminisced about his local McDonald's in the crisis of the early 1990s: "The

Reader: An Intervention in Digital Economy, eds. Geert Lovink et al., Amsterdam: Institute of Network Cultures, 2015, 150–157.

63 Andrea Phillips, "Devaluation," *Parse*, no. 2, November 2015.

64 Rob Nixon, *Slow Violence and the Environmentalism of the Poor*, Cambridge, MA: Harvard University Press, 2011.

McDonald's where I went now and then closed toward the tail end of the '91 recession; so did other businesses in the area. At the time I didn't think much of it, and if I did, I thought it strange." The place seemed to do good business: since the neighborhood didn't have a grocery store or any kind of community center, it doubled for those. Chan remarks that he was "too young and naive to know" much about the causes of the depression, and economic lingo was "as abstract and remote to me as the actual reasons behind the appearance of a recession are in reality." During this period, "survival had nothing to do with measuring the rise and fall of economic indicators, but the cunning of living between these inhuman quantifications, and finding novel ways to be unmoved and unmoored by their movements, in any direction. Progress was not chasing profit, but standing firm where you happened to have found yourself, against the forces that bull or bear either way."[65]

Here, the local McDonald's becomes a dialectical image that could be analyzed much further. What about intensive farming and fast food's footprint? Those engaged with mere survival inside concrete abstraction may not have the energy to ask such questions, and to act on them. As the reduction of life to survival looms large, living with abstraction will require ever more cunning. As the storm of history intensifies, we are only beginning to see the ethical, political, economic and aesthetic challenges.

65 Paul Chan, "The Spirit of Recession," *October* 129 (2013), 3.

On Rendering the D/Recomposition of Context and the D/Recomposition of Form in (Global) Contemporary Art

Jaleh Mansoor

The smooth switching of surpluses of capital and labor from one region to another create a pattern of compensatory oscillations within the whole.

David Harvey, *The Limits to Capital*[1]

Line can no more escape the present tense of its entry into the world than it can escape into oil paint's secret hiding place of erasure and concealment. This fundamental condition can bring it, therefore, much closer to the viewer's own situation than can the image. Drawing...always exists in parallel to that other permanently present time—that of viewing.

Norman Bryson[2]

What does "context" mean for Art History, a discipline founded in the nationalisms of the nineteenth century, wherein place, time, and style have triangulated to form a coherent heuristic frame at different historical moments; after 1945, after 1973, and again now? And how do we find the terms to describe prevailing tendencies in contemporary art among the numerous, scattered, and apparently unrelated trends encountered at art

1 David Harvey, *The Limits to Capital*, London: Verso, 2007.

2 Norman Bryson, "A Walk for a Walk's Sake," *The Stage of Drawing: Gesture and Act Selected from the Tate Collection*, London and New York: Tate and the Drawing Center, 2003, 149–58.

fairs and biennials, and in established museums and institutions of the bourgeois public sphere, as Jürgen Habermas once called them, although what bourgeois means under global capital is shifting as rapidly as the term "context"? These two questions appear unrelated until a pattern begins to emerge suggesting the dependence of one question on the other. The diagram is one (aesthetic) operation within which the questions converge, or are shown to be already entwined. Already operative in the historical avant-gardes of the interwar period (Constantin Brâncuşi, Marcel Duchamp, Francis Picabia), this modality of graphic practice has risen to dominance over the last fifty years: Piero Manzoni (*Linea*, 1961), Barry Flanagan (*Diary of a Conversation, George Melly*, 1972), Dorothea Rockburne, Richard Hamilton, Agnes Denes, Nancy Holt, Lee Lozano, Anna Maria Maiolino, Richard Tuttle, Mark Lombardi, Gabriel Orozco, Ellen Gallagher, William Kentridge, Kara Walker, Cristobal Lehyt, Julie Mehretu, Daniel Zeller, and Nobuya Hoki.[3]

Running more fundamentally perhaps than even the question of art historical "method," the question of context presses on criticism, given that art practices have shown the degree to which the "de-" and "reterritorialization"[4] of the world have affected the basic availability of forms of representation, such

3 Pamela Lee, "Some Kinds of Duration: The Temporality of Drawing as Process Art," *After Image: Drawing Through Process*, Organized by Cornelia H. Butler for an Exhibit at the Los Angeles Museum of Contemporary Art, April–August 1999, Cambridge: The MIT Press, 1999. See *Vitamin D: New Perspectives in Drawing*, London: Phaidon, 2005; Catherine de Zegher. *The Stage of Drawing: Gesture and Act, Selected from the Tate Collection*, Tate Publishing and the Drawing Center, New York, 2003; Briony Fer, *The Infinite Line: Remaking Art After Modernism*, New Haven and London: Yale University Press, 2004.

4 For a discussion of the "deterritorialization" or disarticulation and reorganization of space and time in relation to the specific configuration of capitalist integration, see David Harvey, *Justice, Nature, & the Geography of Difference*, Oxford: Blackwell, 1996. See also Harvey, *The Condition of Postmodernity*, Oxford: Blackwell, 1989.

as drawing, to cohere and to make sense—to show and to tell about this "world." And so, for instance, one sees the rise of the diagram, or indexical functions of line. Line is tasked to convey data, information, rather than to establish contour, divide a figure from ground, and present the rudiments of representation, its historical function. That the basic tools of representation are shown to fail in the wake of world changes that exceed their own representability by the old forms as we recognize them, is already an extreme symptom of the need for new forms and new terms. Art, and rarified cultural production, presciently symptomatizes the yet inarticulable seismic shifts that occur first in the economic sphere, and subsequently resonate throughout the social field. It does so by means of appropriating/re-appropriating the very devices, such as of the diagram, which traditionally belong to forms of rationalization foundational to significant shifts at the level of what was once known as "the base" in relation to a "superstructure."[5] Circular as the description of this process may seem, artistic production is one place along a circuit of cause and effect to locate an etiology of the real movement of time and the metabolic exchange with resources, value, and social reproduction.

From Vincenzo Agnetti on—which is to say, from 1972–3 on —the chart and diagram increasingly overtake the image in many contemporary practices (practices that reexamine basic aspects of art making, such as line), a strong symptom of seismic changes on the register of the real. This, of course, rests on my conviction that art, especially when it is most autonomous, prefigures and symptomatizes changes in the field of the real before they are symbolized and formalized in discourse.

5 Michael Baxandall, *Painting and Experience in Fifteenth Century Italy*, Oxford University Press, 1988. Walter Benjamin, "One Way Street" and "The Work of Art in the Age of its Technological Reproducibility" in *Collected Writings of Walter Benjamin*, Howard Eiland and Michael Jennings, eds. Cambridge, MA: Harvard UP, 2006.

It has long been noted with reference to Constructivism and other practices of the early twentieth century that while "the diagrammatic line is drawn from the realm of science and technical drawing...the final work has elements of notation. The works do not 'represent the world,' if that is taken to be the model used in figurative art, but they contain allusions to the world in which they were produced by the currency of associations, materials, methods."[6] Less elaborated, perhaps, is the degree to which the shift reverberates through the century and, replacing figuration, renders perceptible otherwise unfigurable and invisible shifts in the mediation between the real and its reception, or what were once called base and superstructure. The key here is the shift in the register within which line is expected to deliver meaning. Replacing contour and mimesis with notation, this transition at the heart of basic visual practice signals a more profound relation to the de- and re-composition of content and meaning at a fundamental level, perhaps not unlike the transition the image underwent in the wake of technological reproducibility as famously described by Benjamin. It is the gambit of this essay that the in/coherence of context rides in on the question of the diagram in late capitalist modernity.

As noted above, the list of artistic practices that mobilize the turn from contour to diagram clearly crosses the century, from 1915 to 2016. We could tendentiously situate these practices as so many cultural instances marking the elaboration and development of the purely aesthetic appropriation of the diagram as a heuristic device. But this unfolding of a cultural development, in turn, could be shown to track a parallel,

6 Briony Fer, David Batchelor, Paul Wood, *Realism, Rationalism, Surrealism: Art Between the Wars*, New Haven, CT: Yale University Press, 1993, 108. On the dominance of industrial design and commercial drawing as the matrix of the French and American avant-gardes, most notably Duchamp's practice, see the seminal text by Molly Nesbit, "The Language of Industry," *The Definitely Unfinished Marcel Duchamp*, ed. De Duve, Cambridge, MA: The MIT Press, 1992.

double movement of culture nested in and against the movement brought about by the disintegration of the capitalist mode of production and the reintegration of global resources and demographics. While it would be impossible to map the one (the internal telos of the diagram) onto the other (the historicity of capitalist subsumption), a pattern nonetheless emerges. In the absence of any causal correlation, the transformation of line nevertheless marks the progress of capitalist immiseration and the transitional points between moments of progress. It is as though the deterritorialization of line somehow recorded, indexically, the de- and re-composition of (cognitive) mapping in "line" with "globalization," itself another name for capitalism. In what follows, I will try to isolate a couple of such practices to attempt to "read" them as indices of real abstraction.

In the mid twentieth century, Piero Manzoni's *Linea* radicalized the modernist preoccupation—from Duchamp to Adorno to Cage—with the ascetic reduction of artistic process, particularly the transformation of drawing, formerly conceived and practiced as a means to demonstrate skill, into other modalities of agency.[7] This work about the very possibility of line thinks through the vanishing conditions of mark-making within predetermined systems enforced by disciplinary everyday life in mimetic inscription to value-productive labor on the factory floor. In other words, the artwork demonstrates the way in which disciplinary labor comes to inevitably limit historically established forms of culture believed to transcend lowly matters of economic determination. *Linea* dialectically, and negatively, foregrounds the problem from the point of view of the artist, who, while far from the worker in terms

7 *Linee* (Lines) is a series of artist's books by Manzoni, created in 1959. Each work consists of a cardboard tube, a scroll of paper with a black line drawn down it, and a simple printed and autographed label, which contains a brief description of the work: the artist's name, the date it was created, and its length.

of class identification, was expected to deliver consciousness within and against the dictatorial determinations managed by the capitalist logic of value. Manufacture and authorship alike came to be reticulated exclusively to the same form of general equivalence, irrespective of the numerous qualitative differences among types of workers. The *Linee* posit "self-reflexivity," that lynchpin of modernism, in terms of manufacture, and the vanishing possibility of artistic agency in an era accelerated in the interest of abstracted value. As ever, Adorno is good at translating the issue of subsumption back into cultural terms; hegemonic liberal culture mediates the same processes, legitimating them. "Bourgeois society is ruled by equivalence. It makes dissimilar things comparable by reducing them to abstract quantities."[8]

Manzoni "made" the *Linea* on an assembly line in a factory in Milan. The lines' foreclosure of any expressive, sensual, libidinal content (the role of line from Surrealism through Expressionism, having been lately liberated from its instrumental role in mimetic representation), set into tension with exaggerated packaging, implies the works' embedded dependence on an anonymous subject, the worker/maker whose substantive trace generates the parameters of the very product that doubles back to cancel that presence. Indeed, something is missing. We could call this an object lesson in the preconditions of the commodity fetish that makes things of people and ascribes agency to things, but there's a little more and a little less to it than this.

The agent's (artist standing for worker) trace is recorded and enables the accumulation of canisters and cans, of labels and the many frames of the market. One is confronted with cascading frames, *en abyme*: label, can, pedestal, museum, so many containers, so many forms, but the content seems

8 Max Horkheimer and Theodor W. Adorno, *Dialectic of Enlightenment: Philosophical Fragments*, Stanford: Stanford University Press, 2007, 4.

to withdraw as though by a negative will of its own. This use of modernist hermetic withdrawal nevertheless yields to a frustrated acknowledgment of the active erasure, rather than ontological withdrawal, of both content and agency. Manzoni shifts registers from Heidegger back to Marx: not *this*, but *other* than this entangled *in* this, constituting it and comprised of it is a function of particular labor conditions, specifically a relationship to skill that makes of the grapheme an empty placeholder for value. The *Linee* doubly withhold the corporeal trace: by folding into the industrial procedure and through its packaging. It thus paradoxically shores up the corporeal trace, designating its absence *as* absence, and marks it as *other.*

Returning now to the larger problem of abstraction and the diagram, what is "real abstraction" if not just another term for reification, for the ontological shifts in everyday life brought about by the triumvirate of wage, anonymous labor, and the commodity?[9] How do these ontological shifts move in time? The terms financialization, post-Fordism, even post-modernism suggest a sequence, however accurate or erroneous each may be. They describe a succession of developments in the political-economic reality felt and suffered by workers, masses, and multitudes all over the world, one by any other name, one that generates a condition frequently evoked as "neoliberalism." What is neoliberalism? In *A Brief History of Neoliberalism*, David Harvey argues that the term describes the result of a succession of events in the consolidation of the relationship between the IMF (International Monetary Fund), The World Bank, the WTO (World Trade Organization), and Wall Street. "The process of neoliberalization has entailed much creative destruction not only of prior institutional

9 Georg Lukács, *History and Class Consciousness: Studies in Marxist Dialectics*, trans. Rodney Livingstone, Cambridge: The MIT Press, 1968.

frameworks and powers (even challenging traditional forms of state sovereignty) but also divisions of labor, social relations, welfare provisions, technological mixes, ways of life and thought, reproductive activities, attachments to the land and habits of heart."[10]

Against the narrative according to which a succession of state and institutional alliances policed the globe into so-called neoliberalism, many note that the far reach of capitalism is structurally inevitable, the logical outcome of capitalism's cycles of accumulation necessitating greater territories to be mined for labor and resources. Recent theories (which return to older theories such as those of Rosa Luxemburg, Georg Lukács, and others) of crisis capitalism challenge Harvey's account by pointing to the basic structural condition of capitalism, namely, the need to keep ahead of its inherent tendency to falling profits.[11] And this very tendency is at the heart of the immiseration necessary for generating profits, *unless* capital can absorb resources and sources of labor into its machinery to abet its own structural entropy, thereby returning to accounts of capitalism at odds with Harvey's approach to causality. Paul Mattick's thesis in *Business as Usual*, for instance, acts as a corrective to Harvey in its insistence on structure over the unfolding of secondary political negotiations among global bodies of governance and regulation. But the question is not what Marxian luminary is better than the other, but rather the lacunae that open up in how each tries to describe and periodize emergent conditions *impossible to figure*.

I will go ahead and pose the problem on the larger scale of a historical grand narrative. Given the situation, I am granting myself the freedom to think against decades of post-modernism and its demonization of the attempt to totalize. With Fredric

10 David Harvey, *A Brief History of Neoliberalism*, Oxford: Oxford University Press, 2005, 3.

11 Anwar Shaikh, *Capitalism: Competition, Conflict, Crisis*, Oxford: Oxford University Press, 2016.

Jameson's "Always totalize!" in mind, I am relying as much on the work of David Harvey as on Giovanni Arrighi, Robert Brenner, and others who have proposed ways of thinking historical causality after the complications wrought by the forces of globalization and, above all, financialization, which have come to reshape what we mean by time, place, and cause in addition to determining communications networks.[12] For Harvey, Arrighi, Brenner (despite numerous differences) and others, the oil crisis of 1973 is a signal moment for how it marks strategies on the part of first world nations to keep

12 As detailed in the introduction to *Marshall Plan Modernism*, my work relies on scholarly accounts of the Marshall Plan defined by the rise to international dominance of the US dollar under the Bretton Woods policy, an early and pioneering form of "financialization" structuring the Cold War. Here, in the historical and political conjuncture named by "Bretton Woods," statecraft and capital mutually reinforce the integration of a world power. Salient here is the account of world banking reticulated to the U.S. dollar after the Second World War, and the role of the U.S. dollar in the global balance of power beyond the Cold War, in the oil crises of the 1970s. As elaborated by Giovanni Arrighi in *The Long Twentieth Century*, London: Verso, 1996, the problem of "restructuring" after the oil crisis of 1973 was already implicit and inevitable in the reorganization of political and economic power during Bretton Woods. Gopal Balakrishnan's "Speculations on The Stationary State" in *New Left Review* No. 59, September–October, 2009, relies on Arrighi's work, using the thesis of the *The Long Twentieth Century* to address the decline of the nation state in the face of transnational corporations on the one hand and banking on the other, while updating Arrighi's model of systemic crisis as structurally inherent to the capitalist state conjuncture. See also Robert Brenner, "Persistent Stagnation, 1973–93," *The Boom and the Bubble*, London: Verso, 2002. The best-known and certainly most popular text in English on the organization of the world in the interest of global neo-imperial domination is Antonio Negri and Michael Hardt's *Empire*, Cambridge, MA: Harvard University Press, 2000. The problem with that thesis, however, is the degree to which it displaces forms of capitalist reconsolidation, which *is* neocolonialism, with issues of constitutionality and the limits of national and international law. The task I've set myself is to trace the way in which these shifts ramify in cultural production, through recourse to the question of work and what it meant to make work (autonomous or instrumental; artwork or value productive work) in the global situation.

profits high, strategies that we now refer to in the unexamined shorthand of "globalization": cheap labor in the underdeveloped world, moving from fordist to post-fordist production techniques, emphasizing supply chains over production on the factory floor in the interest of exacting profits more efficiently (to bear the expense of labor less), not to mention new rounds of primitive accumulation exacted by the IMF during the new economy of the Thatcher–Reagan years in the wake of stagnating growth caused by the crisis. In short, we need to a) describe and b) trace—through the etiology provided by cultural production—this hornet's nest of complex determinations wrought by capitalist forms of valorization predicated on the mass movement of people across the planet. What Harvey would call "deterritorialization" and "reterritorialization"— enforced by the creative destruction and reconsolidation of everyday life under the dictates of advanced capital—change the very notions of context and causality.

Enter "the post-medium condition."[13]

The recurrence of the question of displacement may begin to beg the question of the very meaning of placement. It might be said that in an institutional and professional order, itself born of the Cold War, in which specialization is prized, art practices become the last underdetermined (or, by contrast, overcoded) space to enable the exploration of problem sets saturating so many aspects of everyday life as to be otherwise impossible to contain in a circumscribed field of study. From Theodor Adorno to Edward Said, the structural condition of diaspora is frequently understood to be, however violent, one of the given processes of collective transformation born of modernity. And yet within the historicity of modernity, it might be noted that forms of violent displacement are accelerating in

13 Rosalind Krauss, *Voyage on the North Sea: Essays on the Post-medium Condition*, London: Thames and Hudson, 2000. See also *Perpetual Inventory*, Cambridge: The MIT Press, 2013.

intensity and frequency. Diaspora is a form of mass social reorganization across nation states and continents necessitated by the acceleration of capitalism's creative destruction, as it periodically restructures in the interest of resource mining on the one hand, and ever more efficient ways of extracting surplus value from labor on the other.

The shifting relationship between labor and capital, required by capitalism's peripatetic need for surplus labor pools, has redrawn the coordinates of time and space for much of the world's population. Over the course of the twentieth century, over the dare of the histories of capitalism and rounds of accumulation and subsumption, some periods have seen more violent transitions than others. There are two crucial dates, 1945 and 1973, that, I would argue, fundamentally affect the basic meanings of context, origin, and causality. Changing empirical and historical conditions begin to demand scholarly inquiry, including within the humanities, to explore the basic coordinates that subtend classical forms of analysis, of which context, understood as a stable place and time, is fundamental.

The paradox (or dialectical involution) here is that while context (defined as the time and place in which a work is produced) continues to be one of social art history's most basic certainties, it also becomes one of its primary questions. What constitutes a stable time and place, that is, a context, in the wake of the deracination and reconstitution of its perception necessarily governed by networked communication, intimately bound up with financialization, which has made "the bank" (a set of operations) across the globe more causally active in a life than the person who is experiencing this "life"? Agency and the formation of subjectivity have been pressing matters of concern over the last several decades in the wake of theories critical of determination (structuralism, post-structuralism), and yet context has remained a stable category.

I have arrived at a sense of the urgent necessity of this inquiry into "context" through my own research into abstract

art born of the accelerations within capitalist abstraction in the aftermath of the Second World War, during the period known as the "Economic Miracle." Under the aegis of the Marshall Plan, Italy's late and accelerated modernity also coincided with its special role in the Cold War. The factory floor's activity, using surplus labor dredged up from the poorer south, intensified in response to American investment. This work on modernist art during the Marshall Plan has led me to frustration with the received notion of context in practicing a responsible and up-to-date form of social art history— responsible to questions of historicity and causality as much as to the formal operations of works of art. Artists happen to symptomatize anxiety of the moment, its productivist expectations, and its concomitant subject-to-capital relationship, in their own aesthetic "production." Context, then, is born of contingencies having to do with networked markets buffeted by the iron curtain and the ideology that has kept that dynamic spinning, as much as by national identity and territory. At the level of method, it becomes clear that a new tool kit is required when the guarantees of time and place, a geopolitical site and a historical moment, no longer adequately account, if ever they did, for either art practices or artists themselves. As I have argued elsewhere in an analysis of the labor to capital relationship, at once allegorized and organized by the relationship between the IMF and the Global South, whereby the world is literally drawn and quartered in the interest of policing labor-to-capital dynamics outside of the sovereignty of the nation state, "In a globalized art world, the local is always shown to be refracted through a market that is, *a priori*, structurally antithetical to the notion of place and time."[14] This is not a general or formal condition, as elaborated in Benjamin's well-known discussion of how the multiple shatters the aura;

14 Jaleh Mansoor, "Cristóbal Lehyt's Concrete Abstraction: Un-Mapping the 'Global South,'" *Cristóbal Lehyt*, New York: America's Society, Spring, 2014.

specific forms of international accumulation demand an attendant culture. "One problem with this redrawing of the world to accelerate the flow of goods and services for those capable of paying for them was and is those who were and are not capable of paying for them, namely, the working class that produces the surplus value necessary for those circuits."[15] Or as Arrighi puts it: "The conspicuous consumption of cultural products was integral to a state-making process, that is, to the reorganization of the territory into a system. The new and anomalous character of the ruling group meant that they could not rely on the automatic customary allegiance that was available to more traditional kinds of authority. Hence, these groups had to win and hold allegiance by intensifying community self-awareness."[16]

15 Ibid.
16 Arrighi, Giovanni, *The Long Twentieth Century*, London: Verso, 1996, 85.

When Zero Equals Affinity

João Enxuto and Erica Love

Is a diagram of the art field possible? Does this system of knowledge, feeling and finance constitute a reality that can be interfaced diagrammatically? Who would be served by such an abstraction? Standing before a packed auditorium at Munich's Freunde Haus der Kunst on October 2017, Marc Spiegler, the global director of Art Basel, the most prominent art fair on the planet, begins his talk with a slide illustrating a "traditional path to commercial success" in the art field. Spiegler tells the audience that this graph is avowedly uncomplicated, reductive in demonstrating the dynamism of the market. Spiegler then begins to pace behind his podium as a new slide flashes on screen. This second graph offers the audience a "traditional cultural validation path." It is a slightly more complex schematic, but like the first, it begins with "artist" before spreading to other plotted positions—"curator," "gallerist," and so on, ending up in the "auction house." For nearly fifty minutes, Spiegler's talk, titled "Art World 2017: Rapid Shifts, Shifting Roles," cruises through developments and trends that defined the year; his precision and expediency steamrolling any ambiguities from the recent past into rote certainty. Spiegler's approach might be appraised as uniquely American, a brashness that increases almost imperceptibly through the course of the presentation. For the finale, the initial graphs are repurposed to announce a "reality shift," now modified

with hand-drawn lines to illustrate a rudimentary feedback loop. Despite the added multidirectionality, the commercial path continues to flow from artist to auction house, while everything else is put in flux. Spiegler's informal schematic conveys, through feigned amateurism, tactical advantages gained as one plays to the limits of mapping. This heuristic device fails to provide a roadmap for validation in the contemporary art market. We are only guaranteed an initial actant (artist) and a final condition (auction). The rest of the graph is a tangle of arcs and vertices. Criteria are made fungible to subtend a market built on the vagaries of taste-making, where passion has no price.[1] Capitalization is a return to order: "Understanding your market doesn't make you a commercial artist, it makes you someone who is in charge of your own destiny," Spiegler advises. As one of the few exchanges where price is publicly set, the auction house is predestined as the final node in Spiegler's graph.

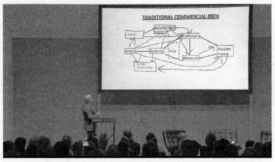

"Art World 2017: Rapid Shifts, Shifting Roles"
by Marc Spiegler—global director, Art Basel

The promise of a better graph has long been attenuated by pricing uncertainty in the art market, as detailed in the well-known 1986 study by American economist William Baumol,

1 Suhail Malik and Andrea Phillips, "Tainted Love: Art's Ethos and Capitalization," in *Contemporary Art and its Commercial Markets: A Report on Current Conditions and Future Scenarios*, eds. Maria Lind and Olav Velthuis, Berlin: Sternberg Press, 2012, 209–40.

who found that unpredictable price oscillations were exacerbated by "the activities of those who treat such art objects as 'investments.'" He concluded: "If the art marketing process really is inherently rudderless, the imperfection of the available information on prices and transactions does not matter in the sense that better information about the behavior of the market really would not help anyone to make decisions more effectively."[2]

Baumol looked at a sampling of sales that extended from 1652 to 1961. These dates, however, offer little insight into the peculiarities of the contemporary art market. Models now implement computational systems, weighted metrics and algorithmic engineering, providing a surge of art market diagrams as explanatory tools. Data about the secondary market has been available since the 1990s through online subscription services like Artnet. Over the past decade, the Artnet platform expanded to include its own online auctions and, in 2012, began publishing analytics reports. In 2014, Artnet expanded again to provide editorial content through Artnet News.[3] In recent years, following Artnet's lead, competitors emerged equipped with big data and algorithmic solutions to sell collectors on a technological edge.

Launched in early 2014, ArtRank remains the most infamous of art market algorithms. It promised to deliver "an unprecedented data-driven advantage in art collecting," while managing to fuel moral outrage by inflating the authority of markets over conventional qualitative standards.[4] The platform's slogan is to "collect smarter," thereby promoting speculation and shedding any pretense that a honing of

2 William Baumol, "Unnatural Value: Or Art Investment as Floating Crap Game," *American Economic Review* 76: 2 (1986), 10–14.

3 In 2018 Artnet News published two in-depth interviews with Marc Spiegler.

4 Artrank.com appears to be inactive, possibly due to overexposure. The last index update was in December 2017. Like many of its listed artists, Artrank burned out quickly instead of fading away.

instinct directs worthwhile art acquisitions. ArtRank unabashedly gamified the contemporary art market by aggregating subjective criteria, affective indicators and price data into a list of artists' names charted for a sequence of boom, bust and/or early blue-chip. The methods used were a distillation of unknowns, yet the obdurate list appeared quarter after quarter, like a corporate earnings report shaping the reality of the market. ArtRank is one of the clearest examples in the art field of derivative logic by acting as if no transaction is final and as if there is always realizable potential for improved performance (or failure).[5]

While ArtRank garnered a disproportionate amount of attention for claiming to topple entrenched market gatekeepers with a dubious algorithm, we became interested in the viability of algorithms to deliver meaningful predictive art market analyses. First, we needed to directly interrogate the developer of a tool that made such claims. Through a mutual acquaintance, we were able to connect with Hugo Liu, a MIT-trained data scientist and co-founder of ArtAdvisor, an artificial intelligence proxy to the fleshy intermediaries that facilitate art market transactions. "Art world, meet aesthetic intelligence" was the service's tagline. After "turning taste data into product" at the startup Hunch and "brand econometrics and prediction science" at eBay, Liu founded ArtAdvisor with Lucas Zwirner, head of David Zwirner Books, the publishing arm of the international gallery owned by his father. We met with Liu three times over the course of several months in 2016. Liu proposed that we convene each time at Ludlow House, a former gold-leaf factory turned members' club in New York City's Lower East Side. After being buzzed in and gaining clearance from reception, we typically sat together in a wood-paneled lounge surrounded by framed artworks, mostly works on paper hung salon style, that could have well

5 Randy Martin, *Knowledge LTD: Toward a Social Logic of the Derivative*. Philadelphia: Temple University Press, 2014.

been the handiwork of an art advisor granted a green light at a lower-tier art fair.

From the beginning, Liu was affable and eager to convey that his algorithmic product was superior to others that relied heavily on auction results. Liu noted that, of an estimated 50,000 active art collectors, only 5,000 were big players who yielded sizable public footprints that could be tracked. He explained that "there are so many overlapping signals in the unstructured data set around art that you can get a sense or data impression about institutions and artists because the bigger players, they act, they touch a lot of data points and they touch a lot of artists." Liu clarified that all data scrapped for analysis are publicly available on the Internet. "It is hidden in plain sight," he explained. Liu concluded that since art experts are able to inherently hone something akin to algorithmic intuitions, it would be possible to measure related "quiet signals" and "build an algorithmic intuition to match the intuitions of the best tastemakers in the art world."

ArtAdvisor used machine learning to measure the "information advantage" of any given institution or tastemaker. Liu often referred to "cultural capital," as he understood his work to be a computational extension of Pierre Bourdieu's *Distinction*.[6] Despite hours of in-depth conversations, it remained unclear to us how cultural capital became uncoupled from economic capital in his system. ArtAdvisor was designed to recognize and predict market performance by following an artist's trajectory using three claimed factors: institutional support, dealer support and critical reception (publications were screened for "sentiment from textual analysis"). The effect of each factor was, again, dependent on the cultural capital assessments of institutions, dealers and publications.

Algorithms are predicated on the analysis of past behavior, just as projecting an artist's career inevitably follows trajectories

6 Pierre Bourdieu, *Distinction: A Social Critique of the Judgement of Taste*. London: Routledge & Kegan Paul, 1984.

taken by previous related artists. According to Liu, ArtAdvisor would eventually detect any and all successful career trajectories, since whatever trend was fueling success would trickle up and be absorbed by larger galleries. These hypothetical trends would ultimately shake out in the data, albeit with a delay. To follow up, we asked him to provide us with some graphs derived from ArtAdvisor: a few are published here.

Available data sets reveal a highly asymmetrical market. Just twenty-five artists are responsible for almost half of all postwar and contemporary art auction sales, according to joint analysis by Artnet Analytics and Artnet News. In the first six months of 2017, work by this small group of elite artists sold for a combined $1.2 billion—44.6 percent of the $2.7 billion total generated by all contemporary public auction sales worldwide. The list of the most profitable twenty-five artists includes only two women.[7] It would follow that algorithmic predictors will continue as a recognition of patterns, serving to further consolidate the art market's preference for certain practices and actors at the exclusion of artists who have not been granted adequate recognition or have been historically excluded.

It is difficult to prove algorithmic bias because machine learning is rarely empirically illustrated. According to Matteo Pasquinelli, current techniques of artificial intelligence have emerged as a "sophisticated form of pattern recognition rather than intelligence, if intelligence is understood as the discovery and invention of new rules."[8] It is often evoked as alchemic talismans of post-humanism with little explanation of the inner workings and postulates of computation. Pasquinelli

7 The two women artists were Agnes Martin and Yayoi Kusama. See Julia Halperin and Eileen Kinsella, "The 'Winner Takes All' Art Market: 25 Artists Account for Nearly 50% of All Contemporary Auction Sales: Here's why the market is as top-heavy as ever—and what it means for the future," *Artnet*, September 20, 2017.

8 Matteo Pasquinelli, "Machines that Morph Logic: Neural Networks and the Distorted Automation of Intelligence as Statistical Inference," *Glass Bead*, Site 1, "Logic Gate: The Politics of the Artifactual Mind," November 2017.

writes that "contrary to the naive conception of the autonomy of artificial intelligence, in the architecture of neural networks, many elements are still deeply affected by human intervention. If one wants to understand how much neural computation extends into the 'inhuman,' one should discern how much it is still 'too human.'"[9]

Liu's product is part of an evolution in computation. The complexity of black-boxed algorithms and their deep neural networks have come to produce outputs that increasingly defy explanation.[10] An inscrutable system does double service in shrouding an opaque art field in a deeper fog of ambiguity. The inability to know with certainty when machine learning contends with probability and correlation becomes a critical problem when lives are at stake, as with medical and military applications. To bring transparency to a system, explainable AI (XAI) has been developed to reveal the logic directing decision-making. However, an art market algorithm is simply made to confirm the legitimacy of established market capitalization. According to Pasquinelli: "In this distributed and adaptive architecture of logic gates, rather than applying logic to information top-down, information turns into logic, that is, a representation of the world becomes a new function in the same world description." In other words, we have computation as the agent of a self-fulfilling prophecy; algorithms become shadows of a collector's established behavior.

With ArtAdvisor, intellectual property stood in the way of explanation. A lack of transparency and knowledge has been beneficial to the art economy. Extrapolating from the general economy, theorist and activist Randy Martin explains that self-limitation and ignorance are important factors in establishing a

9 Matteo Pasquinelli, "Machines that Morph Logic: Neural Networks and the Distorted Automation of Intelligence as Statistical Inference," *Glass Bead*, Site 1, "Logic Gate: The Politics of the Artifactual Mind," November 2017, 7.

10 Will Knight, "The Dark Secret at the Heart of AI," *MIT Technology Review*, April 11, 2017.

belief in market equilibrium "as a kind of automation of thought, an intimately capable information processor or computer."[11] The servicing of art market analytics is a growing enterprise done for the benefit of collectors, auction houses and art funds. While the digital disruption of conventional art market circulation hasn't guaranteed tactical advantages to most young artists other than through a solopreneurialism suited to the social web. Hype amplified through network effects has proved insufficient for an artist that can't deliver a discrete commodity at the end of the day.[12] If the art product reaches the primary market and is sold, it becomes forever decoupled from its producer. These aren't ordinary commodities yet art production is alienated labor all the same, subject to the vicissitudes of the secondary market and the cunning of ArtAdvisor.

As with the graphs of Art Basel's Marc Spiegler, ArtAdvisor conceived of artists solely as engines for art market capitalization without considering them as potential beneficiaries of the derivative value that comes after an artwork is sold and subjected to creative (and coordinated) manipulations by collectors, auction houses, art advisors and other agents.

Could the insights of ArtAdvisor help artists as well as collectors? Liu conveyed that "we'd love to help artists, but we haven't found the right product fit yet." At our suggestion, Liu compiled a Medium Exchange Rate graph that outlined the average value of artworks according to their medium, with oil as the $1.00 benchmark. Short of being prescriptive, such a list could amount to the material considerations for an art piece produced as a fool's errand. As we continued to meet with Liu, conversations, conceptual threads and lines of inquiry would frequently become recursive or hit dead ends. Liu sought to address our skepticism over ArtAdvisor's abilities to chart and rank conceptual art by providing more graphs to illustrate his

11 Martin, *Knowledge LTD*, 12.
12 Brad Troemel, "Athletic Aesthetic," *The New Inquiry*, May 10, 2013.

7.08	limestone
4.24	alabaster
2.64	marble
2.25	wax
2.11	fiberglass
1.93	iron
1.82	stainless steel
1.68	rubber
1.62	steel
1.59	copper
1.42	casein
1.29	porcelain
1.28	bronze
1.24	ceramic
1.20	plaster
1.20	resin
1.07	terracotta
1.00	tempera
1.00	oil
1.00	glass
0.99	aluminum
0.97	wood
0.94	enamel
0.93	metal
0.84	ink
0.81	pigment
0.72	unknown
0.58	pencil
0.52	canvas
0.52	crayon
0.50	pen
0.50	charcoal
0.49	watercolor
0.48	chalk
0.46	pastel
0.46	paper
0.42	collage
0.42	polymer paint
0.42	silkscreen
0.41	cibachrome
0.39	engraving
0.39	photograph
0.38	print
0.35	gelatin silver print
0.35	silver
0.35	mixed media
0.33	encaustic
0.33	drawing
0.32	pochoir
0.32	linocut
0.32	assemblage
0.31	woodcut
0.31	drypoint
0.31	photogram
0.31	poster
0.31	cardboard
0.30	polaroid
0.29	offset
0.28	etching
0.27	monotype
0.27	graphic
0.25	photolithography
0.25	felt tip pen
0.25	c-print
0.24	aquatint
0.23	screenprint
0.23	color lithograph
0.23	photogravure
0.22	brush
0.22	chromolithograph
0.22	mixed technique
0.22	lithograph
0.20	photoengraving
0.19	collotype
0.18	sand
0.18	serigraph
0.18	monoprint
0.16	sanguine

Medium Exchange Rates
The exchange value for artwork relative to an oil
(paint) standard benchmarked at $1.00.

explanations. But when Liu furnished these graphs, we could not make meaning out of them without their creator's exegesis. This was especially true of the affinity graphs.

When asked how institutions are selected for inclusion in the Institutional Affinity graph, Liu told us, via e-mail, that they are determined by "what is considered to be important and influential entities according to a composite of various lists compiled such as institutional prescience, gallery activism, etc." It is unclear what was meant by "gallery activism." In another correspondence, Liu explained that "affinity means the semantic dimension $0 + dim_1 + dim_2 + \ldots$ and the

Institutional Affinity Graph
*Typical pathways between galleries, museum solo or group shows and
biennales using actual institutional names. The labeled nodes in the
current graph are limited to the most important/influential galleries
and museums according to ArtAdvisor. The edges connecting the
nodes are limited only to strong affinities, >0.7 on a 0 to 1.0 scale.*

institutions at either end of the scoring range define the dialec-
tic and part meaning to the dimension." As we had no training
in data science we soon realized that to determine whether
these graphs were correct they should corroborate what we
know to be true.

In a 2013 *Art in America* article, "The Guggenheim's
Favorite Art Dealer," it was reported that "of fifteen solo
shows at the museum since fall 2010, seven have been given
to artists in the stable of [Marian] Goodman Gallery."[13] There
was another show culled from this gallery in spring 2018. We
then measured the Institutional Affinity graph to discover that
Marian Goodman Gallery and the Guggenheim Museum were
not closely mapped on the graph. Liu explained that what was

13 Brian Boucher, "The Guggenheim's Favorite Art Dealer," *Art in
America*, April 16, 2013.

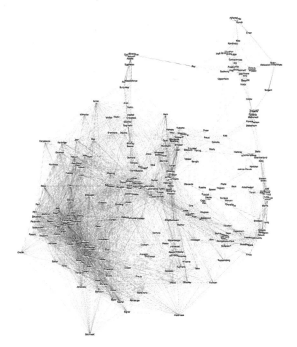

Artist Affinity Graph
Affinity pathways between artists. The edges connecting the
nodes are limited to strong affinities, >0.7 on a 0 to 1.0 scale.

an obvious graphing error could be adjusted by altering the
variances of the graph: the two nodes could be moved closer
to simulate a stronger affinity. Liu warned that this manip-
ulation would violate reasonable variance standards in data
science but could be done in the interest of reality. Liu's will-
ingness to change the variance was done in service of reifying
our subjectivity and prior knowledge of close ties between a
blue-chip gallery and a museum. Ultimately, locating Marian
Goodman Gallery near the Guggenheim offered credibility to
the rest of the graph.

Considering the monopolistic power of a cadre of art col-
lectors, Liu's algorithm might provide an analytic basis to
reduce marketplace uncertainty and seal deals. If ArtAdvisor
were to gain traction among just a few important collectors

(tastemakers), the algorithm could leverage its predictions as a realistic claim on the future of the contemporary art market.

Postscript

For our contribution to this publication, we had agreed with Liu to produce an interview about the development of ArtAdvisor. Shortly after the 2016 United States elections, Liu stopped responding to our e-mails. At that time we were only provided with three preliminary graphs (published here). We took to Facebook to investigate Liu's whereabouts and discovered that he had been busy altering his profile with a series of new occupations: art shaman, reiki healer and data alchemist. In the coming months he made posts chronicling frequent travel and lifestyle changes that signaled a shift toward the ceremonial healing, neo-tribalism and consciousness hacking synonymous with Burning Man and post-Trump Silicon Valley culture. As we came to consider Liu lost to other commitments, we began to write this text. In April 2017, to our complete surprise, ArtAdvisor announced its acquisition by Artsy, the art market's emerging platform monopoly.[14] Liu was given the newly created title of Chief Data Scientist, thereby granting him access to vast new data sets to analyze and deploy.[15] In early July, we received an unexpected email from Liu with the subject line of "Sorry." It was during meditation that morning that Liu came to realize that we were owed an explanation for his "radio silence." Our collaboration had been foreclosed, he said, under strict gag orders from lawyers as the Artsy acquisition deal was closing. It was our desire to understand the promises made by an art market algorithm that initiated this process and it was the opacity of its precondition as intellectual property and eventual marketization that became its undoing.

14 Nick Srnicek, *Platform Capitalism,* Cambridge: Polity Press, 2017.
15 João Enxuto and Erica Love, "Genetic Drift: Artsy and the Future of Art," *X-TRA,* Winter 2014.

Operationalizing Real Abstraction: Art and the General Abstract Image

Diann Bauer, Suhail Malik, Natalia Zuluaga

Abstraction is not simple; it has many variants. There is the abstraction required for the construction and functioning of the large-scale, complex societies of integrated global capitalism —including the systems required for transnational finance, which impacts all aspects of material existence, from food prices to communication networks. There is the abstract image that can represent and communicate the complexity of that condition in schematic form, which in turn assists its systemic functioning—things like data visualization or pricing. Last (for the purposes of this essay), there is abstraction as it's been configured in modern and contemporary art. Though these discrepant notions of abstraction could be made coherent with one another by a common genealogy, or a combined operationalism, or some wide-ranging critique, it is nonetheless more instructive to grasp how the general processes of abstraction and technosocial abstract images are in fact *disconnected* from the stylizations of abstraction familiar in art. The first move of this essay is to identify that disconnection and the reasons for it. The second move is to articulate how art can in fact address the kinds of abstraction necessary for large-scale, complex societies and their operational images. This requires modifying received notions of art from those currently prevailing as contemporary art, and so we give a schematic guide here for those modifications and clarify what

they would enable art to do with its capacities to intervene in complex social organization.

Abstraction, Expression, Representation

Abstraction in art is wide-ranging, but the term is typically shorthand for nonrepresentational art. Mark Rothko provides a supreme example of abstract painting. If you know the narrative of the art, the artist, their mythology and the rest of it, then everything that went into the painting—the emotive leaking and torture of being a macho mid-twentieth-century super-feeler—can be exploded out again. Putting so much into what is in fact a pictorially simple image is like making a zip file of self-torture and intended spirituality. And it is also "abstract art" at another level: as an image of "Art." It signifies Art in some abstract way—as a commodity-sign functioning in an art market, from headline auction sales to posters sold in museums.

In signifying Art, abstract art sets up a loop between abstraction and representation, a loop of art pointing at itself—art's art. But with this, the abstraction splits into two. On the one side, there is the abstraction that supposedly contains the zip file. Let's call this abstracted expressionism. And, on the other side, there is what the abstraction is pointing to, which is the social and collective process, wherein Rothko is a signifier of "Art" and a commodity in a market. Let's call this abstraction an absent representation.[1]

Abstracted expressionism per Rothko depends almost entirely on a kind of spiritual experience of the object's "aura." Vouching for such a subjective experience on the part of the artist or the viewer has structured the now prevailing contemporary relationship to art, and art's own relationship to

1 On representation as the presentation of an absence, see Tristan Garcia, "In Defense of Representation," in *Realism Materialism Art*, eds. Christoph Cox, Jenny Jaskey and Suhail Malik, Berlin: Sternberg/Center for Curatorial Studies Bard, 2015, 245–51.

abstraction. Absent representation, however, is a little harder to negotiate: one would need a more diagrammatic approach to make legible how the Rothko is a concrete embodiment of a circuitry of historical forces or processes. Such a patient approach is of course neither *that* attractive nor satisfactory to the expressionful, idiosyncratic, "feely" requirements of art. Yet, as the present argument contends, the absent representation is not *just* a represented absence. Instead, it opens up the need for a kind of image, a practice that considers abstraction— its own and those it produces, and those it uses—as a concrete, coagulated node in a web of abstract circuitry. And this brings us to the first two abstractions mentioned in the introductory scheme: the abstractions intrinsic to the operation of large-scale, complex societies, and that of the image needed for their functioning. Operational systems such as finance and logistics, for instance, use abstract images all the time, either representationally or as modeling devices. Furthermore, the legibility of absent representation is *not* beyond reach precisely because it *can be* diagrammed in the real—but just not as subjective experience of the "I" to which abstracted expressionism is limited, as is a restricted form of art history that remains focused on the figure of the artist, curator or other individuated agent. With regard to the demands of legibility of the larger technosocial diagram, the art object as abstracted expressionism is totally insufficient. This doesn't imply the end of Rothko art, though. It just means we can demand more from art. What's important is rather the recasting of what abstraction means for art, and—crucially, critically—how art *does* abstraction.

Abstraction: Condition of Production, Condition of Value

This demand presents a problem in that the technical means to make the technosocial diagram legible are so far unclear. For the reasons just given, these means are not available within the

received notions of abstract art, up to and including contemporary art (with its specific abstracted arrangements of symbolic commodity and displays of old-school images of meatspace). It is, however, a problem full of opportunities. Abstraction in the systemic social dimension depends on a kind of modeling: the simplification of an idea or problem. We abstract complexity to better understand or more efficiently analyze and systemically operationalize it. While both this kind of abstraction and the received artistic one of abstracted expressionism make nonmaterial dynamics perceptually observable, abstractions per the technosocial diagram are *simplifications* of complexity and, at once, themselves *amplifiers* of complexity. If complexity cannot be derived from them, they are not effective as abstractions but remain simplifications.

What we've been calling the absent representation in fact represents social conditions. Unlike abstract art, the images representing complex systems are provisional and functional. The relation between representational images and the systems they represent are also themselves mutable and revisable. The particular sense of the absent representation proposed here is a descriptive picture of what otherwise can't be seen or articulated. Let's call it the *general abstract image*—GAI, for short.

The GAI is not new. Systems theory and Marxism both tell us that social abstraction isn't the obvious sense of constructed nonrepresentational perceptions, as abstracted expressionism would have it. Social abstraction instead means that whatever is presented in its supposed immediacy—however sensible, representational, figurative or otherwise—is in fact a result of multiple internal and external conditions, systemic constraints and intangible forces. Immediacy to the senses, to experience, to intuition, are reductive summaries and outlines—yes, abstractions—of extended integrated conditions. Abstraction is part of everything, even the most quickly graspable things. Emojis or brand logos or app icons are good examples here: they are simple and highly intuitive *because* they are precisely

formulated to be quickly deployed by a user integrated into the communicative system, regardless of their familiarity with the tech.

All GAIs are thus images of the extended and integrated social totality, whether or not they look like images in the limited conventional sense. All such images can then be understood as concretized—and temporally limited—versions of otherwise abstract relations. The Art image, to take another, proximate example, doesn't have any special access to "abstraction" in the broader sense. Yet, to return to the opportunities available in the problem presented by the GAI to art, space can be made for art to have a role in how complexity can be conceived. The picturing of complexity is an ordering of that complexity through modeling and abstraction and, as Nick Srnicek points out, such an ordering contrasts sharply against a technosublime in which the picture of the current conditions, being indeed highly complex, is so overwhelming that there is no way to get traction on them.[2] With its own picturing of social complexity against the technosublime, art can be the interface between human orders of perception-action and what would otherwise remain beyond those capacities.

The GAI is also not new in that the "meta" understanding of the relation between representational images and the systems they represent has a clear precedent in Marxist theory. The condition in which material, immediate and experiential realities are intrinsically constituted by the social conditions and forces of (proto)capitalism is called "real abstraction."[3] A commodity is a good example of this because you can handle it, live with it, eat it and so on, but it's a *commodity* and not just the thing that it is—it arrives to you as an object of capitalist exchange. The commodity is full of labor costs, profit

2 Nick Srnicek, "Computational Infrastructures and Aesthetics," in *Realism Materialism Art*, eds. Cox et al., Sternberg Press, 307–12.

3 For a summary of such arguments, see Alberto Toscano, "The Open Secret of Real Abstraction," this volume, pp. 17–42.

margins, systems of distributions having had their effects, and the rest of it. The real concrete thing is constituted by forces and circuits outside of your immediate experience of it. For real abstraction, the immediate thing or experience *begins* from its outside, is subsumed by external structures.

This is why it's also called real subsumption. It becomes clearer by its contrast with formal subsumption, which is the usual model of expropriation and negation. In formal subsumption, an immediate or material reality *preexists* a process that converts it into something else—like a commodity—by abstracting it in other terms. Something is converted from one way of being into another. Capitalist exchange is the privileged example for the good Marxist: a thing or activity (such as labor) becomes a commodity—is converted from what it is anyway—because it enters a system of exchange. The abstracting intervention makes for a new, alien form of a given material. Contrasted to this type of abstraction-by-conversion, abstractive processes in real subsumption are the *pre*condition for the real or material thing. Cash is the obvious example here: the monetary value of the note or coin in your hand is not premised on the paper or metal it is made from. The abstract conditions of money—which are social, relational, intrinsically complexifying—*precede* the material object.

Abstraction: Condition of Cognition

To understand what this argument means for the GAI, it's important to recognize that real abstraction is not just a resetting of material conditions. Alfred Sohn-Rethel argues that the categories of rational thought are really just a transposition and encoding of the commodity form of capitalist exchange into thought and subjectivity itself—including Kant's construction of the conditions of possibility for thought.[4] The

4 Alfred Sohn-Rethel, *Intellectual and Manual Labour: A Critique of Epistemology*, Atlantic Highlands: Humanities Press, 1977.

rational subject of the Enlightenment, who is conventionally assumed to be totally self-subsistent in their cognitive capacity and forms of thought, is in fact only a manifestation of bourgeois property relations internalized in thought itself.

What is most striking and salient about Sohn-Rethel's argument is this: premised on a real abstraction of the system of capitalist exchange, rational conceptual thought is *itself* an instance of abstraction. For Sohn-Rethel, the very *ability* to think and comprehend the real beyond the given terms of the concrete present is not a biological capacity but a *consequence* of real abstraction, of capitalist commodification. And, as a result of real abstraction, rationalization is itself abstract, complex, systemic, and so on, in the manner of the particular mode of social organization that gives rise to it. Furthermore, however much subjective rational thought might strive to establish its unconditionality or autonomy, it is intrinsically socially configured.

What's important for us here is that the primary process of capitalist value extraction is now *real abstraction*, not the formal abstraction that is characteristic of labor qua manual work in the industrial era. More recent Marxian theories coming out of the *postoperaismo* tradition have identified real abstraction as the broad social condition of a "general intellect" that combines collaborative intellectual, communicative and collective forms of production.[5] The subject/s of the general intellect is/are *explicitly* socially constituted, rather than autonomous. Capitalism is then primarily channeled through bodies, thoughts, affect and communication rather than alienated labor and machines. And, concomitantly,

5 See Paolo Virno, "General Intellect," entry in *Lessico Postfordista*, eds. Zanini and Fadini, Milan: Feltrinelli, 2001, trans. Arianne Bove, *Generation Online*; Maurizio Lazzarato, "General Intellect: Towards an Inquiry into Immaterial Labour," trans. Ed Emery, *Multitudes*, 2004; Carlo Vercellone, "From Formal Subsumption to General Intellect: Elements for a Marxist Reading of the Thesis of Cognitive Capitalism," trans. Peter Thomas, *Historical Materialism* 15: 1 (2007), 13–36.

cognitive processes like rational thought, creativity and individuated subjectivity are socialized and collective configurations of real abstraction rather than attributes of the privatized and autonomous Kantian subject.

That the premise for cognition (which is itself abstract) is initially and necessarily collective means that practices and processes—and therefore images—are based on social configurations of abstraction instead of the artist/author matrix. Images that effectively summarize, condense and plot complex information and abstractions in ways that can be comprehended by both human cognition and also machines are now *primary* components in constructing and transforming technosocial conditions—*necessarily* so, given the conditions of real abstraction. Graphs, charts, flow diagrams, interconnecting system diagrams, infographics and data visualizations literally "give a picture" for social conditions now.

Such abstract images are typical of GAIs. They are necessary for the comprehension of systemic operations and aggregate effects. Such images are concrete formulations of the systems that they picture. They are, in this sense, real abstractions. These are the operational images of finance, logistics (including cloud infrastructures), satellite deployment, climate mapping, CERN (*Conseil européen pour la recherche nucléaire/ European Organization for Nuclear Research*), and design processes today from molecules to architecture.

Synthetic Images of Sociotechnical Complexities

Capturing systemic effects as concisely and effectively—which is to say efficiently—as a data visualization, and with as much detail but also generality and further manipulability of information, cannot be organized by narrative forms. For example, abstract sociotechnical images—and, by extension, images in general—are reductive models of processes that are directly

informatic. They are syntheses of abstract complexities: cognitive and also machinic mappings that presume representation and abstraction as their condition. They are also abstract *as images* because they are representational but non-indexical: absent representation, again.

Real abstraction is now the premise for the construction and discovery of large-scale, complex processes, and it *matters* as such. In this sense, abstract images are transformative enhancements of real abstraction by both humans and machines, enabling the fabrication of yet more expansive and integrative sociotechnical complexities. These epistemo-informatic synthetic constructs have less to do with the anthropological shape of the general intellect—and the concomitant Marxist avowals—and more to do with the terms and licenses of GAIs.

Abstraction: The Synoptic Vision

A more profitable account of the GAI than those locating it in the general intellect is provided, we contend, by Wilfrid Sellars' notion of "stereoscopic vision." Sellars' stereoscopic image is not so much about the image itself but about *seeing* and constructing a relation between the abstractions of conceptual knowledge and the social world. Combining Sellars' "manifest image" and "scientific image" provides a unified vision of, respectively, "man-in-the-world" (by which he means the human that knows itself as a social and environmental fact, something like Homo sapiens sapiens) *and* scientific facts that are indifferent to such anthropologies.[6] For Sellars, the relationship between the two kinds of images is a near-algorithmic process where multiple *reals* are set into

6 Wilfrid Sellars, "Philosophy and the Scientific Image of Man," in *In the Space of Reasons: Selected Essays of Wilfrid Sellars*, eds. Kevin Scharp and Robert Brandom, Cambridge, MA: Harvard University Press, 2007 [1960].

play through a retro-feedback relationship between different sets of world models. These sets are what Sellars calls images. And, in other terms and with some modifications, their co-configuration is the GAI. The required modifications include that, at the level of the *process* Sellars is discussing, his preoccupation with concrete premises like the human subject is less important than the actual task of understanding the abstracting *forces* shaping and articulating each of these images and how they inform one another.

For Sellars—granting his limiting condition of "man-in-the-world"—the most comprehensive account of the conjoining of the two kinds of images, of how "things hang together," is philosophy.[7] But extending his argument throws light on the GAI and is worth further attention. As noted, philosophy for Sellars is divided into two images of how the human comes to know itself as well as the natural and social worlds: the manifest and scientific images. The manifest image is a capture term for the habitual behaviors of humans, the "man-in-the-world." It's the place of a valuable intuitive knowledge made of representations and duties; for example, the inferences that can be made from a falling apple ("it's early fall," "time for harvest," "the apple is ripe," "yum!" "oh, gravity," and so on). On the other hand, the scientific image is made of the *knowledge* of the world—meaning, for Sellars, reality as it is—and the consequent practices obtained by theories. These include conceptual inferences of abstract patterns such as natural laws that are not derived from experience alone.[8] Crucially, for

7 The relevant distinction here is that the manifest image of man emerges in "prehistory" while, on the other hand, the scientific image of man takes "shape before our very eyes" and is a construction of modern times. See Sellars, "Philosophy and the Scientific Image of Man," 373–74.

8 For example, if "litmus paper turning red" means proof of the presence of an acid, that is only because of a theoretically derived hypothesis relating absorption and emission of electromagnetic radiation to chemical composition. Ibid., 387.

Sellars' characterization of philosophy, any claims to truth or reality made in the manifest image are *rivaled* (Sellars' word) by the scientific image, precisely because the rational inferences and conceptual stipulations of the scientific image are not themselves given as objects, received views and extant norms. Rather, they are proposed on a speculative, theoretical basis— as abstract images—and the manifest image—the real in that framework—is revised accordingly.

But it is not that the manifest image is naive, uncritical or prescientific.[9] It is, instead, the "original image" of the scientific image, what was once a mythico-historical basis but is now just the empirical condition upon which the scientific image is constructed again and again. For Sellars, then, *both* the manifest and scientific images are needed for a comprehensive view of the world, given that it is composed in its complexity of both material or natural processes and also socio-subjective meanings, of concepts *and* appearances. Sellars' manifest and scientific images are in a perpetual dance of codependent construction. That synoptic vision is how the scientific image makes a real abstraction of the manifest image—a construction constantly adapted and reframed by the scientific image. And while the scientific image presupposes the manifest image, the same is true the other way around: the manifest image then goes on to presuppose a scientific image, and so on. That stereoscopic or synoptic vision is for Sellars the most comprehensive account of "how things hang together in the broadest possible sense": philosophy.

Abstraction After Philosophy

The revised manifest image is a kind of enhanced cognition, one amplified by the systemic technical integration of the scientific image as praxis but also by the consequent gains in

9 Ibid., 374.

rational knowledge. This is a protomodel for the GAI, but one limited by its confinement to philosophy. Yet it resolves the problems and limitations of how real abstraction is dealt with by Marxists. To be clear: this kind of synoptic vision admits and endorses that rational and technoscientific abstractions and conditions are *intrinsic* to the manifest image, which is the socially cogent representation of what is. Abstraction is therefore core to the configuration of social norms and knowledge, not a pernicious mediation that ought to be eliminated in favor of a direct, nonabstract or lived determination of the real.[10] Following Sellars, it would be counterproductive and a theoretical error to call up something like unalienated labor to dispel abstractions as constitutive of rational social conditions, as some Marxists and all of their vitalist-hybrid progeny demand. Rather, such abstraction and its attendant complexity are to be affirmed as the conditions and vectors for *more* techno-rational societies.

Rational conceptualizations inform and shape the manifest image, the society-made representations of what the world is. This is what has earlier been called real abstraction, which is not then only a descendent of capitalist modes of organization. Rather, real abstraction is a consequence of a synoptic vision of two modes of rationality—the two kinds of image Sellars identifies—in constant relay. Abstraction informs and is informed by a technoscientific-social reality.

Real abstraction taken this way stipulates that capitalism is increasingly epistemologically determined and abstract; it is a conceptually constituted, historically specific reconfiguring of the manifest image. And the scientific image is how the manifest image of the (proto)capitalist commodity form provides a basis for critical interventions via abstract determinations of the social space from which it emerged. This is a capitalist

10 This criticism is adapted from Ray Brassier, "Prometheanism and Real Abstraction" in *Speculative Aesthetics*, eds. Robin Mackay, Luke Pendrell and James Trafford, Falmouth: Urbanomic, 2014, 73–77.

development of rationality extended outside of Sohn-Rethel's terms. Equally, surpassing Kantian philosophical limitations (which are somewhat adopted by Sellars), this notion of a synoptic *vision* has to be differentiated from that of a subject position. The question revolves not so much around one's view or framework, but whether the co-construction of manifest and scientific images by real abstraction can be *vectorized* toward new conditions and operations. The synthetic, constructive and dynamic re-vision of real abstraction as a social given is the task of the GAI.

The Imperative of Art: Revising the GAI

Art in its received formats—contemporary art—is incapable of vectorizing the GAI. To be specific, contemporary art currently inhabits three limiting conditions:

1. It cannot accommodate the dynamism of the GAI because it is impervious and/or indifferent to the constructions of the scientific image. While contemporary art may espouse abstractions of many kinds, these are only synthetic constructions of the manifest image, liberated from the synoptic vision; a mutating version of the intuitively given "man-in-the-world" who comes to know himself through interminable interpretation without rational-conceptual qualification via the scientific image and its real abstraction of what is. As a site for the promotion of abstraction, contemporary art does not assume or incorporate rational and theoretical-cognitive imperatives. It is then only a holding formation of the manifest image; a proliferation of real abstractions without the synthetic synoptic revision typical of the GAI.

2. As an adequate repository for the *conditions* for revising the manifest image, and for all of its inclusion of new technical and image forms, contemporary art is not then actually susceptible to any such revision. It's rather an escape valve for the

manifest image to explore its own terrain *without* being subject to the stereoscopic vision that reformulates the *synthetic* image of real abstraction. Oblivious to the disciplinary demands on cognition that constitute the rational knowledge informing and revising the manifest image, these images only appear in and as contemporary art insofar as they are *already* part of the manifest image, not as part of the vision adequate to the modified version of Sellars' comprehensive position proposed for the GAI.

3. In either case, contemporary art is left in the dust by the synthetic abstractions of GAIs and the technosocial field it shapes. Yet, to be clear, the manifest image is for Sellars only rationally corrigible. Contemporary art does not then even make it as a manifest image.

By contrast, an art adequate to vectorizing the GAI—and thus of modifying the abstract technosocial relations that the GAI conditions, represents, and revises—requires the recasting of what abstraction means for art. And if art is constituted in and addresses the GAI, it's certainly no longer a matter of looking to the artist as a subject who is the cause or occasion of abstraction from representation. While the artist can be the immediate material occasion for an image and its historical cause, according to the impersonal forces of real abstraction, the fabrication of such images in the condition of the GAI is de-subjectivized. To surpass contemporary art's limitations and insufficiency with respect to the GAI, the figure of the artist-individual as cause of the image has to be treated as a historical blip.

More importantly, and beyond that provisional and provincial issue of the artist, art has no priority or privilege in the condition of the GAI. It's only one mode of real abstraction among others. What used to be called art takes an integrated part in the continued distribution and transmission of social abstraction, contributing to it with no particular privilege or

paucity—because it has just as much at stake as any other abstract image construction process. The GAI provides another route to identify what art might be and do. And that is to make the image of real abstraction itself explicit *as an image*. Making the GAI explicit as an image is a second-order observation of the stereoscopy of technoscientific-social revision. It is both theoretically speculative (as scientific image) and practically synthetic (as the manifest image of complex intermediated societies). Art's business is then where and how all aspects of the GAI can be directly and overtly addressed qua images, as pliable and mutable in their own terms, not just with establishing the knowledge of those conditions. With that, the real increases in complexity: further abstractions are synthesized as the real of the GAI. Elaboration of the GAI is also a new synthesis of images within that condition. It *adds to* what the GAI is and does, what its logics are.

This increase in abstract complexity is not to be confused with the task of making better "cognitive maps" of social complexity, which Frederic Jameson and others have been pushing for as a way of providing phenomenological guides or pictures of the large-scale abstractions of modern societies to human capacities limited by biology and finitude.[11] Vectorizing the GAI is not a descriptive task, which is the limit of cognitive mapping; rather, it's a constructive one, making epistemoinformatic constructs that would be otherwise unavailable,

11 Following Jameson, cognitive mapping is a way "to think a system so vast that it cannot [otherwise] be encompassed by the natural and historically developed categories of perception with which human beings normally orient themselves." In this, cognitive mapping models the system by scaling down its magnitude to perceivable coordinates and scales, while also sensorially concretizing its abstractive determinants. By contrast, art as a synthetic elaboration of GAI propagates both of these excesses over the capabilities of the sentience that underlies "the natural and historically developed categories of perception;" see *The Geopolitical Aesthetic: Cinema and Space in the World System*, Bloomington: Indiana University Press, 1995, 2.

and thereby recasting the construction of action and knowledge. Unlike cognitive mapping, art's elaboration of the GAI synthetically *advances* the revisionary image and its increasing abstract complexity; a synthetic composition expanding systemic cognition and abstraction at once. In fact, if it is to be adequate to the GAI, that's what abstraction in art *has to be*.

Art and Abstraction in the Present Moment

Benjamin Noys

The paradox of valorization for the artist and for artistic practice in contemporary capitalism is simply stated: on one hand, the artist appears as the most capitalist subject and, on the other hand, the least capitalist subject. In the first case, contemporary forms of artistic practice seem to mesh with contemporary forms of value extraction: precarity, flexibility, mobility and fluidity. In this way, the artist becomes *the* figure of contemporary labor.[1] In the second case, the artist appears as the subject most resistant to capitalist value extraction. The very excess of the artist's creativity resists containment within the limits of capitalist value. This excessive creativity prefigures future noncapitalist relations of the refusal of work, as well as creativity and play. In this instance the flexibility of the artist is not the flexibility of contemporary precarious labor, but the flexibility, as Marx put it, "to do one thing today and another tomorrow, to hunt in the morning, fish in the afternoon, rear cattle in the evening, criticise [or make art] after dinner, just as I have a mind, without ever becoming hunter, fisherman, herdsman or critic [or an artist]."[2] The figure of the artist is both the dystopian figure of complete subsumption

1 Luc Boltanski and Eve Chiapello, *The New Spirit of Capitalism*, trans. Gregory Elliott, London and New York: Verso, 2005.

2 Karl Marx, *The German Ideology* [1845], *Marxist Internet Archive*, marxists.org.

under capitalist value and the utopian figure for the transcendence of the value regime of capitalism.

The classical resolution of such a paradox, derived from Marx's analysis of the position of the proletariat, is to argue that those most subject to capital can be transformed into those who escape capital. The paradox is turned into a contradiction that can be resolved into liberation from capitalist value. To use Marx's description of the proletariat, those with "radical chains" are the dissolution of class society because they suffer a "general wrong," and so also suffer "the *complete loss* of man...[that] hence can win itself only through the *complete re-winning of man*."[3] If this analogy were adopted, the artist who is radically chained to capital would also offer the possibility of "re-winning" a new postcapitalist "value" detached from capital's continual processes of valorization. In this way, the tension of the dystopian and utopian would be resolved by a struggle to realize an existence that transcends the value form. This is a temporal arrangement, in which the dystopian situation is the figure of the present situation of total subsumption and the utopian aspect the figure of what will result from traversing this subsumption.

This account of the proletariat has been disputed, both empirically and conceptually. Jacques Rancière, in one of the most powerful criticisms of this dialectic of emancipation, argues that it implies that the subject to be emancipated suffers from "impotence" and "disempowerment."[4] This positioning means emancipation can only be achieved by a superior subject who can see through this "impotence," and it implies "a culture of distrust based on a presupposition of

3 Karl Marx, "Introduction" in Lucio Colletti, *Early Writings*, trans. Rodney Livingston and Gregor Benton, Harmondsworth: Penguin, 1975, 256. Italics in original.

4 Jacques Rancière, "Communists without Communism?" in *The Idea of Communism*, eds. Costas Douzinas and Slavoj Žižek, London: Verso, 2010, 167–77, 171.

incompetence."[5] The position of the powerless or subjected is, for Rancière, caught in a pedagogic model that implies liberation from outside. While this criticism may be more just about certain currents in the history of communism after Marx than to Marx's original vision, it does complicate the resolution of this contradiction. How can we move from a position of powerlessness and subjection to a position of power and liberation? While this is the hope, even a hope predicated, as Marx put it in a letter to Ruge, on a "desperate situation,"[6] it has not so far been successful and hardly seems on the horizon in the current moment.[7]

This remains the problem for both for the proletariat and for the artist. It also remains for those various attempts to synthesize or articulate the proletariat and the artist into a collective revolutionary subject.[8] The potential alliance between the artistic avant-garde and the worker's movement, as complex and imaginary as this often was, now seems definitively ruptured on both sides.[9] We witness a broken dialectic. The result is that rather than the artist prefiguring a new "artistic communism," as the avant-gardes often claimed, we instead find that we only have an *artistic capitalism*."[10] The triumph of capitalism, even in the moment of contemporary crises, seems to return us to the paradox of valorization and deny us the capacity for articulating contradiction.

Here I want to examine how this problem of valorization and artistic identity is articulated in the work of three

5 Ibid., 172.

6 Marx, *Early Writings*, 205.

7 For a deeply pessimistic reading of this situation, see T.J. Clark, "For a Left with No Future," *New Left Review* 74 (2012), 53–75.

8 See Leon Trotsky, *Literature and Revolution* (1924), Marxist Internet Archive, marxists.org, which remains one of the most sensitive reflections on the tensions of this relationship.

9 For one history, see Alain Badiou, *The Century*, trans. Alberto Toscano, Cambridge: Polity, 2007.

10 Stewart Martin, "Artistic communism—a sketch," *Third Text* 23: 4 (2009), 481–94, 482.

contemporary philosophers who have been highly influential in the art world: Antonio Negri, Alain Badiou and Jacques Rancière. Each, of course, emerges from a self-understanding of their work as communist and each significantly reworks Marx's claims about the proletariat and the dialectic of emancipation. Each has also provided significant reflection on the absorption of artistic radicalism within the value regime of capitalism and proffered solutions to the role of contemporary art. My aim here is to retrace these attempts to engage with the paradox of valorization and to trace the criticisms that each makes of the other. In this way I want to explore not only the various solutions offered by Negri, Badiou and Rancière, but also how the impasses and failures of these solutions offer a horizon of possibility for rethinking the relation of the artist and artistic practice to contemporary capitalism.

The Art of Life

In one of his "Letters on Art," written December 1, 1988, Antonio Negri remarks: "Art has always anticipated the determinations of valorization. So it became abstract by traversing a real development, by creating a new world through abstraction."[11] What Negri suggests is that the plunge into abstraction of high modernism anticipates the developing forms of capitalism's abstract forms of value. The artistic "reduction" of objects to pure signs, such as Cézanne's apples, prefigures the tendency of capitalism to reduce all objects and experiences to the commodity form. If, in Rilke's acerbic remark, "An American apple is not an apple,"[12] if the commodity form reduces the apple to abstract value, then so also the "pure" apple of the artist prefigures the "spectacle"

11 Antonio Negri, *Art and Multitude*, trans. Ed Emery, Cambridge: Polity, 2011, 4.

12 Quoted in Jean-Joseph Goux, "General Economics and Postmodern Capitalism," *Yale French Studies* 78 (1990), 206–24, 219.

of the apple as aestheticized commodity.[13] At first glance, it would appear we are firmly within the dystopian vision of the artist as one who can only predict and prefigure the future of capitalism.

This leads us on the well-worn path of anxieties concerning recuperation—the capacity of capitalism to absorb and rework artistic and political challenges to the status quo. This is the thrust of Luc Boltanski and Eve Chiapello's argument that "aesthetic critique" has fallen prey to capitalism and been internalized by it as its modus operandi.[14] In fact, the work of Thomas Frank, notably in his *The Conquest of Cool*, had already traced a disturbing narrative in which countercultural tropes of artistic self-expression, liberation and play (broadly Romantic notions), were already being deployed by American advertising and business in the 1950s and early 1960s.[15] Here we are close to the most pessimistic form of the recuperation thesis, which Christopher Connery calls "always-already co-optation,"[16] in which capitalism preempts any critical move against it. In this case, there is no exit from the paradox, and the practice of art is always predestined to lead to "aesthetic capitalism."

The work of Andy Warhol would seem to realize this thesis. Warhol himself was happy to identify himself as a "business artist," suggesting that "making money is art and business is art and good business is the best art."[17] Michel Foucault, writing on the philosophy of Gilles Deleuze, would proclaim the

13 Goux, "General Economics," 219.

14 Luc Boltanski and Eve Chiapello, *The New Spirit of Capitalism*, London: Verso, 2007.

15 Thomas Frank, *The Conquest of Cool*, Chicago: The University of Chicago Press, 1998.

16 Christopher Leigh Connery, "The World Sixties," in *The Worlding Project: Doing Cultural Studies in the Era of Globalization*, eds. Rob Wilson and Christopher Leigh Connery, Santa Cruz, CA: New Pacific Press, 2007, 77–107, 87.

17 Andy Warhol, *The Philosophy of Andy Warhol*, New York: Harcourt, 1975, 92.

"greatness" of Warhol as his "stupidity," in which his repetitions of the signs of commodity culture offer "the sudden illumination of multiplicity itself."[18] This "illumination," however, also appears as the illumination of the commodity form bathing in its own light, and so the contradiction and paradox of artistic identity are dissolved in this multiplicity. In this case, there is no way out for the artist, and artistic practice would seem to become nothing more than another sign of the emergent neoliberal model of the self as "enterprise machine."[19]

This, however, is too rapid a reading of Negri. If we follow his remark concerning artistic abstraction, we can note that not only does it traverse a real development, it also creates a new world. The creativity of the artist is not simply absorbed by capitalism. Negri operates from the "tradition" of Italian operaismo and *autonomia*, which holds that the process of capitalist valorization is always dependent on living labor as the real generator of value.[20] Thus, capitalism is only ever a parasite, dependent on the capacity of the working class to generate surplus value. There is a fundamental contradiction between capital's processes of value extraction and the capacities of workers to exceed this through their own processes of proletarian self-valorization. If we transfer this schema to the realm of art, as Negri does, we see that while art might anticipate new modes of capitalist valorization, this does not simply mean that art is *merely* anticipatory. Art and artistic practice is not just a kind of laboratory for capitalism. Instead, the inventiveness and creativity of art promises a traversal, an excess and a rupture.

18 Michel Foucault, "Theatrum Philosophicum," in *Language, Counter-Memory, Practice*, ed. Donald F. Bouchard, Ithaca, NY: Cornell University Press, 1977, 165–96, 189.

19 Michel Foucault, *The Birth of Biopolitics: Lectures at the Collège de France, 1978–79*, trans. Graham Burchell, Basingstoke: Palgrave, 2008, 224–25.

20 For a history, see Steve Wright, *Storming Heaven*, London: Pluto, 2002.

Certainly—writing from prison, as a result of his political activities—Negri does argue that the 1980s are a time of reaction. He also argues that capitalism has penetrated further and deeper into our experience, commodifying all forms of life. In this way he belongs to a common discourse of that time —notably in the work of Jean Baudrillard, who argues that use value has disappeared and that we are all subject to the runaway forces of capitalism.[21] Rilke's American apple, which is no longer an apple, is surpassed by Baudrillard's hyperreal America.[22] The difference is that Negri does not fall into pessimism. In fact, the superior powers of the artist still remain contained within capitalist forms of value. The role of the artist is to reveal "a truth of abstraction,"[23] which is the fact that abstraction is dependent on the creative powers that it subsumes. Negri argues: "We have to live this dead reality, this mad transition, in the same way as we lived prison, as a strange and ferocious way of reaffirming life."[24] If the 1980s were a prison of abstraction, then we do not have to concede defeat, but rather can find new modes of reaffirming the life that is the origin of capitalist value. The forces of abstraction unleashed by art that are absorbed by capital must be reaffirmed so we can traverse and exceed capitalist value.

This process of reaffirming life operates, according to Negri, through an uncanny reversal: "There where the abstract subsumed life, life has subsumed the abstract."[25] Capitalism has subsumed life under the abstract and this, according to Negri, eliminates the possibility of "find[ing] spaces where poetic self-valorization might preserve a corner of freedom for itself."[26]

21 Gail Day, *Dialectical Passions: Negations in Postwar Art Theory*, New York: Columbia University Press, 2010, 182–229.

22 Jean Baudrillard, *America*, trans. Chris Turner, London and New York: Verso, 1999, 28.

23 Negri, *Art and Multitude*, 5.

24 Ibid., 9.

25 Ibid., 78–79.

26 Ibid., 67–68.

This loss of freedom is not defeat, however. The penetration of capitalist abstraction into all realms of life generates the new possibility of turning the abstract back to life. In this case, the practice of art can now prefigure a new global liberation from abstraction. For Negri, following Marx, capitalism has generated its own "gravediggers" by staking everything on the abstract. The artist can now prefigure this reversal of the abstract into life by harnessing and engaging with the monstrous power of the abstract that has extended everywhere. Rather than being isolated in a small corner of freedom, now the artist converges with what Negri would later hymn, with Michael Hardt, as the powers of the multitude.[27] Using Negri's later arguments, we could say that as well as capitalism generating the "general intellect," the productive powers of communication and cognition, we could add that it also develops the "general artist." The artist's paradox is resolved, as in Marx's account of the proletariat, by the transition to a new power.

This model classically restates the contradiction model on the resolution of the paradox of the artist's identity that we stated at the beginning of the chapter. If anything, this is taken to a higher level and, in answer to Rancière's criticism about the deficiency imposed on the powerless, the problem of weakness is resolved by the powers of capitalism. There is, however, some nuance in this argument, which will be flattened in the initial articulation of the multitude. While Negri rightly rejects a purely pessimistic theory of recuperation, he also suggests that the transition to the global power of the multitude may be more complex than we imagine. Within this process the artist also has a role, oddly reminiscent of Gyorgy Lukács, of tracing a "realism of the abstract."[28] In fact, Negri will go so far as to argue for "a punk constructive

27 Michael Hardt and Antonio Negri, *Multitude*, London: Penguin, 2004.

28 Negri, *Art and Multitude*, 54.

realism."[29] This possibility, which I will return to at the end of this chapter, offers the potential for activity within a period of transition rather than the dissolution of transition in reversal.

The Art of Subtraction

Alain Badiou and Antonio Negri appear, in many ways, as antagonistic figures. We have the Platonist Badiou versus the Spinozist Negri, the post-Maoist Badiou versus the autonomist Negri, and so on. Despite appearances, there are commonalities,[30] and one of these lies in the thinking of art; they share a common "affirmationism" (to use Badiou's term), a belief in the power and inventiveness of art that exceeds the power of capitalism to "capture" or control this inventiveness. The difference is, of course, that Badiou rejects completely Negri's contention that the powers of capitalism are merely the powers of the multitude displaced, or misplaced. This is a position that Badiou regards as a "dreamy hallucination."[31] In fact, in *Logics of Worlds*, Badiou singles out Negri's analysis of art as a symptom of contemporary capitalist ideology. Negri's postmodernism is, according to Badiou, really the ideology of "democratic materialism," for which there are only ever "bodies and languages."[32] Negri's attempt to fight on the terrain of capitalism means that, for Badiou, he comes to accept capitalism as the ground of liberation. In fact, we could add, and I do not think Badiou would disagree, that Negri's

29 Ibid., 56.

30 Benjamin Noys, *The Persistence of the Negative: A Critique of Contemporary Continental Theory*, Edinburgh: Edinburgh University Press, 2010, 134.

31 Alain Badiou, "Beyond Formalisation: An Interview," *Angelaki* 8: 2 (2003), 111–36, 126; see also Alain Badiou, *The Rebirth of History*, trans. Gregory Elliott, London: Verso, 2012, 10.

32 Alain Badiou, *Logics of Worlds*, trans. Alberto Toscano, London: Continuum, 2009, 2.

modeling of vital and excessive powers *flatters* capitalism's self-image, not least at its moment of crisis.

What we can see is a shared narrative of the power of capitalism, but very different conclusions drawn when it comes to the role of the artist and art on that horizon. Badiou, like Negri, stresses the moment of high modernism as a moment of invention but, unlike Negri, he does not coordinate this with a prefigurative function. Instead, he insists that "modernism" offers a counter-project to capitalism by developing the powers of a "monumental construction."[33] It should be noted that in doing so, Badiou glosses over all the political and aesthetic differences between those he associates with modernism. This monumental construction of modernism particularly and ironically effaces the political forms of reactionary modernism by leaving modernism as an aesthetic invention.[34] According to Badiou, this grandiose constructive power has been lost in contemporary art, which embraces "the delights of the margin, of obliqueness, of infinite deconstruction, of the fragment, of the exhibition trembling with mortality, of finitude and of the body."[35] While Negri finds the power of art in this dispersion, Badiou insists we invent new forms of concentration and construction to resist capitalism.

This analysis can be aligned with the schema that Badiou develops in *The Century*. The revolutionary sequence of the "passion for the real" that dominated the short revolutionary twentieth century (1914–1989) is now saturated. An earlier common vitalism, emphasizing the heroic powers of the will and the body, contested the value regime of capitalism. The

33 Alain Badiou, "Third Sketch of a Manifesto of Affirmationist Art," in *Polemics*, trans. and intro. Steve Corcoran, London: Verso, 2006, 133–48. See also Benjamin Noys, "'Monumental Construction': Badiou and the Politics of Aesthetics," *Third Text* 23: 4 (2009), 383–92.

34 Jeffrey Herf, *Reactionary Modernism*, Cambridge: Cambridge University Press, 1984; Charles Ferrall, *Modernist Writing & Reactionary Politics*, Cambridge: Cambridge University Press, 2001.

35 Badiou, "Third Sketch," 133.

saturation of these experiments, with the collapse of party communism and the avant-gardes, resulted in a new dispersion that we could link to "democratic materialism." Whereas once the "passion for the real" animated the *collective* bodies of the avant-garde and political vanguards, today that "passion" has become degraded into the sufferings of the *individual* body. If there are only "bodies and languages," then this is why the contemporary artist makes their own mortality and suffering key to their art. This is evident in the turn to acts of self-mortification and self-mutilation, from the Viennese Actionists to Santiago Sierra, where the body becomes a site of playing with the "Real" (in the Lacanian sense).[36] While Negri seems to valorize this dispersion as the site of a new mass and collective power of the multitude, Badiou insists that a true artistic and political practice can only exist through the concentration of and subtraction from forms of contemporary capitalism.

For the artist, Badiou's requirement is that they find, or better construct, "an *independent* affirmation."[37] Unable to rely on the encrypted powers of liberation secreted within actuality, à la Negri, the artist must instead refuse the horizon of the present. This working of subtraction still takes its inspiration from high modernism, but a high modernism split into two. The negative form of artistic practice is that passion for the real, which is animated by destruction and which becomes trapped in the bad infinity of relentlessly trying to find a "Real" outside of representation. Although Badiou does not use it as an example, we could suggest that such attempts at escape would be taken to the extreme in acts of "Dada suicide"—such as that of Jacques Vaché.[38] We could add that this "bad" passion for the real converges with the "democratic

36 Hal Foster, *The Return of the Real*, Cambridge, MA: MIT Press, 1996.
37 Badiou, "Third Sketch," 143, my emphasis.
38 Arthur Cravan, Jacques Rigaut, Julien Torma and Jacques Vaché, *4 Dada Suicides*, London: Atlas Press, 1995.

materialism" of contemporary art and contemporary capitalism, in which destruction is focused on the individual body. This destructive practice has to be traded for a modernism of subtraction. Badiou's example is the asceticism of Malevich's *White on White* (1918), which figures subtraction as the tracing of a pure "minimal difference" between white and white, frame and image, rather than the maximal drive of extracting the Real itself.[39] The difficulty remains, however, in recapturing and reworking this moment in the present. It is the very power of capitalism to debase any "monumental construction" almost in advance that is problematic. In this regard, it is telling that Badiou has very little to offer in the way of examples or instances of contemporary art or artists who measure up to the criteria of probing a subtractive "minimal difference."[40]

If, for Negri, we are all artists, then we might say that for Badiou, no one is, or no one should be. The last thesis of Badiou's "Third Sketch of a Manifesto of Affirmationist Art" is: "it is better to do nothing than to work formally toward making visible what the West declares to exist."[41] This is not necessarily bad advice. We live in a time of the hyperproduction of art, and in the increasing integration of art into the circuits of the market and state. It does seem, however, to leave "monumental construction" as firmly a thing of the past. Such a risk is further reinforced by Badiou's own suggestion that contemporary capitalism is dominated by the ideology of "democratic materialism." His contention in *Logics of Worlds*, that we live in an "atonal world," seems to

39 Badiou, *The Century*, 56.

40 One example is Badiou's discussion of the fiction of Pierre Guyotat, which in Badiou's reading probes the "prostitutional universe" of capitalism, but also offers the possibility of a new world in the face of this absence. See Alain Badiou, "Pierre Guyotat, Prince of Prose," in *The Age of Poets*, ed. and trans. Bruno Bosteels, London: Verso, 2014, 194–205.

41 Badiou, "Third Sketch," 148.

leave the purchase of any subtractive orientation moot; as he puts it: "Empirically, it is clear that atonic worlds are simply worlds which are so ramified and nuanced—or so quiescent and homogeneous—that no instance of the Two, and consequently no figure of decision, is capable of evaluating them."[42] This lack condemns us to an effect of disorientation without any moment of construction or decision. Badiou's suggestion that we need to perform an "originary subtraction capable of creating a new space of independence and autonomy from the dominant laws of the situation"[43] would leave us back in those little corners of freedom that Negri regards as passé.

The point of tension, or even failure, here is in strange symmetry with Negri. In the case of Negri we have the "positive" reading of the paradox of valorization. The fact that capitalism is dominant indicates that it is fundamentally vulnerable to the powers of the multitude on which it depends. All that is required is a reversal. Badiou is more pessimistic, in one sense. In the face of the dominance of capitalism the artist—and activist—must construct or produce new sites resistant to this dominance. Neither thesis seems particularly convincing. Negri requires a reversal that does not seem to appear, and which seems to regard contemporary capitalism as already a nascent communism. Badiou does not seem able to specify the actual spaces and forms of "monumental construction" that could escape being mere ghettos of the art world.

The Art of Distribution

The work of Jacques Rancière is in explicit opposition to the kinds of framings on which Negri and Badiou depend,

42 Badiou, *Logics*, 420.

43 Alain Badiou, "'We Need a Popular Discipline': Contemporary Politics and the Crisis of the Negative," interview by Filippo Del Lucchese and Jason Smith, *Critical Inquiry* 34 (2008), 645–59, 653.

especially their stress on the powers of capital. For Rancière the narratives of increasing abstraction, of real subsumption and of the dominance of the society of the spectacle are counsels of despair. He does not accept the alternative Negri poses between "preserving a corner of freedom" and embracing the monstrous mutational powers of capital as our own. Nor does he accept Badiou's nostalgic invocation of a purified modernism, which Rancière regards as a "twisted modernism."[44] Instead, Rancière's contention is that if we break with the narrative of the totalizing domination of capitalism, we can also break with the false political alternatives that end in either hyper-optimism or hyper-pessimism. In staking this claim, Rancière wants to pose more room for artists to maneuver, so they are not simply trapped in the dialectic of valorization, which also suggests at least one reason for his popularity with artists.

Rancière argues that it is necessary "to contrast so-called historical necessity with a topography of the configuration of possibilities, a perception of the multiple alterations and displacements that make up forms of political subjectivization and artistic invention."[45] This means that no historical necessity dictates the fate of the artist as doomed to always being recuperated by capitalism. This kind of construction serves an agenda that flatters the philosopher or theorist who is somehow free of this domination and can lay down the law to the rest of us dupes. Politics has not been eliminated by an atonal capitalism, or left to the inevitable triumph of the Spinozist powers of the multitude. Instead, politics is an *art*, or more precisely an *aesthetic*, of "disagreement" (*la mésentente*).

44 Jacques Rancière, "Aesthetics, Inaesthetics, Anti-Aesthetics," in *Think Again: Alain Badiou and the Future of Philosophy*, ed. Peter Hallward, London: Continuum, 2004, 218–31.

45 Jacques Rancière, "Art of the Possible: Fluvia Carnevale and John Kelsey in Conversation with Jacques Rancière," *Artforum* XLV: 7 (2007), 256–59, 261–64, 266–67, 269, 257.

This disagreement, which is a fundamental possibility in all social and artistic situations, requires the deliberate disruption of accepted roles, social stratifications and arrangements. It is "a way of reconstructing the relationship between places and identities, spectacles and gazes, proximities and distances."[46] To use the telling title of the interview I am quoting from, it is an "art of the possible."

In this way, we see in Rancière a reworking of scale—capitalism is scaled down from being an all-encompassing monstrous mechanism of capture. Also, the demands of political art for the fusion of art and life are scaled down as well. Instead, the art of the possible works between these two forms of fusion: the fusion of art with capital and the fusion of art with politics. The site of the political is an aesthetic site that involves a new art of distribution that does not suppose a necessary solution. We might note an echo here of the Cold War discourse that rejected the "totalitarian" politicization of art for the "freedom" of nonpolitical art. Rancière also echoes more contemporary discourses that promote the network or the relational as offering modest minor "freedoms," against the grand claims of heroic modernism.[47] He also adopts the contemporary position of rejecting critique: "If there is a circulation that should be stopped at this point, it's this circulation of stereotypes that critique stereotypes, giant stuffed animals that denounce our infantilization, media images that denounce the media, spectacular installations that denounce the spectacle, etc."[48]

46 Ibid., 267.

47 On this discourse, see Benjamin Noys, "Matter against Materialism: Bruno Latour and the Turn to Objects," in *Theory Matters: The Place of Theory in Literary and Cultural Studies Today*, eds. Martin Middeke and Christoph Reinfandt, London: Palgrave Macmillan, 2016, 81–93; and "The Discreet Charm of Bruno Latour," in *(Mis)readings of Marx in Continental Philosophy*, eds. Jernej Habjan and Jessica Whyte, Basingstoke: Palgrave, 2014, 195–210.

48 Rancière, "Art of the Possible," 266.

While amusing enough, Rancière's point seems to blunt the general question of critique by dismissing it totally. He then constrains the true merit of "critical" art to the role of refiguration, which functions as a stand-in for critique. Rancière argues that the aim of the artist and art is: "to discover how to produce forms for the presentation of objects, forms for the organization of spaces, that thwart expectations."[49] The suggestion is that if we scale down the role of art and the artist we actually release more powerful possibilities. In Rancière's model of fundamental disagreement, artistic possibility finds its power in disruption, rearrangement and the thwarting of "political" expectations—whether these come from existing power arrangements or the formulation of "counter-powers." He resists what he regards as the automatic nature of Negri's dialectic and the pessimism of Badiou's condemnation of capitalist nihilism. Instead, Rancière retains qualified faith in the possibility of the artist or artwork as prefiguring the disruption that is socially characteristic of communist "moments."

There is, however, more in common between Rancière and his antagonists than might first be supposed. The point of agreement lies in the conception of the role of art and the artist. In the case of all three thinkers, we can see a common dissatisfaction with any pedagogic, hyper-political art. This is often couched in a critique or historicizing distance from the avant-gardes of the 1920s, but I think it reflects a more local rejection of the reinvention of such projects in the 1960s and 1970s. One symptom of this is a common wariness in relation to the political and aesthetic projects of Guy Debord and the Situationists. The Situationist articulation of the "society of the spectacle," and their austere practice of political "'art'" (not least in Guy Debord's films), is seen as the final avant-garde.[50]

49 Ibid., 263.
50 Alain Badiou, *Theory of the Subject*, trans. and intro. Bruno Bosteels, London: Continuum, 2009, 329; Jacques Rancière, *The Emancipated Spectator*, London and New York: Verso, 2008; Jacques

The problem, which is shared by Negri, Badiou and Rancière, is to go beyond this final form of "political modernism."[51] Certainly, Rancière appears to be the most hopeful or even "empowering" thinker. That said, there is a degree of pessimism in Rancière's work, and this concerns the power of the artist. The artist is limited to powers of reconfiguration or redistribution of the sensible. This could be regarded as merely the power to rearrange existing elements, and so hardly likely to differ from existing capitalist realities. In fact, we are limited in our powers of critique because Rancière associates critique with the inflation of the powers of capital. He suggests that capitalism has recuperated critique and can get along fine with it. Denouncing capital is, we could say, good for business. The replacement is the "power" of disagreement and redistribution, which can never be eliminated. The difficulty, however, is articulating this power within and against contemporary forms of state and capitalist power. While Rancière may object to a "totalitarian" model of capitalist power, he has no analysis to put in its place. The unkind could even suggest that the emphasis on redistribution and disagreement falls within a capitalism dependent on innovation and renovation.

The Art of Abstraction

I have canvassed these different theoretical "solutions" to the paradox of valorization, while indicating my own skepticism with each. Here I want to draw a preliminary balance sheet by identifying what I regard as the crucial questions each of these philosophers poses to any attempt to resolve the paradox of

Rancière, "When We Were on the Shenandoah," trans. Jason E. Smith, *Grey Room* 52 (2013), 128–34.

51 Steve Edwards, *Martha Rosler: The Bowery in two inadequate descriptive systems*, London: Afterall, 2012, 84–100.

valorization. Rancière is correct that our narrative or description of capitalism is crucial to how we frame the problem of art and artistic valorization. My difficulty is that Rancière simply abandons any narrative of capitalism. Instead, he replaces it with a *longue durée* characterization of art in terms of an aesthetic regime constituted in the late eighteenth and early nineteenth centuries (what is usually regarded as the period of Romanticism). While we could long debate Negri's periodization of capitalism and art in terms of real subsumption or Badiou's periodization of the short twentieth century, we can say that they at least present a more fine-grained attempt to grasp mutational shifts in capitalism *and* art. In the case of Rancière, it seems, capitalism tends to drop out altogether, in favor of a model of the political qua disagreement as continuous possibility.

At least Rancière's deflationary approach recognizes the reality that artists might require actual employment within capitalism. That said, Rancière persists, I would argue, in misframing the operations of capital to inflate political and artistic capacities. This is a consoling vision but seems to miss the capacities of capitalism. In contrast, Badiou's fraught discussion of subtraction does have the capacity to realize the stakes involved. While Badiou sometimes seems to slide into recommending "enclaves" of resistance, his stress on the difficulty of subtraction does register the power of capitalism. This is also true of some of Negri's formulations. While Negri relies on a quasi-Christian model of transfiguration of powerlessness into power,[52] his work in the 1980s offers a more critical engagement with capitalism's powers of abstraction. The stress on our immersion in capitalism—thinking of Joseph Conrad's phrase "in the destructive element immerse"—makes this problem unavoidable. If we take a cue from Negri's "punk realism," which unfortunately he did not explicate, this might suggest

52 Alberto Toscano, "The Sensuous Religion of the Multitude: Art and Abstraction in Negri," *Third Text* 23: 4 (2009), 369–82, 377.

a way to be "within and against" these forces of abstraction. Alberto Toscano notes the continuing relevance of the problem Negri poses: "The quandary of art in the postmodern would thus lie for Negri in the invention of an unprecedented realism, a non-representational realism, capable of rearticulating the present into something other than a system of global indifference."[53] Of course, the question then is: what would that look like?

One path here is to suggest that Negri, Badiou and Rancière too rapidly abandon the legacies and possibilities of the historic avant-gardes for their own alternatives of mutation (Negri), subtraction (Badiou) and disagreement (Rancière). Currents within contemporary art and critical practice have argued that the way through the quandary of inventing an "unprecedented realism" is through avant-garde attempts to answer this question. We might call this a creative repetition. For example, we have the cartographic work of Allan Sekula, who integrates Brechtian montage with Lukácsian realism in an effort to map the contemporary forms of capitalist power.[54] There has been a series of historical and critical engagements with the experience of exhaustion, defeat and saturation that confronted the "historic" avant-gardes.[55] This is a more patient work that does not try to recreate the "heroism" of the avant-gardes, but works on unrealized potentials and possibilities to formulate an artistic practice beyond the usual binaries. There is a realism, in the everyday sense, that we cannot simply claim past avant-gardes to justify our contemporary political

53 Ibid., 378.

54 Gail Day, "Realism, Totality and the Militant *Citoyen*: Or, What Does Lukács Have to Do with Contemporary Art?," in *Georg Lukács: The Fundamental Dissonance of Existence*, eds. Timothy Bewes and Timothy Hall, London: Continuum, 2011, 203–20; Alberto Toscano and Jeff Kinkle, *Cartographies of the Absolute*, Winchester: Zero, 2014.

55 John Roberts, "Revolutionary Pathos, Negation, and the Suspensive Avant-Garde," *New Literary History* 41: 4 (2011), 717–30.

identity. At the same time, pace Negri, Badiou and Rancière, we also cannot abandon so rapidly these legacies.

Of course, advice to artists is a perilous, although popular, genre. Here I prefer to think more about the way in which the problem of value might be posed and the necessity for us to confront and *think* of this situation. That said, especially considering the function of the abstract, we can recall a remark by Theodor Adorno: "Those who create works which are truly concrete and indissoluble, truly antagonistic to the sway of culture industry and calculative manipulation, are those who think most severely and intransigently in terms of technical consistency."[56] Again, this is an open formulation, if we leave aside Adorno's own aesthetic choices and recommendations. What I think is useful is that it engages with what something like what Negri calls a "punk realism." Obviously, this phrase would be anathema to Adorno, and the word "punk" carries a problematically nostalgic ring.[57] While we might read Adorno as recommending that the path to the concrete is attention to the "concrete" of technical consistency, I think this is too simple a reading. Instead, I think Adorno is suggesting that the "concrete" cannot simply be reached "as is" but only through a process of mediation and engagement with abstraction.

Adorno poses this problem in terms of philosophy: "Because concreteness has vanished in a society whose law condemns all human relations to abstractness, philosophy wants desperately to evoke concretion, without conceding the meaninglessness of existence but also without being fully absorbed into it."[58]

56 Theodor W. Adorno, *Notes to Literature, Volume Two*, trans. Shierry Weber Nicholson, New York: Columbia University Press, 1992, 296.

57 On the temporality of punk and post-punk in relation to artistic re-elaboration, see Benjamin Noys, "No Future: Punk and the Underground Graphic Novel," in *The Cambridge History of the Graphic Novel*, eds. Jan Baetens, Hugo Frey and Stephen E. Tabachnick, Cambridge: Cambridge University Press, 2018, 235–50.

58 Adorno, *Notes to Literature, Volume Two*, 330.

Whereas Adorno had in mind phenomenology, one does not have to look far today: consider the "object" and its recent adventures to see this desire to evoke concretion at work. In fact, the relative success of such a philosophy in terms of art, which is of course often "composed" of objects, indicates, I think, the problem of the jumping too fast without mediation to the "concrete." This only ever results in another abstraction. Adorno, reflecting on Walter Benjamin, notes that Benjamin's adding of "materialist salt" to the object requires we recognize that the object is inherently socially mediated.[59] It is here, in this "realism of the abstract," that I think a critical engagement with the paradox of valorization lies.

59 Ibid., 328.

12

Numbers

Brian Kuan Wood

1. The Martian

At some point, everything's gonna go south on you...everything's going to go south and you're going to say, this is it. This is how I end. Now you can either accept that, or you can get to work. That's all it is. You just begin. You do the math. You solve one problem and you solve the next one, and then the next. And *if* you solve enough problems, you get to come home. All right, questions?

—Mark Watney (played by Matt Damon) in *The Martian*

You do the math and you get to come home. These triumphal closing lines of Ridley Scott's 2015 film *The Martian* are delivered to a class of university students eager to hear the story of the man who survived and was rescued from Mars. Of course, it is not a true story. But the film is a peculiar parallel to Steven Spielberg's 1998 *Saving Private Ryan*, about a handful of US troops who penetrate enemy lines to rescue a lone soldier (oddly enough, also played by Matt Damon) during World War II. Against all odds, a vast national military or space agency is placed in the service of saving a single life. Whereas *Saving Private Ryan* summons blood and sweat to penetrate enemy lines, in the case of *The Martian*, the power of the state must use science and knowledge to confront a much larger opponent: an inhospitable universe. The nation, through NASA, must summon mathematical and

computational power to struggle against the vastness of space and time before the externalities of duration (life span, food supply, Martian climate) close around what a single human life can endure. The enemy lines of *The Martian* are these externalities, and the means of penetrating them comes not through military struggle but intellectually, through mathematical modeling. When you solve enough problems, you get to come home.

Today, the trillionfold increase in processing power experienced over the second half of the twentieth century and into the twenty-first is slowing down, yet the ways of using and exploiting—or inhabiting—this enormous power are still being explored.[1] The power to communicate, to organize the transportation of goods and people across distances, to register and synchronize changes in value as they enter and exit various zones have radically expanded the way that space and time are expressed and perceived. Yet these extensions are only possible through the medium of alphanumeric or mathematical calculations, which move through space and time with an ease that objects or human bodies cannot match. As Donna Haraway once wrote: "Our best machines are made of sunshine; they are all light and clean because they are nothing but signals, electromagnetic waves, a section of a spectrum, and these machines are eminently portable, mobile—a matter of immense human pain in Detroit and Singapore. People are nowhere so fluid, being both material and opaque."[2] While objects and human bodies are distressed or damaged by the pressures of movement, numbers always arrive at their

1 See Experts Exchange, "Processing Power Compared: Visualizing a 1 Trillion-Fold Increase in Computing Power," pages.experts-exchange.com and "The Future of Computing; After Moore's Law," *The Economist*, March 12, 2016, 11.

2 Donna Haraway, "A Cyborg Manifesto: Science, Technology, and Socialist-Feminism in the Late Twentieth Century," in *Simians, Cyborgs and Women: The Reinvention of Nature*, New York; Routledge, 1991, 149–81.

destination just as they were at their origin—a 5 stays a 5 anywhere in the world, just as it was a 5 three thousand years ago. However, it's important to note that when mathematical vectors are used for modeling, they are not able to plot space in the same way as time. Henri Bergson is known for insisting on the primacy of lived duration in experiencing time:

> As we have said, when one wishes to prepare a glass of sugared water one is obliged to wait until the sugar melts. This necessity for waiting is the significant fact. It shows that if one can cut out from the universe the systems for which time is only an abstraction, a relation, a number, the universe itself becomes something different. If we could grasp it in its entirety, inorganic but interwoven with organic beings, we should see it ceaselessly taking on forms as new, as original, as unforeseeable as our states of consciousness.[3]

Time is extremely difficult to model through mathematical abstractions, whose absolute vectors cannot account for changes that occur. Space, on the other hand, can be assumed as being more absolute, stable and linear—Bergson adds that "when we evoke time, it is space which answers our call," for our understanding of temporal change often suffers from having the properties of space prematurely projected onto it.[4] This can be quite easily imagined through the utility of Google Maps, whose coordinates are usually accurate: one's destination rarely changes position in the course of traveling toward it! In modeling time, however, it is tempting to consider Bergson's foundational principle in relation to the market crash of 2007–08, when immense computational power aided US banks in speculating the value of assets that had become so profoundly abstracted from their real-world application that they detached from even their own values. Many of

3 Henri Bergson, *The Creative Mind*, trans. Mabelle L. Andison, New York: Citadel Press, 1974 [1946], 20.
4 Ibid., 14.

these assets were created from collateralized insurance and debt packages, essentially instruments for protecting against contingencies of nonpayment or accounting for changes in market values spread over time. And it is paradoxical that, if for Bergson lived experience is what truly measures time, thousands of people were "abstracted" from the very base of their lived experience: their homes.

It is against the backdrop of such predatory forms of financial abstraction that much of the artist duo Goldin+Senneby's work is situated, and so in 2016 they were invited to present part of a larger retrospective show in the library of the Stockholm School of Economics. Among the works that faculty and students of the school found themselves confronted with was *Zero Magic*, a "magic" box containing computer software called Zero Magic, a US patented application for a "Computer Assisted Magic Trick Executed in the Financial Markets" and four historical examples of magic tricks played out not as a performance on a stage, but in the world at large.[5] Though apparently made of cardboard, the magic box could resemble the "black box" of computer hardware—a server performing calculations unavailable to the human eye due to their complexity, speed the secretive nature of magic, or for all of these reasons. The patented magic trick Goldin+Senneby developed together with the magician Malin Nilsson and finance sociologist Théo Bourgeron was originally sourced from a secretive hedge fund in the United States; it was designed to use short-selling tactics to undermine the perceived value of a publicly traded company and to then profit from the difference. Of course, it is extremely likely that the original tool sourced

5 See United States Patent Application 20160125542, Inventors: Goldin; Simon Andreas; (Stockholm, SE) ; Senneby; Jakob Hannes Gustaf; (Stockholm, SE) ; Nilsson; Malin Margareta; (Malmo, SE) ; Bourgeron; Theo; (Edinburgh, GB). Full link at: <http://appft1.uspto.gov/netacgi/nph-Parser?Sect1=PTO1&Sect2=HITOFF&d=PG01&p=1&u=/netahtml/PTO/srchnum.html&r=1&f=G&l=50&s1=20160125542>.

from the US hedge fund performed a similar task. Displayed on a plinth, the cardboard magic box would be unremarkable were it not surrounded by a five-sided abacus—a cage sealing in the secretive magic while outwardly performing elementary calculations for all to see. It is indeed a portrait of the two faces of computing: hidden magic, trickery or even powers, and a user interface simple enough for a child to engage with. As a computer, Goldin+Senneby's *Zero Magic* poses a crucial question concerning how it can be possible to reconcile the universal availability and clarity of numerical calculation with the deep (and perhaps equally universal) mysteries and mystical properties also ascribed to numbers. I will deal with this later on.

Many people were astounded by the fact that the catastrophic market crash of 2007–08 did not bring about significant changes in the financial world. New regulatory measures were introduced and toxic tendencies were acknowledged, but, now a decade on, it would appear that the general consensus was that the problem had to be understood as a glitch in a much larger fully functional economic system, or at least one whose power had not yet been exhausted. And it was perhaps naive at the time to foresee the end of capitalism (when we all know capitalism is constantly ending through the perpetual production of catastrophes) when in fact it was most likely an important stress test, marking a new era of computational abstraction—for it has now become clear that the models used for projecting changes in value over time produced feedback, creating numerical values detached from the real-world commodities they were created to account for. How, then, are we to understand this peculiar weaponization of numbers? Numbers are by definition abstract, and even in ancient times were considered to hold incredible power, even as a regulating force for the universe itself. We might begin by asking: how could such a strictly formal world of numerical calculation have unleashed the capacity for creating seemingly

unlimited self-contained worlds? How does the modeling of such worlds invite or restrict habitation by non-numbers such as humans? Eventually, we may be able to ask: do these worlds access, or even amplify, ancient cosmological approaches to numbers and numerology as universal forms regulating and reflecting the chaos of the universe? And from such apparently paradoxical movement between the regulation and reflection of chaos, might it be possible to derive important social and aesthetic functions as well as promise?

An Economist's Paradise

On June 14, 2012, only two years before becoming the charismatic minister of finance in Greece with Syriza's election victory, Yanis Varoufakis wrote a blog post detailing how he became involved as an "economist-in-residence" with a well-known gaming company called Valve. "It all began with a strange email," as Varoufakis details in his initial blog post for the company. The post describes how he was contacted unexpectedly by the president of Valve, Gabe Newell, who candidly described that the company was working to "wrestling with some of the thornier problems of balance of payments" in "linking economies in two virtual environments (creating a shared currency)." It struck Newell that he should contact Varoufakis directly when it occurred to him: "This is Germany and Greece."[6]

Varoufakis took the job almost immediately, describing the remarkable and wonderful young people and working environment at Valve, but also the "economist's paradise" of being able to experiment meaningfully in an economic setting in which the information set was total. A virtual gaming

6 See Yanis Varoufakis, "IT ALL BEGAN WITH A STRANGE EMAIL," Valve Economics blog post, June 14, 2012, blogs.valvesoftware.com.

environment is by definition made of pure metrics—every interaction is accounted for. For Varoufakis, this would allow an escape from the "computerized astrology" nightmare of econometrics, whose statistical reliance on "empirical regularities lacking any causal meaning" identified patterns of behavior without knowledge of real-world factors that might explain them; for instance, whereby "Christmas is explained by a prior increase in the demand for toys."[7] It would appear that in such an economist's paradise there would be neither Christmas nor toys—or that Christmas would appear as a calculable demand (rather than a fuzzy human intention) before the demand for toys would begin.

The end of Varoufakis' brief time at Valve is no doubt part of history, yet his own documentation of his beginning remains curious. What were these "two virtual environments" described in Gabe Newell's initial e-mail? Supposedly, Valve was experimenting with in-game currencies circulating in a secondary market that could synchronize with real-world currency inputs. Such "synthetic economies" have been under development since the early 2000s, when games such as *World of Warcraft* and environments like *Second Life* successfully experimented with exchanging real money for virtual goods. Research into these secondary markets has identified them as black or grey markets hosting extreme income equalities in their own right by pegging the value reaped to either time spent in the game or to the amount of initial investment. They are certainly incredibly fascinating in their own right. But even more fascinating is Valve's president's apparently poetic, and even radical, comparison of the two virtual economic environments of game currency with the all-too-real economies of Germany and Greece. For Gabe Newell, it appeared that Germany and Greece were already inside of such an environment.

7 Ibid.

With Greece's debt crisis triggered in 2009 following the global financial crisis of 2007–08, and its subsequent bailouts by the International Monetary Fund and the European Central Bank, it had already become clear that the country was in dire straits. As the EU's largest economy, Germany had assumed its present position as the EU's debtor. What does Varoufakis's ready acceptance of the poetic equivocation of the virtuality of these two economies mean? Does he intend to say that gamespace is merely a paradise for an economist, or rather that gamespace is actually the real world of the economy itself?

Gamespace

> Everybody knows it is just a figure of speech to speak of the "market forecast" of volatility. When I say the market is the technology of the future, I never meant it in the sense that the future would be here for us to absolutely read from the market!
> —Elie Ayache[8]

> You can go anywhere you want in gamespace but never leave it.
> —McKenzie Wark[9]

If indeed the debts between nations are better understood as synthetic currencies, then undoubtedly the programming and architecture of the game become more important than the value of the currency, for the former can only make the latter possible. Seen this way, money becomes code—pure algorithmic and numerical calculation. What, then, is the architecture of the game? If the map has indeed become the territory, how do we understand the peculiar terrain of the map itself? While Baudrillard's theories of simulacra are clearly relevant today, it

8 Elie Ayache, *The Blank Swan*, Clichester: John Wiley & Sons, Ltd, 2010, 171.

9 McKenzie Wark, *Gamer Theory*, Cambridge, MA: Harvard University Press, 2007.

is interesting to note the recurring primacy of the real in relation to the virtual in his writing. Even if the real has been utterly evacuated and people are doomed to become commodities, the real persists as an ancestral home to which we are barred access. Where Baudrillard faced the dread of simulations treating people as commodities on the market, today it is more accurate for people to fear becoming numbers in a game. Where commodities appeal to subjective and affective domains of desire, numbers carry a much stronger and more direct claim to an empirical and scientific domain. The architecture and construction of this domain thus becomes the game—as well as the place where subjective desires and even deliberate misunderstandings are installed. In an interesting way, the claim that numbers are dehumanizing can only be ridiculous, for numbers are by definition inhuman and absolute points used to measure relations. Games, on the other hand, establish a playing field where those relations then become a lifeworld inhabited by humans. A number will not subtract life or humanity from a person but will only measure the amount subtracted by another human within the game.

The great reliance of economic, social and political activity on computational means has rendered those means an intractable part of the activities themselves. High-frequency trading is accompanied by the risk of global financial meltdown, social network-driven uprisings have opened new inroads to authoritarian regimes (or worse) and access to information creates a reverse opening to spying and harassment while online news mixes with fake news and bot armies paid by state agencies to troll and spread "opinion." Feminist data scientist Cathy O'Neill has remarked, "Thanks to the extraordinary powers that I loved so much, math was able to combine with technology to multiply the chaos and misfortune, adding efficiency and scale to systems that I now recognized as flawed."[10] As

10 Cathy O'Neill, *Weapons of Math Destruction*, New York: Random House, 2016, 2.

democratic processes become "number games" of exit polls and campaign fundraising, voters themselves vote against their own economic or social interests simply to undermine technocracy, to opt out from the game itself.[11] Supposedly, abolishing technocratic gameplay would herald a return to the primacy of the real. But when numbers represent absolute values, where else could the real possibly be found? What if we were to instead seek out the real within the fabric of simulation, in the material or formal aspects of gameplay itself?

In *Gamer Theory*, McKenzie Wark suggests that "the game might not be utopia, but it might be the only thing left with which to play against gamespace." Earlier: "You do not play the game to win (or not just to win). You trifle with it—playing with style to understand the game as a form. You trifle with the game to understand the nature of gamespace as a world—as *the* world."[12] In *Gaming*, Alex Galloway described gameplay as an operational correlative to Roland Barthes' foundational postmodern distinction between text and work, whereby the text can be attributed to an author but a work can be reshaped and filled by readers' subjectivities. The architecture of a game thus functions as a script, but the play of a game can refashion that script by grappling with its inner logic: "Play reconstitutes the field, not to create a new wholeness but to enforce a sort of permanent state of nonwholeness, or 'nontotalization.'"[13] The intricacies of these encounters suppose diegetic actions occurring within the script's narrative as well as non-diegetic actions arriving from a meta-domain of the user or the hardware of the console. These meta-behaviors can range from cheating (undermining the rules of the game) to pausing the game, which can be "as significant as shooting a weapon."[14]

11 This seems to underlie many Brexit and Trump voters' "antiestablishment" motivations in 2016.

12 Wark, *Gamer Theory*.

13 Alexander R. Galloway, *Gaming: Essays on Algorithmic Culture*, Minneapolis/London: University of Minnesota Press, 2006, 26.

14 Ibid., 8.

Gamespace quickly becomes less a metaphor than a concrete reality when considering the degree to which managing personal finances already overlaps with gameplay. In most games, a player's remaining life or number of points gained is measured and displayed as a finite amount. A player is always mindful of this figure as if noting the amount of money available in one's own bank account. What would happen if we were to assume the bank account to be the specific measure of life remaining in the game—a larger field of course, but gamespace nonetheless. Though we know wealth can never reflect a person's true value, it can be said to reflect the amount of life or power remaining in worlds that recognize its currency. This is the larger gamespace Wark describes in *Gamer Theory*—the gamespace of computational capitalism, and perhaps by extension the fluid power relations that emerge from the contingencies released by it. On one hand, it should offer some relief to remember that a game is nothing more than a model and a form of hypothetical play. At the same time, as the rules and architecture of this game grow further entangled with life-sustaining processes, it becomes a game no one can afford to lose.

In many parts of the world now, digital wallets are replacing cash as well as credit cards—in China, WeChat and Alipay have made credit cards payments almost obsolete. Nearly all street vendors, landlords and even some beggars now accept digital payments. In the United States, Apple Pay is becoming common as a standard, but at a slower rate than in China. The advantage of digital wallets is not only in the convenience of waving one's phone at a point of sale to buy a coffee or split a dinner check. On a higher level—for economists, for instance—they promise the phasing out of liquid currency and the full integration and registration of all payment activity within a single framework. It begins to look precisely like the economist's paradise of a total dataset that Varoufakis described in the case of Valve's online gaming engine, where

all transactions are recorded and subject to analysis, from the level of the individual to that of the society. Just as it offers a clear picture of an individual's movements to serve the purposes of surveillance (or of their buying habits for targeted product placement), it offers an economist or government official an unparalleled image of real economic activity in incredibly high resolution.

When combined with one's browsing history and private exchanges, a human or machine can assemble a quite detailed picture. Philosopher Matteo Pasquinelli has pointed out that, for all their faults and biases, pattern recognition algorithms have, with vast computational power and ever-larger datasets at their disposal, become so powerful that they now identify real patterns that were previously undetectable by humans themselves—which is to say that I could learn things about myself and my own history or family history that I myself had not been aware of before. It is important to note that, once their results attain the status of real knowledge, their empirical value is often too strong for what they reveal to become unknown.[15] This situation vastly supersedes the Orwellian Big Brother surveillance state paranoia we remember from earlier eras of moralist or militarist police-state control, for nonideological economic management must first and foremost embed itself in existing life processes in order to maintain command.

Given the enlarging of gamespace to the scale of a lifeworld, we might ask to whom this gamespace answers: who is its architect and whom must *it* obey? Put another way, if gameplay and life processes can indeed be made so seamlessly interchangeable, could it be that they in fact share more than previously thought? Or could it be that the border between real world and game worlds is little more than a moral boundary between sacred and profane, established to maintain order

15 Legal scholar David Kim has pointed out that once knowledge has been made empirical, it is extremely difficult to restore its former status.

for the psyche? Were that boundary to be removed, we might, like Neo in *The Matrix*, blossom into a full realization of our own powers and capacities in perceiving the world as an absolutely programmable meta-platform. Or perhaps we would instead end up closer to the figure of the gamer in China who wears a diaper to avoid leaving the game even to use the bathroom—on one hand a slave or prisoner to the game, but on the other hand a god ruling over many worlds. And what kind of god takes bathroom breaks? None that I know of.

Numerology

> Music is the unconscious joy that the soul experiences on counting without realizing that it is counting.
> —Gottfried Wilhelm Leibniz[16]

What happens when gamespace not only describes the virtual worlds created by capitalism or computer modeling, but the functioning of the universe itself? For those who prefer the Platonic cave allegory found endlessly in films such as *The Matrix* or *The Truman Show*, the encounter with the real is created by a painful liberation from the creature comforts of false consciousness.

But even in Plato's cave, the slaves who have been liberated from their enslavement to illusion exit the cave to encounter a world with few characteristics beyond the light of the sun. The domain of the real in Plato's allegory is in fact so abstract that one wonders how real such a space can actually be in relation to the cave—and indeed, seen today, Plato's description of the cave resembles precisely the architecture of a cinema. The question remains whether it comes as a relief or a horror to leave the myopia of gamespace only to be faced

16 Gregory Chaitin, *META MATH! The Quest for Omega*, New York: Vintage Books, 2005, 47.

with a universe that looks uncannily similar and even operates according to similar rules. One might also rephrase the question in a more extreme way: If it were possible to identify that the universe itself operated according to a binary code similar to digital instruments, then would computer models—even reductive ones—of that universe be any different from the universe itself?

Alfred North Whitehead described Western philosophy as a series of extended footnotes to Plato. But before Plato, Greek philosophy was engaged in a far more mystical investigation into the laws of the universe informed by Egyptian, Chaldean, Phoenician, Arabic, Jewish and Persian traditions.[17] For Pythagoras, who greatly influenced Plato and is known for having developed the theorem for the right-angled triangle and the western system of musical notation, numbers offered direct access to the source code of the universe. But before Plato and Aristotle began to develop the terms for distilling a scientific viewpoint, Pythagoras' interest in numbers was an ecstatic one—he is known for playing enchanting music on the monochord and for having the ability to communicate with animals. There is even a story of how he tamed a wild stallion by whispering into its ear after it had previously killed those who tried to tame it through more conventional means. For Pythagoras, numbers were a crucial means through which the universe gives form—and ethics—to matter that would otherwise flow infinitely. And it is the logical systems derived from numbers that reveal what we might call God's programming language. To build with this language is to create music and philosophy, as well as communication with other forms of creation—animals, matter and the cosmos itself.

In West African drumming, the different metrics of rhythm are often said to create tension through suspending a state

17 Algis Uždavinys, "Introduction" in *The Golden Chain: An Anthology of Pythagorean and Platonic Philosophy*, ed. Algis Uždavinys, Bloomington: World Wisdom, 2004, 8.

of permanent contradiction—it can also be called syncopation, cross-rhythm or even funk. It happens on the level of timing, or a sophisticated metric that expands and contracts, falling in and out of alignment through overlapping patterns based in twos and threes. Consider how difficult it is, how much strength is required to persist in playing your own meter within and against an ensemble playing in another time. You have to force your way forward, knowing that what you're doing is correct when you are also completely off the grid—operating by your own grid, folding it onto their grid and falling back off. This is not Western music, whose orchestra looks like some kind of parliament assembly, reading from scripts and following the direction of a conductor.

If we want to stay in the domain of primary numbers, it should come as no surprise that Gottfried Wilhelm Leibniz, the seventeenth- and eighteenth-century "universal" philosopher credited with the discovery of binary code (as well as with integral calculus and the encyclopedia), first learned of the *I Ching* from a Jesuit missionary friend in China.[18] The *I Ching* is an ancient Chinese text whose origins are often described in the same mythical terms as the origin of humanity, and it is structured as a "game" for divining many possible fortunes using a binary code. Zero and one correspond with *dào* ("the way") and *qì* ("material energy"), male and female, presence and absence, on and off, form and matter. These are not moral parameters, but a kind of source code of the universe that allows for more complex combinations of things to come into being. If the ethos of globalization has been that it is only through money that we can connect to one another and to the cosmos, we might find some reassurance in realizing that it is only through computation that we can even connect to money—or, to put it differently, it is only through numbers. Perhaps connecting to one another and to the

18 Thanks to Jack 阿德 for pointing this out to me in Hangzhou.

universe through numbers is not an altogether absurd idea if
we are to take the numerical fundamentalism of the *I Ching*
and its binary code as our point of departure.

From medieval guilds to today's contemporary art fairs,
artists have always served power, or they have sought to avoid
power completely. However, this comes as a matter of immense
human pain in places where art students and young artists have
learned to be autonomous, sovereign or even bohemian agents
of free creativity. But from where is this power to be derived?
Who ensures and protects this sovereignty? The state, through
funding bodies such as arts councils? The father who provides
the stipend? The gallery, through the market? The artist's own
obstinacy and grit? Or God, through the moral principle of
autonomy as a human entitlement? Rather than approach this
equation as a zero-sum game where, no matter which direc-
tion we turn, we must sell our soul, perhaps we should look
instead for ways of accessing the source code through which
power itself becomes fluid and diffuse, for the points at which
we can neutralize and defuse the question entirely.

Michel Foucault has been criticized for having taken consid-
erable interest in the 1970s American neoliberals of the Chicago
School—Milton Friedman, Gary Becker and others who were
essentially the architects of the neoliberal economic theories
adopted by Reagan and Thatcher in the 1980s to dismantle
social services, and which has become a norm throughout most
of the world today. But it is interesting to revisit what he says in
his *Lectures on Biopolitics* from 1978–79:

> [the American neoliberals] try to use the market economy and
> the typical analyses of the market economy to decipher non-
> market relationships and phenomena which are not strictly
> and specifically economic but what we call social phenomena...
> what I think is at stake in this kind of analysis is the problem of
> the inversion of the relationships of the social to the economic.
>
> On one side it means generalizing the "enterprise" form
> within the social body or social fabric; it means taking this

social fabric and arranging things so that it can be broken down, subdivided, and reduced, not according to the grain of individuals, but according to the grain of enterprises. The individual's life must be lodged, not within a framework of a big enterprise like the firm or, if it comes to it, the state, but within the framework of a multiplicity of diverse enterprises connected up to and entangled with each other, enterprises which are in some way ready to hand for the individual, sufficiently limited in their scale for the individual's actions, decisions, and choices to have meaningful and perceptible effects, and numerous enough for him not to be dependent on one alone. And finally, the individual's life itself—with his relationships to his private property, for example, with his family, household, insurance, and retirement—must make him into a sort of permanent and multiple enterprise.[19]

Reading this today, it would appear that what he calls "the grain of [permanent and multiple] enterprises" is no longer small business or even currency but has been subdivided further into smaller grains—clicks, views and hits. If we were to continue to process of reduction, to break the grain down to ones and zeroes, would we end up with such a fundamental and basic substance shared with many other domains of life that we could essentially build back up into whatever we want?

Today we may recognize that what Foucault saw in the atomization of state or social economic management down to the level of private, family or individual enterprise has undergone a further step of pulverization down to the level of intelligent units. Blockchain architecture is most exemplary for being reducible to a vapor cloud of bits that can instantaneously reassemble itself into its original totality once all its pieces are present and accounted for. The remarkably high level of abstraction used in BitTorrent files, for instance,

19 Michel Foucault, *The Birth of Biopolitics: Lectures at the Collège de France, 1978–1979*, ed. Michel Senellart, trans. Graham Burchell (London: Palgrave Macmillan, 2008), 239–40.

allows a single file to be shared by a group of people when no single party possesses the whole. How is this possible? How can so many people circulate pieces of something that no one actually possesses? It is only possible on the condition that each piece of the puzzle—to the smallest bit in the pool—contains a map of the totality and knows exactly where to place itself in relation to the other parts when the whole is eventually reconstituted. Such a high level of generalization can only be underwritten by an immensely powerful force of regimentation—a crucial fact to remember as their machine architecture becomes increasingly tested as social models. It is here that such forms of abstraction hold out a false promise of free recombination—of building back up into whatever we want—when in fact they can only form sensible connections according to a predestined or already existing map.

Foucault actually saw some promise in this brute application of the economic grid because its technocratic management might provide some relief from more heavy-handed forms of governance by moralizing or punitive apparatuses. As techniques of managing human desires and freedoms, however, organs such as the modern state can only repeat the function of the Platonic cave, of enslaving citizens within an enclosed technical apparatus whose only relief is found in an escape to an ill-defined and abstract outside awash with natural light. But the escape into such an Enlightenment abstract has repeatedly proven to introduce new terrors, as well as old ones. Does one then rush back into the cave for shelter, return to enslavement and repeat the bipolar process of circulating through this model endlessly? Or is it possible to instead reprogram this model by shifting the location of the technical, the virtual and the real in relation to one another?[20] Perhaps the shelter of the cave is not only the locus of enslavement, and the contingencies and freedoms of the weather outside are not only truth in

20 See Yuk Hui, *The Question Concerning Technology in China: An Essay in Cosmotechnics*, Falmouth: Urbanomic, 2016.

itself. Perhaps a corridor that is no more and no less technical runs through the interior and exterior, where numbers carry the same stabilizing or destabilizing values regardless of where one is standing in the universe.

By way of conclusion, we might return to Mark Watney's technocratic engineer's ethos:

> At some point, everything's gonna go south on you...everything's going to go south and you're going to say, this is it. This is how I end. Now you can either accept that, or you can get to work. That's all it is. You just begin. You do the math. You solve one problem and you solve the next one, and then the next. *And if you solve enough problems, you get to come home.*

My only question for Mark Watney would be: Where exactly is home?

13

Day by Day

John Miller[1]

I don't want to work. I just want to bang on the drum all day.
I don't want to play. I just want to bang on the drum all day.

—Todd Rundgren, "Bang the Drum All Day"

In its own way, Todd Rundgren's song attacks the central problem of work and leisure; it counters that dichotomy's instrumentalizing inanity with an almost purely existential inanity. The singer wants to turn himself into a metronome. The drumbeat divides the continuum of time into sections and so marks its passing.

Banging the drum insures a certain regularity, but that regularity remains organic. At night the banging stops. The rhythm is keyed to the drummer's body and—played out over time—the seasonal waxing and waning of the days. Yet, unlike certain African cultures where drumming initiates work or festivity, Rundgren's drummer uses the beat to wrest himself away from a standing demand to produce and consume. This drummer could even be autistic, like the boy in Günter Grass's novel, *The Tin Drum*. Still, drumming goes back to the body. That is the difference between the drum and a clock.

The clock is a machine that turns time into an abstraction by abstracting it from bodily experience. It promises to break

1 All images in this chapter are from John Miller's ongoing photographic project "Middle of the Day" (1994–present).

down the continuity of time into uniform, interchangeable units. This standardization is a fundamental premise of the wage/labor equation. The mechanization of time necessarily precedes the mechanization of labor. As it projects uniform, "empty" time into the past and future, the coordinates form an inescapable matrix. i.e., the "universality" of political economy. Inscribed within the demand to produce is the inexorable demand to consume. The political economy consigns the labor of consumption, however, to so-called leisure or "free" time. Nevertheless, how free is free?

One cannot know or understand time apart from its representation. Assumptions about the nature of time are embedded in the structures of various languages. The Hopi Indian language, for example, does not construe objects to exist independently of the continuum of time—and vice versa. For that reason, every noun carries a tense, as do verbs in Indo-European languages. This contrast suggests that while cultural concepts of time may vary, all are bound to linguistic structures. Narrative modes, as such, occur only within "the prison house of language." Archaic narrative modes carry into the present, coexisting alongside newer modes, contradictions notwithstanding. Although the implications of oral history, for example, differ greatly from those of the bourgeois novel, the capitalist political economy promises to synthesize them. This it does via a lowest common denominator: by rationalizing and instrumentalizing the very idea of time, casting it as either work or leisure. This creates the illusion that time must be either one or the other. Time, then, becomes synonymous with the schedule. In this way, the dynamism of the ideology of progress is predicated upon a more fundamental stasis.

As a narrative form, the diary promises a method with which to confront passing time. Confrontation, however, does not guarantee mastery. Its relation to the work/leisure split is refractory, even if the empty diary pages, waiting to be filled, seem to reinforce the notion of time's regularity. Just what goes

into a diary is heterogeneous; the coherence of its form lies not
in the continuity of its content but in the relation between its
parts: the seriality of daily entries. The textual nature of the
diary form is open-ended. It can be a passive record of observa-
tions or a plan of action, as in a daily planner. Although diary
entries need not be autobiographical, readers typically ascribe
them to the subjectivity of the diarist. That may be the reason
one never calls—or even thinks of—oneself a "professional
diarist." Nor can leisure—as the managed and manageable
form of consumption—readily recoup this surplus form of
production.[2] Like poetry, the material means of the journal
are too meager to be able to yield much in the way of profit.
Yet within it, one typically examines one's own self-worth and
one's value to others.

According to structuralist psychoanalysis, subjectivity is
always an effect of language. One therefore comprehends the
diary as a refuge for unreconstructed individualism only by
denying the material nature of the words in which it is written.
The speaking subject comprises a tripartite structure (ego/
id/superego) characterized more by conflict than harmony.
Language makes the speaking subject coherent. Language
acquisition occurs not in the abstract, but though an overlay
of competing discourses and ideologies. Thus, even the most
hermetic diaries necessarily exceed the fiction of the auton-
omous individual. One might consider the individual as the
tailor-made subject of capitalist political economy. Yet the
diary gives itself over to surpluses that do not readily enter
this tautology: the dreamwork, the desire of history's van-
quished, the dissent of "other" races and genders. In this way,
modernist innovations in literary narration are unthinkable
without reference to the diary form: among others, those of
Sade, Proust, Genet and Robert Walser. Popular novelists,

2 In *The Theory of the Leisure Class*, Thorstein Veblen argued that
conspicuous consumption functions as an instrument of class domina-
tion within the field of "free" time.

however, rarely chronicle everyday life because the cycle of work and leisure leads to a purely repetitive narrative: the routine. Parents ask their kids what they did in school today. "Nothing." They ask them where they are going after school. "Nowhere." Walter Benjamin has noted how the detective novel requires the criminal to set things in motion. Otherwise, the novelist is at a loss for a plot.

The diary suggests new possibilities for historiography. In his last essay, "Theses on the Philosophy of History," Benjamin described conventional historiography as the history of winners, a heroic narrative. In contrast, the history of the vanquished remains latent. The diary can capture these lost aspirations. It can serve as the repository for the ongoing, anonymous making of history. This "other" history might include what traditionally has remained the unaccounted work of women and dominated classes or what is too quotidian to be heroic. Diary notations can show ideas in a premonitory, embryonic form, before they assume a clear rhetorical definition, before they clearly become ideas. In this way, these unformed impressions and observations may be richer than systematic thought. This was Walter Benjamin's goal in the only diary he ever kept, the two-month long *Moscow Diary*. At the time Benjamin traveled to the Soviet Union, it was nearing the end of its heroic, revolutionary phase. Benjamin fully expected to come to a great city where revolutionaries were in the process of abolishing the division between work and leisure. In that spirit he vowed that his journal would maintain an "absence of judgment" in which "all factuality is already theory." The absorption of the diary by literature proper reflects the utopian aesthetic impulse to dissolve the boundary between work and leisure. From this perspective, as Baudelaire remarked in his *Intimate Journals*, the man of letters is "the enemy of the world"—that is, the way the world is now configured.

Standing at the threshold of the modern era is Sade's *The*

120 Days of Sodom. Sade wrote the book while he was confined to the Charenton prison and the Bastille. Maybe the most rudimentary kind of diary comprises the marks a prisoner scratches into his cell wall; four verticals and one diagonal equal five days. *The 120 Days* takes the form of a log. It charts the escalating debauches of four libertines who lock themselves away with their charges in a remote château. There they remain for a designated period of nearly four months. Although the log itself is a fantasy, it is nonetheless an analog of Sade's very real confinement, an enforced period of neither work nor leisure. The impulses and motivations for the prison system are ambiguous and often contradictory. Even so, one of its most consistent institutional premises is that removing the inmate from the cycle of everyday life can serve both as an inflicted punishment and as a catalyst for atonement. Sade's most productive periods were the times he spent in prison; the prolonged isolation drove his imagination to a fever pitch. For him, punishment became inscribed in eroticism—and eroticism in punishment. Throughout, he remained unrepentant. Because of its forbidden nature, he had to write *The 120 Days* surreptitiously, in miniature script on a narrow scroll of paper.

When revolutionaries stormed the Bastille on July 14, 1789, Sade regained his freedom. In the process, however, his manuscript disappeared. Until his death, Sade believed it to have been destroyed and claimed to weep "tears of blood" over its loss.

The French Revolution is the definitive bourgeois revolution. It attempted to rationalize and to systematize not only government, but also the social understanding of time and space. It put into place the metric system and the revolutionary calendar. In this respect, the revolution realized the implicit ideology of the pocket watch, invented in Nuremburg some two hundred years earlier. Although he was a noble, Sade joined the revolution, holding a district position in the Paris city government. Nonetheless, he remained ambivalent

Kredyt gotówkowy od eksperta

Dominika Walczak
Doradca Klienta

801 33 00 11
koszt wg stawki operatora

www.credit-agricole.pl
Credit Agricole Bank Polska S.A.

Kredyt gotówkowy od eksperta

6 mln udzielonych kredytów

oprocentowanie
4,99%

CREDIT AGRICOLE

RRSO 9,5%

about the revolution's institutionalization. What he feared was not corporeal violence, but the displaced and detached violence of bureaucratic power that was to follow.

If the invention of the clock made possible the division of labor and the assembly line, the figures that anticipated the worker's functional condition after the Industrial Revolution were the Arabic and French mechanical automatons of the eighteenth century. The best-known creator of these mechanical marvels was Jacques de Vaucanson (1709–82). His most famous inventions included a duck, a flutist and a drummer. Through their astonishing capacity to imitate organic movement, these machines suggested how the assembly line would later integrate the human body into its own works.[3] Such a figure, a chess-playing puppet in Turkish garb, allegorizes the dialectics of history in Benjamin's "Theses on the Philosophy of History." Instead of springs and gears, however, a hidden dwarf animates this figure. Benjamin called the dwarf "theology." Writing at the onslaught of the holocaust, he argued against the ideology of progress, noting that the Messianic prophecy of their religion prohibited Jews from investigating the future. The predictability and regularity of rationalized, bourgeois time, for Benjamin, resulted in empty time.

This appeared as "spleen" in Baudelaire's work, characterized by the repetitive movements of the gambler. The gambler neither works nor plays; his task is to fill the void of time. For him time is heavy and fraught with self-consciousness; each moment seems like an eternity; the living body approaches the state of inorganic matter. Benjamin's "Theses" essay implicitly construes fascism as a problem of mobilizing production vis-à-vis historic ideologies of time. Previously, in his *Passagenwerk,* Benjamin had noted Baudelaire's most ominous journal entry, a "joke:" "A fine conspiracy could be organized for the purpose

3 Siegfried Giedion, "Springs of Mechanization," *Mechanization Takes Command,* New York: W.W. Norton & Co., 1969, 34.

of exterminating the Jewish race."[4] Later, Anne Frank's *The Diary of a Young Girl* was to offer a firsthand account of the genocidal anti-Semitism that Baudelaire had intuited so long before.

Benjamin's *Moscow Diary* is a record of profound disillusionment. Benjamin had been drawn to Moscow both by its revolutionary promise and by his infatuation for the Russian actress, Asja Lacis. Shortly before leaving for Moscow, he divorced his wife. He told his friends that, after this trip, he would join the German Communist Party. In December 1926, Moscow greeted him with the onset of the Stalinist counter-revolution and the stony indifference of Lacis, whom doctors had confined to a sanatorium. Because he spoke no Russian, Benjamin had to rely on Bernhard Reich, an Austrian playwright who had become Lacis's lover, as a guide and interpreter. Even the narrow, ice-covered Moscow sidewalks afforded the inveterate flaneur no enjoyment; rather than looking around the city, he was forced to watch his every step. In the daytime he wandered, visiting museums and collecting children's toys. During the brief interludes he spent alone with Lacis, they usually quarreled. Evenings, he, Reich and Lacis went to the theater. Afterward, Reich often spent the night in Benjamin's hotel room.

To characterize Benjamin's stay in Moscow as clearly either "work" or "leisure" is difficult—and perhaps beside the point. Several subsequent texts drew from his experience there, but even so, most of his plans met with defeat:

> Nothing ever happens as planned or expected—this banal formulation of life's complications is borne out so implacably and so intensely in every single instance here that you quickly come to grasp the fatalism of the Russians.[5]

4 Charles Baudelaire, cited in Susan Buck-Morss, "The Flaneur, the Sandwichman and the Whore: The Politics of Loitering," *New German Critique* 39 (1986), 115.

5 Walter Benjamin, *Moscow Diary*, ed. Gary Smith, trans. Richard

People live on the street as if in a frosty hall of mirrors, and every decision, every stop becomes incredibly difficult: it takes half a day of deliberation to go drop a letter in a mailbox, and despite the bitter cold, it takes an effort of the will to enter a store to buy something.[6]

The change in cultural politics brought on by Stalin's ascendancy was marked and subject to vehement debate in the theater circles through which Benjamin moved. Baudelaire had described the man of the crowd as "a kaleidoscope equipped with consciousness"; ironically, just as Benjamin was about to pursue a narrative form in which "all factuality is already theory," the Soviet state started to redeploy principles of photomontage as falsified, totalitarian propaganda. Although Benjamin returned to Berlin thoroughly disillusioned, his desire to make something of the diary itself became even more ardent:

Differing ink colors indicate that Benjamin's last entries, those dated January 29 [1927], were made in Berlin. He left wide margins and relatively large amounts of space at the top and bottom of the manuscript on only the first few pages. Thereafter his strokes become increasingly compressed and miniature. After the eleventh page, he leaves no margin at all, and by the conclusion of the manuscript the number of words on each page has more than doubled from over 500 to more than 1100 words per page.[7]

The handwriting of another well-known flaneur, Robert Walser, got smaller and smaller toward the end of his life, as he verged on complete nervous collapse. Sometimes Walser could fit an entire short story on the back of a postcard. Many of his stories are without any plot at all, organized simply

Sieburth, Cambridge, Massachusetts: Harvard, 1986, 30.

6 Ibid., 35.

7 Gary Smith, "Afterword," *Moscow Diary,* 146.

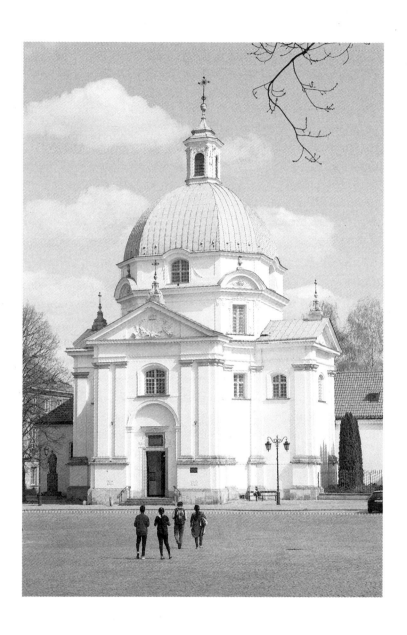

around the device of taking a walk. They exude delight in the superfluous and a hatred of mercantile values. By shrinking the size of his script, it is as if the writer had tried to create a separate world, small enough to control. Benjamin also noted how Proust's similar proofreading habits exasperated the typesetters at his publisher, Gallimard: "The galleys always went back covered with marginal notes, but not a single misprint had been corrected; all available space had been used for fresh text."[8]

Another kind of desperate whimsy characterizes the denizens of Andy Warhol's Factory in the sixties. Looking back on this period, Warhol was often struck by how these otherwise creative individuals (especially trans people) from whom he took so much were incapable of making anything of their lives. Rather, their intelligence turned toward expenditure, both real and symbolic. Warhol once described them as the kind of people who spend their days taking walks in the park and writing in their journals.

One of Warhol's most memorable declarations is: "My mind is like a tape recorder with one button: erase." The paradox of this statement is that the "machine" of Warhol's mind, by eradicating time, was bent on destruction, not production. In the same breath, this metaphor expresses both nihilism and liberation. In practice, however, Warhol was an assiduous user of tape recorders...with the record button always on. The tape recorder, moreover, displaced writing in his work. He came to call it "my wife." Oddly enough, one could construe this technological intrusion into the most personal sphere as a delayed carryover of the Soviet productivist aesthetic. Warhol's first novel, *A*, is an unedited transcription of mostly the amphetamine-charged ramblings of Ondine, a key figure at the Factory. Similar such transcriptions comprised early issues of his *Interview* magazine.

8 Walter Benjamin, "The Image of Proust," *Illuminations*, trans. Harry Zohn New York: Schocken Books, 1969, 202.

In 1968, the ordinarily apolitical Warhol agreed to produce a campaign poster for Democratic presidential candidate George McGovern. The poster simply featured a silk-screened picture of Richard Nixon, his face in green, with the slogan "Vote McGovern!" Shortly after the election—which Nixon, of course, won—the Internal Revenue Service regularly began to audit Warhol's federal income tax returns. Warhol regarded this as a reprisal, but whether it was or not, it forced him to start keeping a record of all his expenses. Each morning he would call his editor and secretary, Pat Hackett, and dictate these to her.

This little ritual soon expanded into a summary of all the goings-on from the previous day...and night. Although Warhol's calls to Hackett may have been therapeutic, his observations were typically terse and unsparing, resulting in a no-holds-barred chronicle of New York City's beautiful people in the 1970s and '80s. Benjamin's understanding of Proust's *Remembrance of Things Past* could pertain just as well to *The Andy Warhol Diaries*: "Proust's analysis of snobbery, which is far more important than his apotheosis of art, constitutes the apogee of his criticism of society. For the attitude of the snob is nothing but the consistent, organized, steely view of life from the chemically pure standpoint of the consumer."[9] Benjamin also claimed that no one has ever abhorred physical contact with another person more than Marcel Proust.[10] Until the appearance of Andy Warhol, that may have been true. Because Warhol paid everyone who worked for him so badly, many tried to figure out other ways to make their involvement with him pay off. Eventually, his employees realized that a firsthand memoir could be quite marketable; they started keeping journals of their own, causing Warhol to quip that no one did anything around his office anymore but write in their diaries.

9 Ibid., 210.
10 Ibid., 212.

The ostensible usefulness of any diary would depend largely upon who wrote it and under what conditions; someone with a sense of historical or public mission might address her or his remarks to posterity, while someone else might restrict the entries to fleeting intimacies. Nevertheless, the second kind of diary may carry the greater political charge. In his analysis of the psychological structure of fascism, Georges Bataille posited a dichotomy between homogeneity and heterogeneity that helps inform diaristic forms of address:

> Homogeneous society is productive society, namely, useful society. Every useless element is excluded, not from all of society, but from its homogeneous part. In this part, each element must be useful to another without the homogeneous activity ever being able to attain the form of activity valid in itself. A useful activity has a common denominator with another useful activity, but not with activity for itself.[11]
>
> The very term heterogenous indicates that it concerns elements that are impossible to assimilate; this impossibility, which has a fundamental impact on social assimilation, likewise has an impact on scientific assimilation. These two types of assimilation have a single structure: the object of science is to establish the homogeneity of phenomena…[S]cience is not an abstract entity: it is constantly reducible to a group of men living the aspirations inherent to the scientific process…The [de facto] exclusion of heterogeneous elements from the homogeneous realm of consciousness formally recalls the exclusion of the elements, described (by psychoanalysis) as unconscious, which censorship excludes from the conscious ego.[12]

The division between homogeneous and heterogeneous activity extends to morality. One deems useful that which one can

11 Georges Bataille, "The Psychological Structure of Fascism," *Visions of Excess: Selected Writings* 1927–1939, eds. and trans. Allan Stoekl et al., Minneapolis: Minnesota, 1985, 138.

12 Ibid., 140–41.

put in the service of something else; one deems wasteful that which resists serviceability. The worker is useful because he exists in the service of capital. By extension, consumption and recreation are useful because they prepare the worker to work again. Typically, the bourgeoisie thinks that the underclass does not spend its money wisely: if it did, it too might live as well as the bourgeoisie. A family of six goes out for a Sunday walk. They pass an ice cream stand and everybody has to have a big ice cream cone. They cannot wait; the whole family has to have everything now. They pass a street vendor and everyone has to have a new cap. By the end of the day, they have spent all their money, the kids have ice cream all over their shirts, they ruin the hats and everyone is fighting. What this view ignores is that the need to spend "freely" results, as a kind of compensatory reaction, from the underclass's structurally instrumentalized condition. The pragmatic, moralizing view, however, mistakes effects for causes. A more pressing problem is capital's colonization (to paraphrase the Situationists) of leisure. When not stigmatized under the ideology of unemployment, leisure time inevitably translates into profits for someone somewhere else. All becomes business. This renders pure expenditure virtually impossible. In this regard, Bataille's "political unconscious" accords with Benjamin's vision of unredeemed history. What one must examine, however, is the quality of selfhood he ascribes to heterogeneity in the formulation "valid in itself"—especially because Bataille explicitly equates it to Freud's division of the "self" into three sometimes conflicting elements. Within Bataille's schema, selfhood appears to be a tautological condition, arising from dysfunction or excess. Understood this way, the seemingly most trivial diaries may work to instantiate a sense of self—rather than to reflect it. Henri Lefebvre, noting the correlation and conflicts between identity and role in everyday life, links the nascent sense of selfhood to alienation:

it is certain that a worker does not play at being a worker...
He is completely "that," and at the same time he is completely
other and something else...For him and within him, at his best
moments and his worst, contradictions and alienations are at a
maximum. For us, in our society, with the forms of exchange and
the division of labor which govern it, there is no social relation
—relation with the other—without a certain alienation. And
each individual exists socially only by and within his alienation,
just as he can only be for himself within and by his deprivation
(his private consciousness).[13]

The newspaper column is one of the few professionalized
forms approximating the diary: here the writer publishes
daily observations. These, however, the writer must usually
direct outward. Maybe the rightful home for private senti-
ments and personal reflections too trivial for anyone else to
read can only be the diary. Even so, this kind of textual mate-
rial could be political dynamite. Its suppressed or unfulfilled
aspirations can give new life to the feminist dictum, "The per-
sonal is political." Perhaps the next revolution (if that word is
still appropriate) must learn to accommodate better the unide-
alized dross of everyday peoples' lives. Nonetheless, this can
only become politicized when those who write go on to turn it
into action, if indeed writing is not already action.

13 Henri Lefebvre, "Foreword," *Critique of Everyday Life, Vol. I*,
trans. John Moore, London and New York: Verso, 1991, 15–16.

Visceral Abstractions

Sianne Ngai

the spirit and the beef

—Rob Halpern, *Music for Porn*

Eating Face

Barbara Johnson opens *Persons and Things* with a memorable anecdote about her childhood inability "to eat anything that had a face."[1] As she elaborates:

> Not anything that *had had* a face: I was not an incipient vegetarian and was perfectly happy to devour a hamburger, but I could not bring myself to consume anything that might be looking at me while I ate it or that continued to smile cheerfully as parts of its body disappeared into my mouth—gingerbread men or jack o' lantern candies.[2]

Highlighting a gut feeling about ingestion, this anecdote calls up the most common definitions of visceral: "felt in or as if in the internal organs of the body"; "instinctive, unreasoning"; "dealing with crude or elemental emotions."[3] It is not hard to understand how any of these qualities might attach to the act of consuming a humanoid body part. However,

1 Barbara Johnson, *Persons and Things*, Cambridge, MA: Harvard University Press, 2010, 4.
2 Johnson, *Persons and Things*, 4.
3 *Merriam-Webster Dictionary* online, "visceral."

what if we read Johnson's anecdote as a story about a visceral response, not to a visceral act or visceral object, but to a kind of abstraction?

This possibility might initially seem hard to swallow, since the visceral seems to encompass everything the abstract is not. Indeed, its specificity and corporeality seem to have made "visceral" resistant to theory in a way that noticeably contrasts with the fate of "abstract"—which, as Leigh Claire La Berge points out, has been taken up by so many different theoretical discourses that when deployed casually, "its precise meaning is almost impossible to ascertain."[4] While abstraction in aesthetics refers to "a mode of nonfigurative representation," and in philosophy to "something not fully realizable by a particular," La Berge notes that in popular as well as specialist writing on finance, "abstract" has increasingly come to designate "complex," "fictitious," and "unrepresentable"—adjectives that disturbingly imply that the understanding, representation and regulation of contemporary financial operations are somehow no longer possible.[5]

Understood as fictitious or unreal, the meaning of abstraction in contemporary economic writing is the exact opposite of what it means in Karl Marx's writing. For Marx, as for Hegel, for whom knowledge moves from abstract to increasingly concrete notions, the distinction between abstract and concrete does not map neatly onto the distinction between the ideal and the real.[6] As I show below, there is what commenta-

4 Leigh Claire La Berge, "The Rules of Abstraction: Methods and Discourses of Finance," *Radical History Review* 118 (2014), 93.

5 La Berge, "Rules of Abstraction," 93, 96. As La Berge puts it, the characterization of financial operations as abstract would "seem less to elucidate financial operations than to obfuscate them," calling forth, on the one hand, "an immediately knowable and representable world of institutional financial transactions," but then "suspend[ing] knowledge and description of that world by claiming its mechanisms are beyond our collective cognitive, linguistic, and epistemological reach."

6 Encyclopedia of Marxism, Marxist Internet Archive, s.vv. "abstract," "concrete," marxists.org. The argument that the method of presentation

tors call "practical" or "real abstraction" for Marx (even if Marx himself does not use these terms). Moreover, in Marx's critique of political economy, the abstract is simple while the concrete is complex, in the sense of being the "result" or "concentration" of multiple determinations: "The concrete is concrete because it is the concentration of many determinations, hence unity of the diverse. It appears in the process of thinking, therefore, as a process of concentration, as a result, not as a point of departure, even though it is the point of departure in reality and hence also the point of departure

(as opposed to the method of inquiry) in Marx's *Capital* tends to move from the abstract to the increasingly concrete is the generally accepted account, based on Marx's remarks in his draft work. See Karl Marx, *Grundrisse: Foundations of the Critique of Political Economy (Rough Draft)*, trans. Martin Nicolaus, London: Penguin Books, 1973, 100–108, esp. 101, 108. For a more nuanced account of the dialectical relationship between the abstract and concrete in Marx's presentation as it relates to the tension between logic and history in his method overall, see Ernest Mandel, introduction to Karl Marx, *Capital: A Critique of Political Economy, Vol. I*, trans. Ben Fowkes, London: Penguin Books, 1990, 11–86, esp. 20–21 (cited in Beverly Best, *Marx and the Dynamic of the Capital Formation: An Aesthetics of Political Economy*, New York: Palgrave Macmillan, 2010, 91–93). Kevin Floyd follows Mandel's lead in noting that, contrary to his remarks in the *Grundrisse*, Marx's method in *Capital* involves a "double movement" from concrete to abstract and then abstract to concrete. In the first movement, a "chaotic conception of the whole" like capitalism is broken down into increasingly simple abstractions (commodity, value, human labor in the abstract, socially necessary labor, etc.), which are disclosed as determinations that internally differentiate that totality, while in the second movement, the simple abstractions "are themselves concretized by establishing the simultaneous differentiation and connection *between* the various determinations to which they refer—by establishing, for example, the social process of capital of which social class, wage labor, and value are all defining moments." See Kevin Floyd, *The Reification of Desire: Toward a Queer Marxism*, Minneapolis: University of Minnesota Press, 2009, 28. For an alternative argument highlighting the predominance of abstraction in Marx's own method of analysis as continuous with the social abstraction that is the motor and defining characteristic of the capitalist mode of production, see Best, *Marx and the Dynamic of the Capital Formation*, esp. 61–116.

for observation [*Anschauung*] and conception."[7] As La Berge glosses this passage, for Marx "the concrete is a metabolized result and the abstract a social intuition capable of leading to the concrete," which is precisely why the two must be deployed together: "If we begin with too abstract a concept to orient our investigation, then we preclude our own access to the quotidian, material, perceptible world. And if we begin with too concrete a term, then we may be unable to understand its organization within a larger social totality."[8]

Across all the theoretical traditions in which it has played central roles, however, the abstract is consistently defined as opposed to the concrete, and as such closely associated with the nonsensuous and unparticularized. This brings us back to the oddness of reading Johnson's anecdote as a response to abstraction. What could be more of a corporeal experience than "parts of [another's] body disappear[ing] into [one's] mouth"? And what could be more irreducibly particular than what Emmanuel Levinas calls the "face of the other"?[9] Yet the cheerful visage we find stamped not just on food but on virtually every type of artifact in the capitalist economy, from Band-Aids to diapers to text messages, is obviously not a representation of a specific, unrepeatable individual, nor even the idea of one. The smiley face rather expresses the face of no one in particular, or the averaged-out, dedifferentiated face of a generic anyone. It calls up an idea of being stripped of all determinate qualities and reduced to its simplest form through an implicit act of "social" equalization, relating every individual face to the totality of all faces.

The simplest abstractions are the achievements of the most highly developed societies, as Marx notes in the *Grundrisse*, though in a way that their unreflective use in political economy

7 Marx, *Grundrisse*, 101.
8 La Berge, "Rules of Abstraction," 97.
9 Emmanuel Levinas, *Totality and Infinity*, trans. Alphonso Lingis, Pittsburgh, PA: Dusquesne University Press, 1969, 24.

often obscures. He elaborates this claim with the example of "labor" or "labor as such": a "general" abstraction "aris[ing] only in the midst of the richest possible concrete development, where one thing appears as common...to all" and thus "ceases to be thinkable in a particular form alone."[10] There are thus determinate conditions for the emergence of the abstract category of "labor in general," for which Marx credits Adam Smith with introducing into political economy, despite its "validity—precisely because of [its] abstractness—for all epochs."[11] At the same time, Marx suggests that there are also historical conditions under which "labor in general" not only becomes mentally conceivable but also "true in practice":

> Indifference toward specific labors conforms to a form of society in which individuals can with ease transfer from one labor to another, and where the specific kind is a matter of chance for them, hence of indifference...Such a state of affairs is at its most developed in the most modern form of existence of bourgeois society—in the United States. Here, then, for the first time, the point of departure of modern economics, namely the abstraction of the category "labor," "labor as such," labor pure and simple, becomes true in practice. The simplest abstraction, then, which modern economics places at the head of its discussions, and which expresses an immeasurably ancient relation valid in all forms of society, nevertheless achieves practical truth as an abstraction only as a category of the most modern society.[12]

A similar thing could be said about the smiley face, which first achieves its "practical truth" not in rapidly industrializing, nineteenth-century England but in the postwar United States during the golden age of capitalism. Designed in 1963 by the

10 Marx, *Grundrisse*, 104.
11 Marx, *Grundrisse*, 105.
12 Marx, *Grundrisse*, 104–105.

adman Harvey Ball, who was hired to create a logo to improve customer service and employee cooperation for the State Mutual Life Assurance Company of America (now Allmerica Financial Corporation) after a series of disorienting mergers and takeovers, the smiley face quickly migrated out of workplace culture into sixties consumer culture and counterculture.[13] To this day, numerous subcultures continue to appropriate the corporate version of the smiley and endow it with ironic or subversive inflections. Whether as the bloodstained smiley of Allan Moore's *Watchmen* or the relentlessly affirmative "rollback" smiley of Walmart, however, the smiley always confronts us with an image of an eerily abstracted being. Is the disturbing effect of this icon's averaged-out appearance something we should chalk up to a long-standing American phobia about the loss of individual distinction to social homogenization? Or could it be registering something else?

Finally, if it is the idea of eating an abstraction that generates visceral sensations for Johnson, what about the equally unsettling if arguably queerer idea of fucking one? This is what we are asked to imagine in *Music for Porn* (2012), a contemporary book of war poetry in which Rob Halpern depicts "the soldier's body *hieroglyph of value*" as simultaneously "spirit" and "beef."[14] For Halpern, the body of The Soldier is one abstracted at multiple levels: as a national representation "severed from the real bodies of military men"; as a corpse removed from public view; as a homosexual icon or "exaggerated type like one you'd see in gay porn from the 70s"; and as a "*hieroglyph*," or allegory of value.[15] At the same time, this abstract-allegorical body is incongruously presented as the visceral object of the poet's lust, sexual fantasy and a range

13 See Jimmy Stamp, "Who Really Invented the Smiley Face," Smithsonian.com, March 13, 2013.

14 Rob Halpern, *Music for Porn*, New York: Nightboat Books, 2012, 153.

15 Ibid.

of conflicting emotions: love, hate, disgust, shame. In evoking "the soldier as neither a thing nor an idea, but rather a relation *like capital like value* visible and measurable only in the effects it achieves and the affects it arouses," *Music for Porn* not only insists on the compatibility but stages the interpenetration of queer and Marxist thought.[16]

This chapter focuses on Halpern's decisively queer take on visceral abstraction—a take facilitated by the poetry's explicit engagement with Marx's concept of abstract labor and his notoriously tricky description of it as "value-forming substance."[17] Before doing so, we need to take a closer look at Marx's concept itself.[18]

16 Ibid., 51.

17 Marx puts this last phrase in quotation marks, seeming to indicate his ironic distance from it, but there is no attributed source. See Marx, *Capital, Vol. I*, 129.

18 The phrase "abstract labor" is used rather sparingly by Marx. Its uses are concentrated in the first chapter of *Volume I* of *Capital*, where they always appear in jarring conjunction with the image of "congealed" labor or labor-time. There is only a single subsequent reference in the rest of *Volume I*, where Marx's irony becomes less concentrated and less ambiguous (isolated sarcastic remarks pop up, but also clearly signposted as such), as his analysis of capital becomes increasingly historical. There are no uses of the phrase "abstract labor" in the unfinished *Volume II* and *III*, where Marx's use of irony is also more intermittent and clearly demarcated. (An index entry exists for "abstract labor" in *Volume II*, but the entry seems to have been created not for this precise phrase but for mentions of "value-forming labor.") The appearance of the phrase "abstract labor" thus seems roughly to correlate with the intensity of Marx's irony and use of figurative language, and to correlate inversely with the concreteness of his analysis of capital. For all these reasons, the phrase "abstract labor" (if not its concept or meaning) needs to be seen as one about which Marx himself clearly had some ambivalence, perhaps because of, as I will show, the explicitly metaphorical language that its elucidation appears to require. At the same time, a robust body of work has grown around the concept of value-forming labor as "abstract" labor by commentators who recognize—rightly—that despite the infrequency of the term in Marx's writing and the verbal and tonal ambiguity that surrounds its use, the "value theory of labor" it describes is absolutely central to Marx's

Abstract Labor

In the capitalist production process, existing value in the form of constant capital, or what Marx at times calls dead labor, is brought together with variable capital or living labor. Only living labor has the capacity to produce additional value while also carrying over the value of the commodities functioning as means of production, such as machines and raw materials, into the value of the product. Capitalist production is thus a "valorization" process that takes place only when the two things whose separation forms the basic precondition of generalized commodity production, labor power and means of production, are rejoined through the newly privileged and expanded agency of money capital. Yet the values valorized in production also have to be "realized" through their conversion into the independent and necessary form of value, which is money.[19] As Jim Kincaid glosses:

> Value is not realized, made *real*, until the commodity has been sold for money—and that depends on its use-value finding a matching demand on the market. If no one wants to buy the commodity, or if those who want or need it lack the necessary cash to buy it, then some or all the labor that went into making that commodity is negated, wasted, annulled, does not achieve real existence. Value exists only potentially until the sale is made, and the final metamorphosis of commodity into money has been effected.[20]

theory as a whole. For this reason, I examine the concept of abstract labor from the perspective of these commentators before turning to the more complex difficulties it presents in the writing of Marx himself. On Marx's theory of value as a "value theory of labor" as opposed to a labor theory of value, see Diane Elson, "The Value Theory of Labour," in *Value: The Representation of Labour in Capitalism*, ed. Diane Elson, London: CSE Books, 1979, 115–80.

19 Jim Kincaid, "A Critique of Value-Form Marxism," *Historical Materialism* 13: 2 (2005), 99.

20 Kincaid, "Critique of Value-Form Marxism," 99.

The realization of value is an unstable process that depends on the uncoordinated actions of a vast number of independently acting, often unknowingly interconnected actors. It is here, in the C'–M' phase of the circuit of capital, where the "suprasensible or social" phenomenon of abstract labor first emerges.[21]

Abstract labor contains a fundamental tension: it is the form that *social* labor assumes in a society based on the *private* organization of production and circulation. As Marx states in the *Grundrisse*, because capitalist production is not immediately organized by society but rather consists of private, independently expended acts of labor, "the social character of production is *posited* only *post festum* with the elevation of products to exchange values and the exchange of these exchange values."[22] Abstract labor therefore reflects what Ernest Mandel calls the basic contradiction of capitalism: "that goods are at one and the same time the product of social labor and private labor; that the social character of the private labor spent in their production cannot be immediately and directly established; and that *commodities must circulate*, their value must be *realized*, before we can know the proportion of private labor expended in their production that is recognized as social labor."[23]

It is crucial to emphasize that abstract labor is not an abstraction by thought, but rather achieved by the collective practice of actors who do not know they are achieving it.[24] As Marx puts it in a passage where he famously describes value as a "social hieroglyph," "Men do not…bring the products of

21 Marx, *Capital, Vol. I*, 165. Marx uses this phrase to describe commodities, "sensuous things which are at the same time suprasensible or social," but as Nicole Pepperell and others have noted, the concept applies to abstract labor, value and capital as well. See Pepperell, "Disassembling Capital," PhD diss., RMIT University, 2010, 1.
22 Marx, *Grundrisse*, 172.
23 Ernest Mandel, introduction to Karl Marx, *Capital: A Critique of Political Economy, Volume II*, London: Penguin Books, 1992, 15.
24 Marx, *Grundrisse*, 105.

their labor into relation with each other as values *because they see* these objects...as the material integuments of homogeneous human labor" (my emphasis). Rather, he notes, "The reverse is true: *by* equating their different products to each other in exchange as values, they equate their different kinds of labor as human labor. They do this without being aware of it."[25] Value and abstract labor, the "substance" that gives value its "form," are thus the achievements of the empirical behaviors of persons, even if they are produced, as Marx likes to say, "behind their backs."[26] While multiple commentators have stressed this point, Georg Lukács puts it in an especially compelling way in his late and unfinished *The Ontology of Social Being*:

> [The emergence of the "average character of labor"]...is not a matter of mere knowledge...but rather the emergence of a new ontological category of labor itself in the course of its increasing socialization, which only much later is brought into consciousness. Socially necessary (and therefore *ipso facto* abstract) labor is also a reality, an aspect of the ontology of social being, an achieved real abstraction in real objects, quite independent of whether this is achieved by consciousness or not. In the nineteenth century, millions of independent artisans experienced the effects of this abstraction of socially necessary labor as their own ruin, i.e. they experienced in practice the concrete consequences, without having any suspicion that what they were facing was an achieved abstraction of the social process; this abstraction has the same ontological rigor of facticity as a car that runs you over.[27]

Abstract labor is difficult to grasp, Nicole Pepperell stresses, because it is what Marx called "suprasensible or social" or

25 Marx, *Capital, Vol. I*, 166–67; my emphasis.
26 Marx, *Grundrisse*, 225.
27 Georg Lukács, *The Ontology of Social Being: 2. Marx*, trans. Ferenc Jánossy, London: Merlin, 1978, 40.

what we would today call "emergent," arising "as an indirect, aggregate effect of complex interactions among many different sorts of social practices, none of which is explicitly oriented to achieving this specific overall effect."[28] Abstract labor is also difficult because its concept is circular. When we think of how labor might "form" or "produce" value, we naturally assume the former's logical and ontological priority. First, the labor; then, the value. Yet abstract labor—the only labor that for Marx specifically constitutes value, as opposed to material wealth—is not labor physically expended by workers in real time in heterogeneous and uncoordinated acts of production, as Michael Heinrich emphasizes. It is rather a "relation of social validation" posited retroactively in exchange, which fulfills the actual function of relating independently performed labors to the total labor of society.[29] The relation between exchange value and abstract labor is thus one of reflexive circularity: as is so often the case in Marx's writing—and as many commentators, including Marx himself, note—what seems like the presupposition (abstract labor) turns out to be the result, and what seems like a result (exchange value) turns out to be the presupposition.

It is of course true that abstract—or what Marx elsewhere calls "socially necessary"—labor ends up having a palpable effect on concrete, actually expended labor, insofar as it comes to inform, via the mediations of the wage and other, similarly emergent capitalist abstractions like the average rate of profit, how concrete labor is practically organized, whether or not it is intensified in what lines of production, how much or little of it hired, and under what conditions.[30] And so it is not the case

<hr>

28 Pepperell, "Disassembling Capital," 16–17.

29 Michael Heinrich, *An Introduction to the Three Volumes of Karl Marx's "Capital,"* trans. Alex Locascio, New York: Monthly Review Press, 2012, 50.

30 Marx, *Capital, Vol. I*, 129. I am grateful to Jasper Bernes for stressing this point to me (e-mail message to author, February 20, 2014). The reverse is also true, since socially necessary abstract labor is also

that socially necessary labor, simply in being posited retroactively in circulation rather than expended in the real time of production, is somehow radically disconnected from empirical labor. To forestall this impression, Diane Elson argues that abstract and concrete labor are not generic "kinds" but rather "aspects" of capitalist labor mediating each other, though with the former aspect dominating the latter.[31] Yet abstract value-forming labor is still not identical to concrete or actually expended labor, just as it is not the same thing as the abstract *concept* of "labor in general" or "labor pure and simple." As Heinrich argues, what makes "concrete acts of expended labor *count* as a particular quantum of value-constituting abstract labor, or...*valid* as a particular quantum of abstract labor, and therefore as an element of the total labor of society" is the mediation of the individual labor of isolated producers to the total labor of society.[32] In societies where producers do not explicitly coordinate their acts of production, this mediation happens only when their products are exchanged. But although the mediations of exchange have the "formal ability to weave a web of social coherence among the mass of private individuals all acting independently of another," as Alfred Sohn-Rethel notes, the socializing effects of their activities *also come to appear to them as an independent force not of their own making*, one that oppositionally confronts them as a "second nature."[33] As Marx puts it, referring to the rise of the world market, what appears is not just the "connection of

adjusted in response to the concrete, historical development of technology and the skill of workers. On this see Best, *Marx and the Dynamic of the Capital Formation*, 15; see also I.I. Rubin, "Marx's Labor Theory of Value," in *Essays on Marx's Theory of Value*, trans. Milos Samardzija and Fredy Perlman, Delhi: Aakar Books, 2010, 61–275, 119–20 (quoted in Best).

31 Elson, "Value Theory of Labour," 148–50.
32 Heinrich, *Introduction*, 50.
33 Alfred Sohn-Rethel, *Intellectual and Manual Labour: A Critique of Epistemology*, Atlantic Highlands, NJ: Humanities, 1978, 33.

the individual with all, but at the same time also the independence of this connection from the individual."[34]

The "*connection of the individual with all*, but at the same time also *the independence of this connection from the individual*" —this is what I would argue we "see" when faced with the capitalist smiley. It is perhaps the best explanation for why this utterly banal image nonetheless has the power to unsettle us. "In a society in which individual activities have a *private* character, and in which therefore the interests of individuals are divided and counterposed," writes Lucio Colletti, "the moment of *social unity* can only be realized in the form of an *abstract equalization*."[35] Abstract labor, the result of this equalization, is therefore labor "said to be *equal* or *social*, not because it genuinely belongs to *everyone* and hence mediates between the individuals, but because it belongs to *nobody* and is obtained by ignoring the real inequalities between the individuals."[36] Or as I.I. Rubin puts it, abstract labor "becomes social labor *only* as impersonal and homogeneous labor."[37] I

34 Marx, *Grundrisse*, 161. As Marx puts it: "Their own collisions with one another produce an alien social power standing above them, produce their mutual interaction as a process and power independent of them. Circulation, because a totality of the social process, is also the first form in which the social relation appears as something independent of the individuals, but not only as, say, in a coin or in exchange value, but extending to the whole of the social movement itself. The social relation of individuals to one another as a power over the individuals which has become autonomous, whether conceived as a natural force, as chance or in whatever other form, is a necessary result of the fact that the point of departure is not the free social individual. Circulation as the first totality among the economic categories is well suited to bring this to light" (196–97).

35 Lucio Colletti, "Bernstein and the Marxism of the Second International," in *From Rousseau to Lenin: Studies in Ideology and Society*, trans. John Merrington and Judith White, New York: Monthly Review Press, 1972, 87.

36 Colletti, "Bernstein and the Marxism of the Second International," 87.

37 Rubin, "Marx's Labor Theory of Value," 142; my emphasis.

would therefore argue that the visceral feelings provoked by the smiley are underpinned by something more profound than a bohemian distaste for corporate aesthetics (such as the sort encouraged by the slick anti-consumerist magazine *Adbusters*) or a liberal individualist dread about the erasure of individual particularity. For the smiley is not just an image of abstract personhood but also an uncanny personification of the collectively achieved abstractions of the capitalist economy: abstract labor, value, capital. Its unflinching gaze as we encounter it daily as a cookie, on a price tag, or in a comic book, confronts us with conditions of generalized commodity production.

Let us deepen our discussion of Marx's concept of abstract labor a little further before turning to *Music for Porn*. We have seen that for Marx, abstract labor qua "value-forming substance" is a form of labor specific to capitalist reproduction and its peculiarly asocial sociality.[38] Patrick Murray helpfully refers to this labor as "practically abstract" labor, which he meticulously disambiguates from two very different versions of abstract labor in *Capital*: the richly phenomenological account of universal human labor as a "metabolic interaction between man and nature," which Marx discusses briefly in chapter 7 of the first volume; and more significantly, since it is more easily confused with it, the analytically abstract category of "labor in general" that Marx credited Smith for introducing into political economy in the *Grundrisse*.[39] Though historically determinate in origin, this abstraction has

38 I am therefore with Pepperell when she argues that interpreters of Marx's theory of the fetish character of the commodity form are just slightly off when they describe it as a theory of how an *intersubjective* relationship among human agents takes on the appearance of a property of things. As Pepperell notes, the commodity as value-bearing form more accurately points to "a distinctive type of *non*-intersubjective social relation" ("Disassembling Capital," 95).

39 Patrick Murray, "Marx's 'Truly Social' Labour Theory of Value: Part I, Abstract Labor in Marxian Value Theory," *Historical Materialism* 6 (2000), 27–65.

a legitimate, general applicability to the labor of all societies in a way that implies—and for Murray, permits—its conflation with "simple" physiological labor.[40] As labor from which all concrete qualities have been subtracted and reduced to a hypothetical, minimal expenditure of calories, "simple" labor is also a mental abstraction. Although we can easily imagine it, no labor in such reduced form actually exists (although, as Murray notes, the concept of such labor is logically presupposed by the concept of "labor in general").[41]

For all these reasons, it seems clear that Marx's concept of abstract, value-forming labor is neither "human labor in general" nor the concept of "simple" physiological labor that the former logically entails. Confusions nonetheless arise because of the infamously contradictory first chapter on the commodity in *Volume I* of *Capital*, where Marx repeatedly refers to abstract, value-forming labor in exactly these terms: as "an expenditure of human labor power, in the physiological sense"; as "human labor pure and simple, the expenditure of human labor in general"; as "simple average labor"; as the "expenditure of simple labor-power, i.e. of the labor-power possessed in his bodily organism by every ordinary man, on the average, without being developed in any special way."[42] The contradiction comes to a head in "The Value-Form, or

40 As Murray further disambiguates, the concept of abstract "physiological" labor used in political economy refers to an aspect of *all* labor and is thus a "general abstraction," whereas the concept of "practically abstract" labor introduced by Marx refers to a specific *kind* of labor and is thus a "determinate abstraction" ("Marx's 'Truly Social' Labour Theory of Value," 32).

41 Note the irony here: it is the superficially concrete-sounding approach to abstract labor as simple physiological labor that is the most abstract or general abstraction, since it applies to the labor of every single society, while the much more abstract-sounding definition of abstract labor as a "relation of social validation" is the concrete or determinate abstraction, both in the sense of being specific to capitalism and also in being achieved by the empirical activity of human beings.

42 Marx, *Capital, Vol. I*, 137, 135, 134, 135.

Exchange-Value," section 3 of chapter 1, where we are con-
fronted with diametrically opposed accounts of value-creating
labor placed in almost overlapping proximity:

> It is only the expression of equivalence between different sorts
> of commodities which brings to view the specific character of
> value-creating labor, by actually reducing the different kinds of
> labor embedded in the different kinds of commodity to their
> common quality of being human labor in general.
>
> However, it is not enough to express the specific character
> of the labor which goes to make up the value of the linen.
> Human labor-power in its fluid state, or human labor, creates
> value, but is not itself value. It becomes value in its coagulated
> state, in objective form. The value of the linen as a congealed
> mass of human labor can be expressed only as an "objectiv-
> ity" [*Gegenständlichkeit*], a thing which is materially different
> from the linen and yet common to the linen and all other
> commodities.[43]

The first of the two paragraphs tells us that the "specific
character of value-creating labor," which Marx has already
referred to several times as "abstract labor," is brought to view
"only" through "the expression of equivalence" that "actu-
ally reduces" different labors to a social average. This evokes
what we have seen Marx's commentators call the real or
practical abstraction of the capitalist realization process, the
retroactive positing of social labor through the transforma-
tion of independently produced commodities into money in
exchange. So far, so clear. The ambiguity enters with the next
paragraph, which, in an unremarked transition, seems subtly
to shift its purview from labor rendered abstract in exchange
(in which the becoming-value of labor entails the social equal-
ization of multiple, independently performed labors, hence an
"expression of equivalence") to a seemingly different kind of

43 Marx, *Capital, Vol. I*, 140; my emphasis.

abstraction of labor in the production process (in which the becoming-value of labor involves something like its transformation from a liquid to a solid state, hence an "expression of objectivity"). This is where Marx describes value, elsewhere described as a form of *abstract*, "suprasensible or social" labor, as a *"congealed mass* of human labor."[44] Startling in its incongruity with Marx's previous presentation of value-forming labor as socially averaged or equalized labor, the phrase now invites the reader to regard "value-forming substance" as a *physical* substance, which in turn seems explicitly to invite a view of value-constituting labor as departicularized, "simple" physiological labor.[45]

How do we account for this seemingly contradictory juxtaposition of "suprasensible or social" *and* sensuously material accounts of abstract, value-forming labor? Noting the difficulty of clearly distinguishing Marx's own point of view at moments from those of the economists he critiques, commentators who focus on what Kincaid calls the "performative dimension" of *Capital* might invite us to attribute it—as they tend to attribute the tonal ambiguity, stylistic assertiveness and occasional theoretical inconsistency of the early chapters of the first volume overall—to Marx's often deceptively unmarked use of irony or what Dominick LaCapra calls "double-voicing."[46] It is true that in a manner akin to Hegel's

44 Marx, *Capital, Vol. I*, 142; my emphasis.

45 For Murray, there is something "ludicrous" about the very act of describing "abstract" labor as "congealed" or "embodied" ("Marx's 'Truly Social' Labor Theory of Value," 57–58).

46 For a particular example of focus on the "performative dimension," see David Harvey, *A Companion to Marx's "Capital," Volume II*, New York: Verso, 2013, 306. On "double-voicing," see Dominick LaCapra, "Reading Marx: The Case of *The Eighteenth Brumaire*," in *Rethinking Intellectual History: Texts, Contexts, Language*, Ithaca: Cornell University Press, 1983, 270. For a particularly interesting example of the difficulty of distinguishing Marx's perspective from those of the economists he subjects to critique, see Harvey, *A Companion to Marx's "Capital," Volume II*, 306.

way of inhabiting the perspectives of the various shapes of consciousness in *Phenomenology* (which Katrin Pahl suggestively describes as a kind of "free indirect discourse"), Marx often ventriloquizes the perspectives of the "pundits of economics" to mock them.[47] Critics such as Robert Paul Wolff accordingly follow the early lead of Edmund Wilson in reading the first chapter of *Capital* as a "burlesque" of political economy as well as of the idealist metaphysics that tacitly inform its major concepts.[48] In a similar vein, Murray argues that Marx's counterintuitive alignments of abstract labor in chapter 1 with "substance," "embodiment," "crystals" and "congealed labor" are aggressively "taunting" and perhaps even meant to "shock" the reader.[49] Indeed, Murray suggests that one of Marx's earliest descriptions of abstract labor, as the "'residue' that remains once all the concrete, natural properties of commodities have been abstracted away," is a satire of "Descartes's famous derivation of material substance (*res extensa*) from his analysis of the bit-turned-blob of wax at the end of the second Meditation."[50] Pepperell pushes this

47 Katrin Pahl, *Tropes of Transport*, Evanston: Northwestern University Press, 2012. "Pundits of economics," Edmund Wilson, quoted in Robert Paul Wolff, *Moneybags Must Be So Lucky: On the Literary Structure of Capital*, Amherst: University of Massachusetts Press, 1988, 9.

48 Wolff, *Moneybags Must Be So Lucky*, 54.

49 Murray, "Marx's 'Truly Social' Labour Theory of Value," 60, 57. At the same time, Murray also argues that the copresence of the specifically Marxist concept of abstract, value-forming labor and political economy's concept of abstract, in the sense of "simple," physiological labor, is due to the fact that "the concept of abstract labor is presupposed by the concept of value-producing labor...we need to know what it means for labor to be abstract before we can tell whether or not a certain social type of labor is abstract in practice. So the 'physiological' concept of labor is a necessary object of analysis, even though it is not the ultimate object of analysis" (60).

50 Murray, "Marx's 'Truly Social' Labour Theory of Value," 60. I hear an echo of Hegel's equally ironic presentation of the claim to certainty of the second of the "two Enlightenments" into which pure Insight splits after its antagonistic conflict with Faith in *Phenomenology*

logic furthest by reading Marx's early chapters as a literal instance of satirical theater: as a series of "plays" containing smaller "playlets" in which Marx amplifies his parody of the arguments of bourgeois economy by aligning them with consciousness's various claims to certainty in Hegel's *Phenomenology*.[51] The voice in chapter 1 describing "abstract labor" in such a strangely universal, un-Marxian way as "human labor, pure and simple," and "value" as a strangely thinglike "congealed mass of human labor" might thus be that of an economic and/or metaphysical point of view that Marx is only temporarily ventriloquizing in order to satirize.[52]

Reading Marx's writing in this section as satirically double-voiced (and therefore booby-trapped) would certainly be a way to explain the contradictory characterizations of abstract, value-forming labor in the two paragraphs above.

of Spirit. For this second Enlightenment (who may in fact be Descartes?), *"pure matter* is merely what is *left over* when *we abstract* from, feeling, tasting, etc., i.e. it is not matter that is seen, tasted, felt, etc.; what is seen, felt, tasted, is not *matter,* but color, a stone, a salt, etc. Matter is rather a *pure abstraction;* and so what we are presented with here is the *pure essence of thought,* or pure thought itself as the Absolute, which contains no differences, is indeterminate and devoid of predicates" (*The Phenomenology of Spirit*, trans. A.V. Miller, Oxford: Oxford University Press, 1977, 351, para. 577).

51 Highlighting Marx's description of *Capital* as a narrative featuring "characters" placed on an "economic stage" (*Vol. I*, 179; quoted in Pepperell, "Disassembling Capital," 73), Pepperell more specifically argues that Marx makes his representatives of the ideas of bourgeois economy (never explicitly marked as such) deliver their monologues (also never explicitly marked) from the one-sided perspectives of Hegel's Perception, Understanding and Force. Pepperell cautions that we therefore cannot unilaterally trust Marx to mean what he is saying in the first six chapters of *Capital*—not, however, because he is attempting to obscure or deconstruct his own theory, but precisely in the interests of constructing an imminent critical theory.

52 Hegel himself often satirizes the claims to certainty of his shapes of consciousness in *Phenomenology* (the hilarious phrenologist of Observing Reason, for example, for whom "the being of Spirit is a bone" *Phenomenology of Spirit*, 208, para. 343).

If not a parodic echo of the story of melting/hardening wax in Descartes' derivation of *res extensa,* as Murray suggests, for instance, one might hear in the second paragraph's reference to value as a "congealed mass of human labor" a parody of David Ricardo's embodied-labor theory of value. Yet the meaning of the contradiction as such deserves more attention. Highlighting a metamorphosis in its form, the distinction between "fluid" and "coagulated" labor in the second paragraph is fairly clear: the former refers to living labor deployed as variable capital in the production process, whereas the latter corresponds to dead or past labor—that is, previously produced, realized or fixed value—in the form of commodities functioning as constant capital or means of production. The second paragraph emphasizes that the former "creates" value, while the latter simply is or "becomes" value (Marx refers to this "previously worked up" labor as "crystallized" or "congealed" labor repeatedly elsewhere in *Capital* and in many other writings). But what is the relation of the abstract labor/ value relation in the production process, once we recognize its interacting facets of "fluid" living labor and "congealed" labor, *to* the abstract labor/value relation described in the first paragraph about exchange? Is Marx presenting accounts of the *same* abstraction or becoming-value of labor from the dual perspectives of circulation and production, as if to reflect the "twofold" nature of labor itself—always both abstract and concrete—under conditions of generalized commodity production?[53] Are these intended to emphasize distinct yet fundamentally continuous ways in which labor finds itself abstracted by the "law of value," one corresponding to the

53 In the second section of the first chapter of *Volume I* of *Capital,* Marx states that like the dual character of the commodity (use value and exchange value), "labor, too, has a dual character: in so far as it finds its expression in value, it no longer possesses the same characteristics as when it is the creator of use-values. I was the first to point out and examine critically this twofold nature of the labor contained in commodities" (*Vol. I,* 132).

realization of exchange value, the other to the creation of use values and surplus value? If there are in fact two distinct concepts of the becoming abstract or value of labor here, what is the relation between the two, and what does *that* relation tell us about the "specific character of value-creating labor"?

One thing we can be certain about is that the passage's tone, like that of the entire chapter, is hard to pin down. Marx's diction changes midstream, making an unannounced shift from the dry, anti-imagistic, theoretical language of political economy used to describe value-creating labor in the first paragraph ("It is only the expression of equivalence between different sorts of commodities which brings to view the specific character of value-creating labor") to the sensuously material language of fluidity and viscosity used to describe it in the second. Passages like the second make it easier to understand the otherwise puzzling proliferation of "naturalist" or "substantialist" approaches to Marx's "value theory of labor."[54] Finally, while Marx's language of congealing substance is empirical or even "materialist" in the vulgar sense (where "matter" means visible, tangible, physical substance), Marx's *use* of that language is imagistic or figurative. Regardless of the ambiguity surrounding the characterization of value-constituting labor in the two paragraphs above, by the end we are left with that labor reframed by metaphors

54 Marx, *Capital, Vol. I*, 140. Heinrich, *Introduction*, 50, 54. For an overview of the key differences between the neo-Ricardian, "crystalised-labor" or "embodied labor" approach to Marx's labor theory of value and the "abstract labor" approach," see Alfredo Saad-Filho, "Concrete and Abstract Labor in Marx's Theory of Value," *Review of Political Economy* 9: 4 (1997), 457–77. Departing from Heinrich and others who emphasize (I think rightly) that abstract labor is not labor expended in production (though this emphasis risks giving the impression that abstract and concrete are freestanding *types* of labor), Saad-Filho helpfully argues that "in capitalism workers perform concrete and abstract labor simultaneously." More specifically, the "commodity's use value is created by the concrete labor performed, and its value is created by the simultaneous performance of abstract labor" (468).

that make value-creating labor *seem like* generic, transhistorical labor.[55] Indeed, these metaphors leave the reader with a conspicuously un-Marxian impression: that as a "crystal" of labor lodged unchanging in the commodity, value is a natural, intrinsic, embodied property of the individual commodity, as opposed to an emergent, historically contingent relation.

While sharing the interest of LaCapra, Wolff, Kincaid, Murray and Pepperell in recovering *Capital*'s affective and specifically satirical dimension, Keston Sutherland takes a different tack in reading this passage. Instead of arguing that Marx's description of value as a "congealed mass"—Ben Fowkes's translation of "bloße Gallerte"—is problematically substantialist, or so grossly materialist that we might even suspect it of being a parody of Descartes or Ricardo, Sutherland argues that the term is too conceptually *abstract*; that like Samuel Moore and Edward Aveling's translation of the same phrase, "mere congelation of homogeneous labor," it does a disservice to the visceral impact of Marx's "bloße Gallerte unterschiedsloser menschlicher Arbeit" by erasing the specificity of Gallerte: a gelatinous condiment made from the "meat, bone, [and] connective tissue" of various animals.[56] Sutherland writes,

> Gallerte [unlike "congelation"] is not an abstract noun. Gallerte is now, and was when Marx used it, the name not of a process like freezing or coagulating, but of a specific commodity. Marx's German readers will not only have bought Gallerte, they will have eaten it; and in using the name of this particular commodity to describe not "homogeneous" but, on the

55 For an explicitly political critique of the misinterpretation of abstract labor as physiological labor (and a useful survey of different approaches to Marx's theory of abstract labor), see Werner Bonefeld, "Abstract Labor: Against Its Nature and on Its Time," *Capital and Class* 34 (2010), 257–76.

56 Keston Sutherland, "Marx in Jargon," *world picture* 1 (2008), worldppicturejournal.com.

contrary, "unterschiedslose," that is, "undifferentiated" human labor, Marx's intention is not simply to educate his readers but also to disgust them.

As a word referring to a more richly determined and socially meaningful artifact, "Gallerte" as opposed to "congelation" undeniably bestows greater detail to Marx's unparticularized, perversely substance-like image for the objective expression of value. In both cases, however, the imagery of *substance* remains fundamentally the same—and the use of that imagery remains fundamentally catachrestic.[57] The question of whether Gallerte is more true to the spirit of *Capital* than congelation thus seems less important than the question of why Marx is using physical matter as such a conspicuously strained metaphor for the concept of abstract, value-constituting labor to begin with. What is gained by using an image that makes a specifically capitalist abstraction (and specifically Marxist theoretical concept), abstract or socially necessary labor,

57 This observation about Marx's use of catachresis in his account of the relation between abstract labor and value is by no means original. For a helpful overview of differing theories of catachresis and a brief deconstructive account of the trope's role in Marx's writing in particular, see Gerald Possett, "The Tropological Economy of Catachresis," *Metaphors of Economy*, eds. Nicole Bracker and Stefan Herbrechter, New York: Rodopi, 2005, 81–94. For a more extensive account of Marx's concept of "value" as catachresis mediated through a reading of Gayatri Spivak's writings on value, see Best, *Marx and the Dynamic of the Capital Formation*, 80–82. Both Possett and Best approach catachresis as a "figurative and performative act of resignification which—in applying (abusively) a familiar term with a somewhat different signification—does not signify a pre-discursive object, but rather constitutes the identity of what is named" (Possett, "Tropological Economy," 86), as "a name that has no literal or adequate referent but is used as if it did, temporarily and provisionally, so that a narrative can be constructed around it" (Best, *Marx and the Dynamic of the Capital Formation*, 80). Similar to what Pierre Fontanier calls a trope of "forced *and* necessary usage" (quoted in Possett, "Tropological Economy," 86, 84), I use the term to convey the broader, more literal meaning of the Greek word *katachrêsis* as "abuse" or "improper use."

sound confusingly *like* simple physiological human labor? Is it because there is no existing terminology other than that of substance to express the "objectivity" of "suprasensible or social" value?[58] To rephrase the question, borrowing language from Wolff, why *must* Marx mobilize catachresis to capture the peculiar ontology of capitalist abstractions?[59]

The Soldier's Body

Music for Porn's treatment of the male soldier's body as an eroticized abstraction—but also, quite specifically, a capitalist abstraction—has its own unique way of meditating on the questions raised by Marx's presentation of abstract labor above. Though the labor of soldiers is what Marx would call unproductive (that is, nonproductive of value, which does not rule out its possible necessity for enabling value-productive labor to take place), the body of the soldier in Halpern's text is so tightly coupled with "value" that the terms almost always appear together: "Value clings to the soldier like self-preservation *a film of cash*."[60] This body enters the world

58 Marx, *Capital, Vol. I*, 126. Or is it because there is an inevitable crossing of semantic registers in Marx's implicit characterization of the "material content" of value as "abstract labor" and its "social form" as "exchange value"? Everyday language and practice arguably make it strange for most of us to think of something abstract as being material.

59 This is the simple but powerful question Wolff devotes the entirety of his short book to answering: "What is the logical connection between Marx's literarily brilliant ironic discourse and his 'metaphysical' account of the nature of bourgeois social reality? Why *must* Marx write as he does if he is to accomplish the intellectual tasks he has set for himself?" (*Moneybags Must Be So Lucky*, 10).

60 *Music for Porn*, 152. Halpern's phrase echoes this passage from *Volume I* of *Capital*: "Men do not therefore bring the products of their labor into relation with each other as values because they see these objects merely as the material integuments of homogeneous human labor. The reverse is true: by equating their different products to each other in exchange as values, they equate their different kinds of labor

of the poem already "working overtime as allegory." Even prior to being reenlisted by Halpern to explore capitalist abstractions and their material effects, the soldier is already The Soldier: a "phony apparition"; "an exaggerated type"; a "comic strip character" with features as "amplified and distorted" as "those of the capitalist, the worker, the terrorist" and who "might appear among the Village People, that band of iconic queer bodies: Indian Chief, Construction Worker, Leatherman, Cowboy, Cop, Soldier."[61] As *Music for Porn* suggests, there is a further complexity to The Soldier's allegorical abstractness, since the official symbolism he provides for the coherence of the nation depends on his being a "sacrifice" or body for use. While the soldier's labor is thus like that of the sex worker, Halpern suggests that his contractual agreement

as human labor. They do this without being aware of it. *Value, therefore, does not have its description branded on its forehead; it rather transforms every product of labor into a social hieroglyphic.* Later on, men try to decipher the hieroglyphic, to get behind the secret of their own social product: for the characteristic which objects of utility have of being values is as much men's social product as is their language. The belated scientific discovery that the products of labor, in so far as they are values, are merely the material expressions of the human labor expended to produce them, marks an epoch in the history of mankind's development, but by no means banishes the semblance of objectivity possessed by the social characteristics of labor. Something which is only valid for this particular form of production, the production of commodities, namely the fact that the specific social character of private labors carried on independently of each other consists in their equality as human labor, and, in the product, assumes the form of the existence of value, appears to those caught up in the relations of commodity production (and this is true both before and after the above-mentioned scientific discovery) to be just as ultimately valid as the fact that the scientific dissection of the air into its component parts left the atmosphere itself unaltered in its physical configuration" (166–67; my emphasis).

61 Ibid., 152–53. One finds numerous precedents in literature for these pornographic archetypes. See, e.g., Melville's Handsome Sailor, represented as both an object of male desire and a sociological type in *Billy Budd*, as well as the poems of the modernist Luis Cernuda, who caresses his "Young Sailor" as both a hot body *and* a cool abstraction.

to being potentially *used up entirely* makes him that much more of a "meat man," "purest meat," *"bare life, dead meat."* Indeed, one of the other things for which Halpern's soldier functions as allegory is a "corpse"—moreover, one that the nation hygienically hides from view. Qua "sacrifice," the soldier's *death* can be brought into the public sphere and mourned, but ironically not the soldier's *body*, qua "corpse."[62]

Yet at every moment where we might expect *Music for Porn* to rescue this repeatedly abstracted and occulted body by insisting on its concreteness as object of the poet's lust, the description flips back into a testimony to its abstractness. As if to refuse to let us ever forget the covert barring of the combatant's corpse from public view by repeatedly reenacting it, "the body" is a perpetually "withdrawn" body, subsumed into economic abstractions almost immediately on mention: "The body required to ensure the nation's vision of freedom and democracy is a dead one *note the nimbus around his withdrawn corpse, function of pure exchange*"; "My soldier's no match for this, he's too real, being capital's proper corpus, extension of its management and concern." First expropriated as sign from the bodies of real combatants who no longer control its dissemination or meaning, only to be "removed from public circulation" as corpse, it comes as no surprise that the soldier's body seems available to stand in for virtually anything (*"function of pure exchange"*). He can even seem like the agent of his "own" alienation and ensuing symbolic availability: "Having cut himself loose from the social relations that make him what he is, his figure stands in for universal profit."[63]

"Universal profit" is the organizing principle of a society for which global wars have repeatedly helped fend off economic crisis, and whose official military culture surreptitiously conscripts—even while explicitly proscribing—male homoerotic affect and camaraderie, "pressing it into the service of

62 Ibid., 50, 83.
63 Ibid., 55, 152, 153.

nation building," as Halpern notes about Whitman's *Drum-Taps*. The instrumental use of "queer affections...to bind our national interests" thus perversely results in the denial of the very body for which homoerotic desire is aroused, even as that body becomes further sublimated, by way of The Soldier's more conventional symbolic work, into transcendent concepts like democracy and freedom. It is this particular elision of the soldier's body, in contradictory lockstep with its simultaneous exploitation *and* eroticization for national symbolic ends, that Halpern calls "unbearable,"[64] and which his experiment in making poetry into an accompaniment to pornography tries to undo representationally by countering its abstraction with...more abstraction. Rather than insist on the concretely physical as every abstraction's obscured truth, as do many of philosophy's new materialisms, *Music for Porn* is poetry about war in which the soldier's body is phantasmically reclaimed precisely through the mediation of allegory, and indeed by a doubling down on its use.

The difficulty of this political project is mirrored formally in *Music for Porn*'s unstable status with respect to genre, as it alternates between sequences of stark, carefully patterned objectivist lyrics (some collaged from site reports and military intelligence interviews), prose poems in a more discursive vein and essays that, in directly addressing the theoretical aims of the lyric and prose poems, enable Halpern to fold an account of the book's making into the book itself. The theoretical essays are haunted, however, by an italicized subdiscourse that implicitly questions the validity of the statements to which they cling by whispering substitutable expressions: "vehicle of exchange and pleasure *receptacle of cash and cum*"; "militarization *financialization*"; "phony apparition *fragile appearance*"; "allegories *zombies of living labor*"; "ghost money."[65] The main effect of these phrases is that of correcting

64 Ibid., 47.
65 Ibid., 158, 153, 152, 155, 154.

or even undoing the concepts immediately preceding them, even when their function also seems to be explicating or elaborating them further:

> I want to undo Whitman's militarized vision *democracy fulfilled by betraying its perversity.* And yet my poems become evermore distorted, frustrated, and perverted in the process *turned away from their impossible aim* because their own utopian longings are blocked by current conditions under which a demilitarized world is inconceivable *depressing conclusion of this research.*[66]

Capitalist abstractions and their palpable effects intermingle constantly with the language of sexual trade, with concepts like circulation, overproduction and trade imbalance mixed into descriptions of blow jobs: "The feel of his balls in my mouth is pretty hot, and his theory of agrarian development in the South is even hotter." The coupling of the sexually explicit with forms like value and capital is especially prominent: "Value clings to the soldier like self-preservation *a film of cash, relation of no relation* betraying my love for the death drive"; "Just as he disavows the debauchery of capital *whose servant he is* my soldier becomes evermore debauched *sinks below the hemisphere of sense, as I might sink my nose in his ass* down along the precipitous fault of old imperialisms."[67] More importantly, this "interpenetration of corpus and finance" by which "global processes...collide with the body's intimate recesses" is reinforced by an image of a congealing substance exactly identical to the kind we have seen used by Marx and highlighted in Sutherland's reading of Marx:

> The hole a weapon makes, where global processes *accumulation by dispossession*, neoliberal austerity, environmental degradation, profitable incarceration collide with the body's intimate recesses all my desires and repulsions externalized,

66 Halpern, "Notes on Affection and War," in *Music for Porn*, 56.
67 Halpern, *Music for Porn*, 111, 152, 153.

obdurate and opaque to my cognition. <u>Residues of living labor congeal in such bodies where love hardens with the muscle</u> *interpenetration of corpus and finance.*[68]

Getting hard obviously refers not just to sexual arousal or to the objectification of abstract labor in/as value (a process for whose expression no concept other than that of hardening seems available) but to their perverse "interpenetration," as if this is what truly constitutes the poem's pornographic dimension. The imagery of hardening and congealing in association with the interpenetration of sexual and economic registers recurs repeatedly throughout *Music for Porn*. Consider the following instances (my underlining below):

I mean the soldier, he's my sick muse and deserves more compassion than I appear to offer, but <u>he's already hardened into allegory</u>.

So I go on thinking about…this poem, how it goes on and on and on because the moment to realize has become my job, my filth, a collective residue, <u>a thin film of integument that hardens</u> around a body interred behind the wall, or buried in the yard, where it goes on secreting the mystery of my well-being.

Ghostly void or <u>dead zone around my body // Collects a hyaline film and my mucous hardens</u> / Yielding new sugars upon decomposition sordid / Shapes assume their own lost object

Being is a <u>value-slope, a residue of aura hardening</u> inside refurbished Gulf War mat obstruction.

Thus the spirit's wiped clean, purged, <u>leaving this residue of life, a hardened edge of mucous and bile</u>. Like a film of cash, yr hot soldier jizz, never again on earth becoming.

<u>Nature hardens</u> in the money form *whore's make-up soldier's thighs*

68 Halpern, "Notes on Affection and War," in *Music for Porn*, 57; my underlined emphasis.

<u>Nucleus of time crystallizes</u> in a lug way down deep inside //
My soldier's groin goes deeper still

My soldier is the narrative of these disjunctions...eternal
integument <u>hardened skin</u> around a liquidated meaning, as if
his hardening alone could arrest these processes of decay

Strewn in fields of waste, organs sensing under siege, <u>mere
shadow case of value, a hardened rind</u>, or money form, what-
ever remains when you stop believing it.

Time itself, having already become <u>a hardened artifact of the
system</u>, renders my orgasm co-extensive with the demands of
production, but this is neither true nor false.

Hazy eros *residue of money* hovers around this figure, and
<u>settles on my skin</u>. I can't wash myself of its <u>thick condensation</u>.

And now, as the rain keeps falling on this deserted town, my
<u>social relations cohere</u> around all these militiamen I want to
fuck inside abstracted huts where no one lives anymore.

My soldier thus becomes my swan, my muse, my washed-
up whore. <u>Like an allegory, he hardens around all our abstract
relations</u> *values* assuming a shape around history's contusions
and contradictions, a scar where my alienable form has been
hygienically sutured to the loss he represents.

<u>Aura concentrates</u> in the figure of the fallen soldier *so attrac-
tive so repulsive*[69]

Note that for the most part, the entities described as hard-
ening or congealing are conspicuously *intangible*: "time";
"eros"; "aura"; "social relations"; "void"; "value" or "value-
slope"; "allegory."[70] Exaggerating the "abuse" of the already
mixed metaphor of likening *body* to *value*, these intangibles
are endowed with qualities that further underscore their ethe-
reality: the "eros" that condenses is a "*hazy* eros"; the "value"
that becomes a "hardened rind" is a "*mere shadow case* of
value"; the "void" that "collects a hyaline film" is a "*ghostly*

69 Ibid., 7, 4, 78, 112, 117, 156, 93, 156, 97, 119, 154, 4, 156, 56.
70 Ibid., 93, 119, 154, 112, 56, 4, 78, 97, 112, 156, 97.

void."⁷¹ As if to replicate Marx's similarly catachrestic descriptions of abstract labor and value, the imagery of congealing in *Music for Porn* is applied predominantly to abstractions, and especially capitalist abstractions. The abstract noun "abstraction" itself repeatedly appears in the poem as continuous with "value" and "allegory": "With the militarization *financialization* of daily life, <u>lyric is caught up in these abstractions *value credit debt*</u> as overproduction penetrates the soldier's body and weds it strangely to my own *radical discontinuity of flesh and world that the poem longs to bridge*"; "Like an allegory, he hardens around all our abstract relations *values* assuming a shape around history's contusions and contradictions."⁷²

"Value," arguably the most "abstract" of all Halpern's abstractions, is also the one most frequently described with the stereotypically "concrete" language of solidifying matter.

Conversely, *Music for Porn* abounds with the names of viscous fluids—"jizz," "glue," "sap," "cum," "mucous," "ejaculate," "plasma"—which are presented in the *already hardened* form of "film," "laminate," "veneer," "trace," or "residue."⁷³ While both the viscous substance "glue" and the intangible social relation "value" appear as these "distillations of capital," only abstractions like the latter are counterintuitively depicted as *actively* congealing.⁷⁴ Why does this admittedly subtle

71 Ibid., 154, 97, 78; my emphasis.

72 Ibid., 153, 156.

73 Here, as if to highlight the thinness of the border simultaneously connecting and separating the concrete and the abstract in *Music for Porn*, these words refer to physical matter existing in such an attenuated or reduced form (as in "*distillations of capital laminated on my skin*," 158) that it verges on seeming, well, "abstract."

74 These complex maneuvers are not the only way in which *Music for Porn* explores the dialectical relation between the concrete and abstract. The book also deploys a much more straightforward alignment of "the spirit and the beef" (5), an anomalous pairing echoed by "this confluence of widget and plasma" (35) and "the convergence of lyric and ballistics" (25). At the sentence level, moreover, highly specific local details often get densely piled up only to veer off into abstraction

difference matter? Again, wherein intangible abstractions like "value," "value-slope," "allegory" and "aura" are shown in the present-tense process of "hardening" right before us as if they were physical substances *like* glue, a substance whose whole point is to harden, but which in Halpern's book does not?

With *Music for Porn*'s repeated return to the cohering functions performed by the "soldier's body *hieroglyph of value*," as we see it put to the task of shoring up entities such as the nation, homophobia, the public sphere, imperialism, finance, the prison system and capitalism, we might start to suspect that one reason both Halpern and Marx make use of the same catachrestic image of congealing substance as a metaphor for value is to underscore the *socially binding* or *plasticizing action of capitalist abstractions*.[75] And more specifically, they do so to emphasize the *synthetic action* of an abstraction-like value—the way it palpably shapes the empirical world of collective activity to which it belongs and in which it acts. This view stands in vivid contrast to both the idea of value as an inert substance residing in the individual commodity after its production and forming one of its natural properties (as in the embodied-labor value theory of Smith and Ricardo—who, as Marx notes, neglect "the form of value which in fact turns value into exchange-value") and also the idea of value as a "void" or ontologically empty form constituted entirely in the exchange process (as in some versions of Marxist value-form theory, which, like what Marx describes as a contemporary form of neo-mercantilism explicitly opposed to classical

at the last minute, yet by way of that abstraction, leading to the specificities of a vast global economy: "Rocky lowlands, marginal wood ferns densely covered with golden fur and rare lichens brought in from the island, bind the world to theologies of labor, all the cotton gins and pharmaceuticals" (8). A paragraph beginning with historically meaningful descriptive details such as a soldier in "traditional grey, loose fitting Afghan salwar kameez clothing" culminates in the flat announcement of "his particularity being no more than a type" (151).

75 I owe the evocative term "plasticizing" to Jasper Bernes.

political economy, run the risk of "see[ing] in value *only* the social form, or rather its insubstantial semblance").[76] If the former "overlook[s] the specificity of the value-*form*" (which is acquired in the exchange of already produced commodities for money), the latter overlooks its "substance" (which is acquired in the production process itself, through the interaction of living and dead labor).[77]

Value, as depicted with strikingly materialist imagery in both Halpern and Marx, is neither an inert "crystal" created in a production process isolated from circulation *nor* a pure form constituted in an exchange process isolated from production and operating on an entirely separate plane from everyday practical activity (although, as Beverly Best stresses, it is inherent to the social mechanism of abstraction, which is the "core function of the capitalist mode of production," that value take on the objective *appearance* of this independence or autonomy).[78] Value is rather, as the acts of catachrestic or "abusive" metaphor enable both Marx and Halpern to emphasize, a social relationship brought into being by the unintended and uncoordinated actions of a multitude of actors. Hence, in line with previous arguments made by Wolff, Kincaid and Best, I would argue that *only* a catachrestic use of language seems adequate to both authors for objectively capturing the contradictions of value and the world that it and other capitalist abstractions bring into being. Like the abstract or socially necessary labor that constitutes it, value is an "emergent" phenomenon that demands catachresis as its only truly logical form of representation. It is neither an obdurately thingly substance nor an "insubstantial semblance" or

76 See Marx, *Capital*, Vol. I, 174*n*34. According to Christopher Arthur, the value-form "expresses an ontological emptiness which lies at the heart of capitalism" (quoted in Kincaid, "Critique of Value-Form Marxism," 88).

77 Marx, *Capital*, Vol. I, 174*n*34.

78 Best, *Marx and the Dynamic of the Capital Formation*, 20.

contentless, frictionless form, but a "suprasensible or social" relationship whose representation *requires* a constant crossing of the realms of "the spirit" and "the beef." Value resembles the generic Animal perversely commingling with specific real animals below, in Marx's allegory of money as the relatively autonomous, freestanding expression of exchange value that the "realization" of value created in production necessitates and that in turn constitutes its form:

> It is as if, in addition to lions, tigers, hares, and all other really existing animals which together constitute the various families, species, subspecies, etc., of the animal kingdom, *the animal* would also exist, the individual incarnation of the entire animal kingdom.[79]

Fabular yet scientific (we hear echoes of both Aesop and Darwin), this portrait of a capitalist abstraction never fails to give me the willies, perhaps for reasons identical to those underpinning the willies that Johnson gets from the idea of eating a smiley face.

Highlighting the synthetic and plasticizing effects of capitalist abstractions, and the fact that they are continuous with concrete activities while only seeming to be entirely autonomous, Halpern's use of catachresis to describe the abstract-allegorical work of the soldier's body in *Music for Porn* thus helps clarify what might be at stake for Marx in his own use of the figure to describe "value-forming substance" in "The Value Form." There is a key difference, however, in how the agency of abstraction gets figured in Marx and Halpern. For in contrast to Marx's description of the value expressed in the commodity's exchange value as Gallerte, animal parts boiled and then cooled to harden into a semisolid jelly, the dominant image in *Music for Porn* is not that of a *material substance* congealing *into* something. It is rather that of an

79 Marx, quoted in Heinrich, *Introduction*, 78.

intangible abstraction, congealing *around* a *nothing,* or void (my underlining in the following):

> The consistency of the situation hangs on the body, being <u>a</u> <u>hole around which everything that appears to cohere.</u>
> And now, as the rain keeps falling on this <u>deserted</u> town, <u>my</u> <u>social relations cohere</u> around all these militiamen I want to fuck <u>inside abstracted huts where no one lives</u> anymore.
> Sensing its own decay, value clings with fierce tenacity to the very things <u>bodies that will be sacrificed for it.</u>
> Even after swallowing his piss, I still see myself everywhere I look, a series of seemingly endless grammatical subordinations, <u>circling</u> the <u>withdrawn violence</u> that structures the limits of our perceptual field, <u>a blank</u> in my own dislocation.
> *note the* <u>*nimbus around his withdrawn corpse,*</u> *function of pure exchange*
> A whole metaphorics of love and war *my phalynx of clichés* <u>converge around</u> his <u>vulnerability to penetration.</u>[80]

As if to suggest a portrait of catachresis itself, understood as a figurative operation based on a "lexical lacuna," or the "absence of an original proper term which has been lost or never existed," everything that "cohere[s]" or "converge[s]" in the lines above does so around a "hole."[81] Social relations cohere in a deserted place. Value clings to what will eventually be sacrificed in its name. A nimbus collects around the space left empty by a withdrawn corpse. Substitutions circle around a blank. Metaphorics converge around a wound or orifice (evoked by "vulnerability to penetration"). And note, again, that what coheres *around* these sites of past, present and future absence is not a tangible substance but an abstraction: "everything," "social relations," "value," "substitutions," "metaphorics."

80 Halpern, *Music for Porn,* 119, 4, 153, 55, 56.
81 Possett, "Tropological Economy," 86.

Is this imagery of abstraction hardening around nothing not an allegory of the "ontological emptiness which lies at the heart of capitalism," which is the inherent emptiness of the value-form?[82] Not exactly, since as with the other abstractions above—"social relations," "everything"—its insistence is on "value" as a "suprasensible or social" *substance* in the process of plasticizing. Moreover, the void around which this synthetic action takes place is not an "ontological emptiness" but a space that Halpern is careful to show as having been *rendered* empty, by the agency of social actors, from something in it having been actively *withdrawn*. I therefore think that the image of the "hole" or "blank" around which social substance is shown cohering in *Music for Porn* is summoned to metaphorically counteract the impulse to triumphantly uncover a thingly substance—as opposed to an emergent or unintended social relationship—as the hidden truth of every abstraction. At the same time, the image of matter hardening or congealing seems contrapuntally deployed to combat our temptation to regard the abstractions in *Music for Porn* as ideal or immaterial: that, because the "soldier's body *hieroglyph of value*" is an abstraction cohering around nothing, as opposed to a kernel of matter obscured by a shell of abstraction, it is therefore somehow less real than the "car that runs you over."

Applied to "value" in a way that seems intended to produce a visceral response, the almost cartoonish "concrete" image of hardening substance seems put to work, in other words, like a prophylactic seal or caulk against the idea, recently resurrected by many of the "new materialisms," that abstractions are exclusively thought-induced mystifications of particularity —and therefore mystifications that can be easily dissolved simply by being corrected *with* thought. Calling attention to the oft-remarked tension between the concrete and abstract dimensions of *Capital* as well as to its own illicit coupling of

82 Arthur, quoted in Kincaid, "Critique of Value-Form Marxism," 88.

poetry and theory, *Music for Porn*'s openly catachrestic poetics thus clarify the stake of Marx's similarly catachrestic use of Gallerte and/or congelation as a *metaphor* for the theoretical *concept* of abstract, value-constituting labor. But in addition to providing an exaggerated, figurative way of impeding the dissemination of the increasingly popular conception that "abstract" means "not real," the metaphor also implies that with the objective distortions of logic created by capitalism, its own act of exaggeration is somehow *theoretically* necessary. In this manner, Halpern's use of catachresis dramatizes what Wolff, Kincaid and others note Marx uses the "performative dimension" of *Capital* to dramatize: that an "abuse" of logic by the analyst—including the logic of equivalence and substitution underpinning metaphor—is perversely required to show how the basic relations and operations of capital make sense.[83] It also highlights another peculiarity of capitalist reproduction already visible in the passage from "The Value-Form." Although what makes capitalism distinctive is its historically unprecedented integration of production and circulation— starting from the worker's "free" exchange of her labor power as a commodity, production and exchange mediate each other at every point—the two spheres often appear autonomous, even to extremely perceptive and dedicated analysts of the system.[84] A kind of "abuse" strangely begins to seem necessary to restore the fundamental connection between the two halves in representation, as evinced when we begin to suspect that Marx's references to labor "in a coagulated state" in *Capital* are a deliberately hyperbolic, catachrestic way of reminding us of the material effects that abstract social labor, qua "relation of social validation" established exclusively in exchange, ends up having on labor actually used or expended in production.

83 Kincaid, "Critique of Value-Form Marxism," 86.

84 For an example of how this disconnection between production and circulation plays out in the world of theory, see Joshua Clover, "Value/Theory/Crisis," *PMLA* 127: 1 (2012), 107–13.

Labor is abstracted or socially homogenized by the practice of
social actors in *both* capitalist exchange and capitalist produc-
tion, in *both* the realization of value and the valorization of
value, but in different ways that seem to call for different reg-
isters of discourse (recall the shift in language between the two
paragraphs above). *Music for Porn* suggests that the effort to
rejoin these languages, part of its larger effort to think labor as
use value and exchange value together, will inevitably involve
a poetics of catachresis.[85]

The visceral abstractions in *Capital* and *Music for Porn*
thus finally direct our attention to a philosophical problem.
In theory, it always seems unmistakably clear that whatever

85 It is useful here to note La Berge's reminder that in "Marx's own
Marxism, abstract and concrete are not mutually exclusive positions";
rather, "each is possible only in its realization of the other" ("Rules
of Abstraction," 98). Departing from other commentators who argue
that only abstract labor is specific to capitalism (see, for example,
Bonefeld, "Abstract Labor"; and Moishe Postone, *Time, Labor, and
Social Domination: A Reinterpretation of Marx's Critical Theory*, Cam-
bridge: Cambridge University Press, 1993), Elson argues that because
of the unity (if also relative autonomy) of production and circulation in
capitalism, the relation between concrete and abstract labor, like that
of socially necessary labor to value, is not one of "discretely distinct
variables which have to be brought into correspondence" but "one of
both continuity and difference" such as that existing between the dif-
fering forms of appearance of a single organic substance. For Elson,
Marx's natural or chemical and biological metaphors of "crystalliza-
tion" and "embodiment" are used to index precisely this metamorphosis
or "change of form" ("Value Theory of Labour," 139). For his part,
Postone rigorously traces this inseparability of the abstract and con-
crete back to the dual nature of the commodity form; its fundamental
split between exchange value and use value giving rise to the very idea
of "labor expressible in [both] abstract and concrete dimensions" and
to all the forms that come to embody this particular tension in turn
(including value, money, and time itself); see Postone, *Time, Labor, and
Social Domination*. Taking a slightly different approach, Floyd suggests
that the concrete and abstract dimensions of the commodity (and by
extension, of commodity-producing labor) as elucidated by Marx are
inseparable *because* of the inseparability of concrete and abstract in
Marx's larger methodology (*Reification of Desire*, 28).

value is or can be said to be, one thing that we can all say it is definitively *not* is an inherent, unchanging property of the individual objects in which it is said to reside. This is strikingly true for "value" in its three main incarnations. Moral values such as "good" and "bad" are most conspicuously projections of subjective evaluations onto objects —evaluations that are ultimately expressions of desire and the will to power, Nietzsche argues, even when they seem or purport to be neutral. Similarly, but in a way that is less obvious and for reasons Kant devotes the entire *Critique of Judgment* to showing, the aesthetic value of "beauty" is not an objective quality possessed by the thing judged beautiful but a subjective feeling of pleasure referring to a harmonious relationship between the subjective capacities of the judge. Finally, and perhaps least obviously of all, a commodity's value is not a property that the individual commodity possesses in and of itself. Nor is its magnitude determined by the amount of labor or time an individual producer has expended on and thereby "stored" in the commodity. Value, as Marx repeatedly shows us, is not a thing nor the property of an individual thing but a process and a complex, dynamic relationship between multiple social actors.

Yet in a way also strikingly true for all its forms—moral, aesthetic, economic—value *cannot but be perceived* as an inherent property of individual things, and *cannot but be spoken of* as an inherent property of individual things. Value *itself* is not illusory in the sense of unreal or insubstantial, as Marx and Halpern draw on their array of almost exaggeratedly materialist images to underscore. Like the generic Animal incongruously mingling with specific animals, value is just as much a part of the empirical world as the human beings whose uncoordinated actions give rise to it. But there is something illusory *about* value, in that it not only objectively but by *necessity* appears as something that it is finally not (a freestanding property of individual objects). This "spectral

objectivity"—or is it an objective spectrality?—is something that capitalist value holds *in common* with aesthetic and moral value, as I noted above.[86] Yet the aesthetic representations that I have been referring to as "visceral abstractions" in this chapter—Johnson's smiley face, Halpern's soldier's body, even Marx's Animal—bring this peculiar aspect of value in general home to us in a way that the concept of capitalist value does not. Precisely by triggering crude and elemental feelings, these representations allegorize the catachresis of the value-form with an affective power that mirrors the "material force" of all capitalist abstractions.[87]

86 "Spectral objectivity" is an alternative translation of Marx's "gespenstige Gegen- ständlichkeit," which Ben Fowkes translates as "phantom-like objectivity" (*Capital, Vol. I*, 128). See Heinrich, *Introduction*, 49. What distinguishes economic value based on abstract labor from all the other kinds of value, Lukács argues, is that while the other kinds presuppose and reflect a given kind of sociality, the former produces and also reproduces this sociality on an extended scale. See Lukács, *Ontology of Social Being*, 154.

87 Marx writes, "The weapon of criticism cannot, of course, replace criticism of the weapon, material force must be overthrown by material force; but theory also becomes a material force as soon as it has gripped the masses" ("A Contribution to the Critique of Hegel's Philosophy of Right: Introduction," marxists.org).

Acknowledgements

This book tracks an emergent trend. Increasingly, the notion of "real abstraction" is being applied to cultural discussions in an effort to salvage critical artistic production from being fully lost to capitalist logic and relations. The authors in this book share, if not a last vestige of hope, then certainly the call to attend to the disintegration of art's promises with proper rigor. I am extremely thankful to all the writers for allowing us to bring their works together and to the artists who enthusiastically shared their images. I am also grateful to the editors and journals (listed below) in which some of these texts originally appeared. Lastly, I want to acknowledge Natalia Zuluaga at [NAME] publications, and Rachael Rakes, Duncan Ranslem, and Jenn Harris at Verso.

Alberto Toscano's "The Open Secret of Real Abstraction" first appeared in *Rethinking Marxism*, 20:2, 273–287. Copyright © Association for Economic and Social Analysis, reprinted by permission of Taylor & Francis Ltd, tandfonline.com on behalf of Association for Economic and Social Analysis.

Leigh Claire LaBerge's "The Rules of Abstraction: Methods and Discourses of Finance" first appeared in *Radical History Review,* Issue 118, Winter, 2014, (c) by MARHO: The Radical Historians' Organization, Inc.

Victoria Ivanova's "Art, Systems, Finance," first appeared in *Intersubjectivity Volume II: Scripting the Human,* edited by

Lou Cantor and Katherine Rochester, published by Sternberg Press, November 2018.

Nathan Brown's "The Distribution of the Insensible" was originally published in *Mute*, on 28 November 2014, metamute.org. The images of Nicholas Baier's *Vanités (bureau d'artiste)* /*Vanitas (artist office)*, 2012, that accompany the text appear courtesy of the artist.

Benjamin Noys's text was published as "The Art of Capital: Artistic Identity and the Paradox of Valorisation', in *Playgrounds and Battlefields*, ed. Francisco Martínez and Klemen Slabina (Tallinn: TLU Press, 2014), pp.384–400.

Sven Lütticken's "Concrete Abstraction—Our Common World" is a significantly reworked version of a text published under the same title in *Open!* in 2015, in the series *Commonist Aesthetics,* co-edited with Casco (Utrecht). The images of Paul Chan's works that accompanied the text appear courtesy of the artists and Greene Naftali Gallery, New York.

Jaleh Mansoor's "On Rendering the D/recomposition of Context and the D/recomposition of Form in (Global) Contemporary Art" first appeared in *Situational Diagram*, edited by Karin Schneider and Begum Yasar, published by Dominique Lévy, New York, 2016.

John Miller's "Day by Day" was previously published in *The Price Club: Selected Writings (1977–1998)*, JPR Editions & Les Presses du Réel, Geneva/Dijon, 2000. The images that accompany the text are part of Miller's on-going photographic project "Middle of the Day."

Sianne Ngai's "Visceral Abstractions" first appeared in *GLQ: A Journal of Lesbian and Gay Studies*, Volume 21, Number 1, January 2015, pp. 33–63. Published by Duke University Press.